Caught in Motion

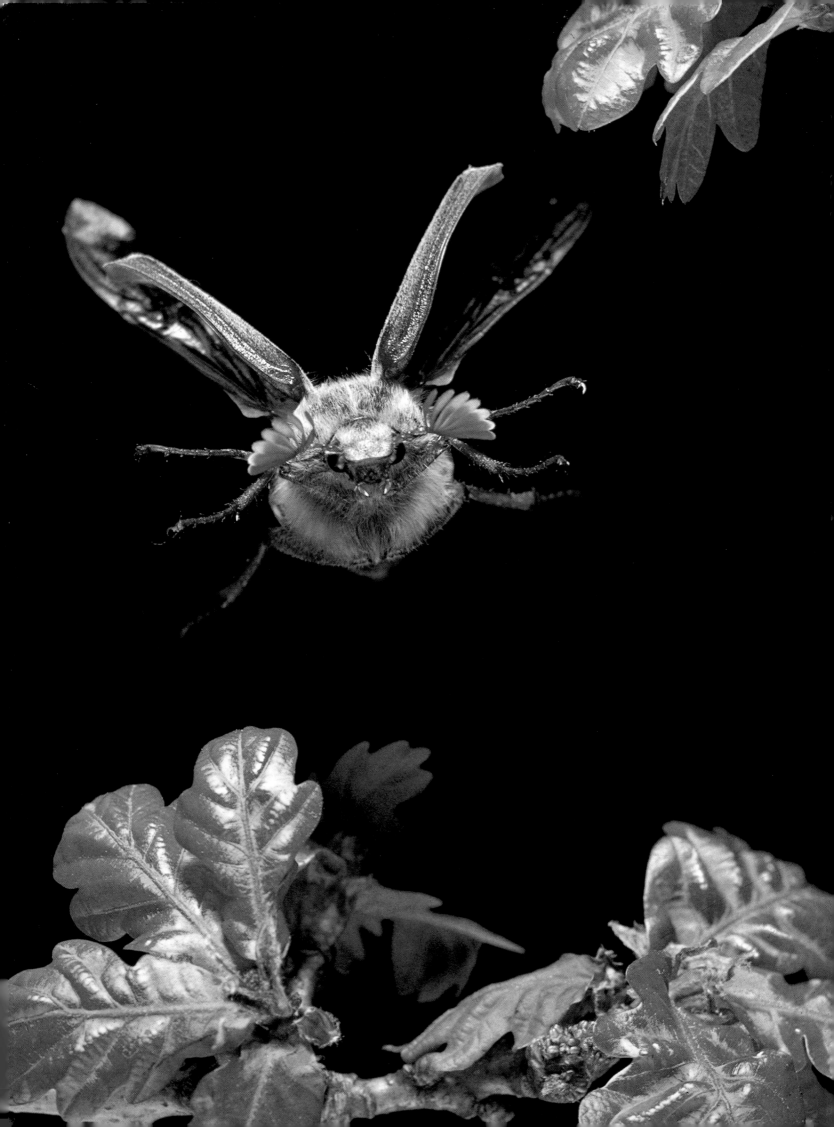

Stephen Dalton

Caught in Motion

High-Speed Nature Photography

Weidenfeld and Nicolson
London

To the Possage

First published in Great Britain by
George Weidenfeld and Nicolson Ltd
91 Clapham High Street
London SW4 9TA
1982

Paperback edition published 1984

This book was designed and produced by
John Calmann and Cooper Ltd
71 Great Russell Street, London WC1B 3BN
Designer: Gail Engert

Cased ISBN 0 297 78066 2
Paperback ISBN 0 297 78556 7

Filmset by Keyspools Ltd, Golborne, Lancs
Printed in Hong Kong by Mandarin Offset Ltd

The author and John Calmann and Cooper Ltd would
like to thank Oxford Scientific Films Ltd for
their kind permission to reproduce the photographs
of horseshoe bats, frogs and other creatures

Frontispiece **Cockchafer**
The cockchafer or maybug cannot fly until it has
filled numerous air sacs in its body. Even then
it is a slow, noisy, clumsy flier.

Contents

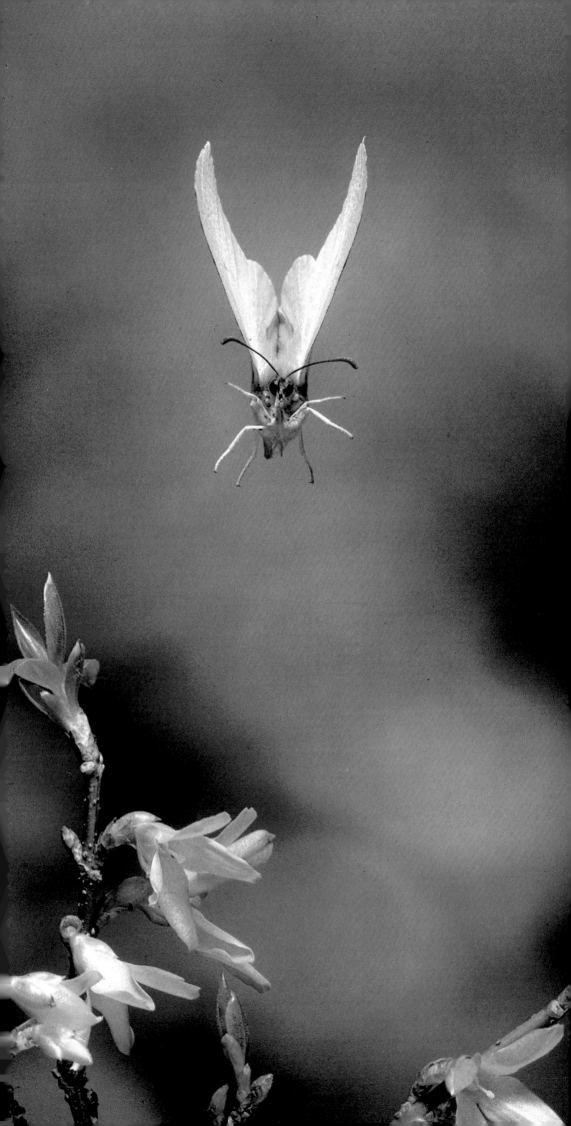

Introduction

At the age of about seven I was captured by two absorbing interests that, together with a third acquired when I was older, developed into the obsessions of my life. These separate passions – flying, insects and afterwards photography – ultimately coalesced into a preoccupying challenge that has dominated the past fifteen years of my existence.

My interest in flying stemmed from World War II. My father was in the Royal Air Force, so that I was always conscious of planes droning through the night sky of the English countryside. We were living then near an airfield and I would go close to its high wire fence and watch for hour after hour as the planes took off and landed. I was not really concerned, I think, with where they were going and where they had been, but rather with the actual flying. I soon decided that I also wanted to be a pilot, and ultimately I did qualify for a private pilot's licence.

The second preoccupation was fairly predictable. The whole family was intensely aware of nature and living things: domestic pets, birds and animals of the field and forest. My own interest gradually narrowed to insects. Relegated to the outer boundaries at school cricket matches, where my ineptitude at catching the ball was least apparent, I would spend my time gazing at a beetle on a blade of grass or a swarm of gnats hovering over a hedge. My school athletic report commented acidly one year: 'Dalton is more interested in the lilies of the field than in the pursuit of the game.'

A landmark in my life occurred at the age of nine, when the family moved from their modest and somewhat confined quarters to an old mill-house in the country, where I was to spend the next twenty years of my life. Our new home was set amidst twenty-five acres of glorious countryside and included a one-and-a-half-acre lake and two delightful mill-streams. Such a setting provided an ideal environment for all sorts of creatures, particularly for insects which thrived on the plant life in and around the water.

While my knowledge and appreciation of natural history steadily grew, my first attempt at insect photography was short-lived. On my twelfth birthday my father, a keen ornithologist, gave me a box camera from which I immediately expected the most advanced results. Longing to capture the perfect image of a hoverfly on a dahlia, or a beetle on a rose, I romped happily round the garden from flower to flower, snapping every insect I could find. The resulting totally fuzzy impressions gave me a shattering and indelible first lesson on the limits of photographic equipment. Another ten years passed before I picked up a camera again.

After leaving school I drifted into a company which manufactured agricultural machinery. Here I dabbled in a bit of photography for the sales promotion department, but as nobody knew the first thing about the subject, my knowledge and expertise made little progress; besides which, I soon realized that I did not want to spend the rest of my life photographing baler knotters, ploughshares and bulldozers. I began to wonder whether I might combine my new-found interest in photography with natural history. At about this time I spotted an advertisement for a full-time photographic course at a famous London college, where eventually I was offered a place. Here, apart from learning about matters which had long eluded me such as photographic theory and darkroom technique, I learnt to become hypercritical about my work. This perfectionist attitude has remained with me ever since.

2 Brimstone
One of the first butterflies to emerge in the spring, the brimstone can be seen on the wing even on warm February days. The yellow forsythia was an obvious choice for the foreground – a typical early spring flower which harmonized with the butterfly.

The pale greenish-white female can be mistaken for the cabbage white, its close relative, but the brimstone has a more direct flight, stronger than the cabbage white's aimless fluttering.

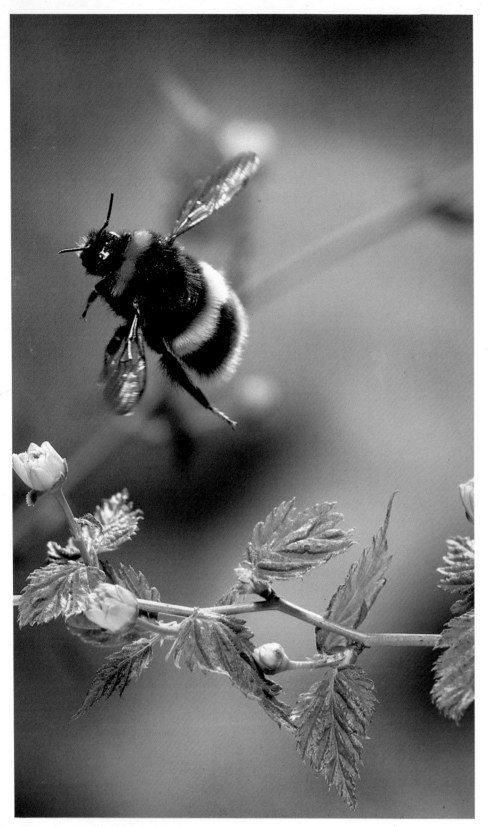

3 **Bumblebee**
Before taking to their wings, large-bodied insects such as hawk moths and bumblebees have to raise the temperature of their bodies to 30°C or 40°C by shivering their wings. Even more remarkable, the bumblebee has the ability to uncouple the flight muscles from its wings, vibrating and warming them up without moving its wings at all.

This bumblebee demonstrates the lifting power of insect wings.

4 **Rhododendron leafhopper**
It was easy to find this quaint little insect, as it thrives on the rhododendron bushes at the bottom of my garden. All leafhoppers are extremely active leaping bugs which have earned their common name, dodgers, because when alarmed they run round to the other side of their leaf or twig, and a few moments later peep out to see if all is clear.

Although these creatures are capable of flying in a conventional manner when going comparatively long distances, high-speed photography demonstrated that normally they do not open their wings until an inch or two after take-off. Even then, rather than flapping, they tend to use their wings simply as gliding planes.

When my course was finished I began building up a library of natural history photographs and it was not long before I found commissions to illustrate articles and books. Among the most interesting and challenging was the one to supply all the photographs for a book on honeybees, which included the life history of the bee in minute detail. One picture which I particularly wanted was of a honeybee in full flight returning to its hive. I remember spending much time and effort in attempting what in those days was an almost impossible task. After making up some crude electronic gadgetry and borrowing a 'semi high-speed' flash unit I managed something, but the final result was far from perfect.

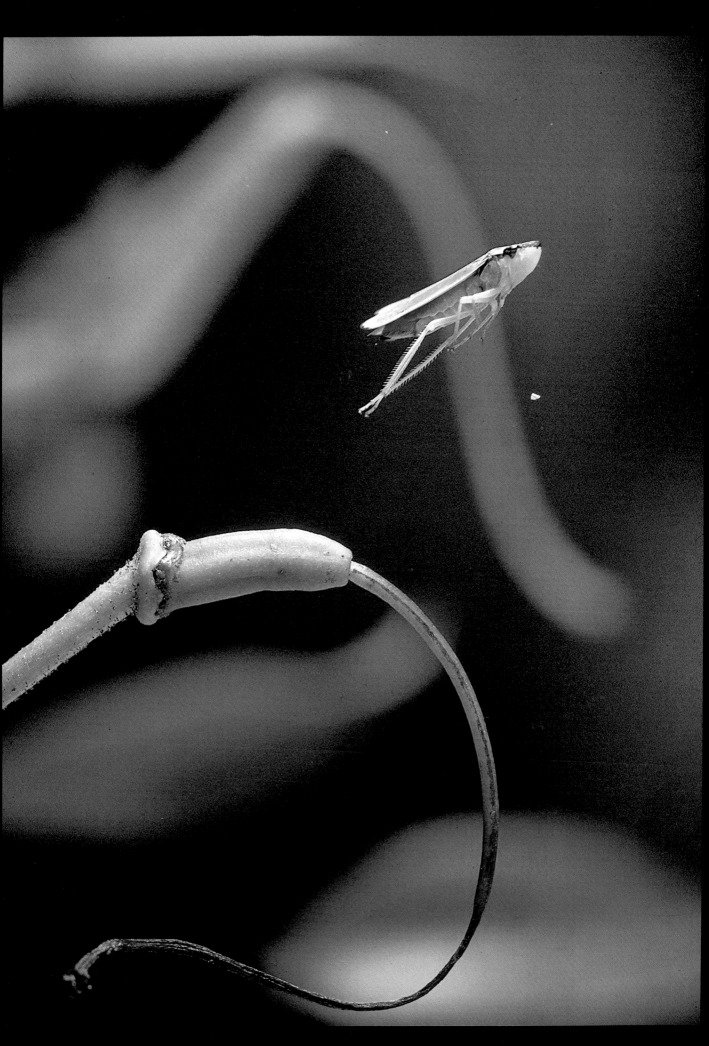

9

By now it began to dawn on me that over the last few years I had only been photographing insects at rest or crawling – neither I nor anybody else had ever photographed them in free flight. Yet, for me, the most wonderful thing about insects is that they fly. Birds fly too, but the flight of insects seems far more mysterious. You can quite clearly watch a bird fly; with large birds you can more or less follow each wing beat and see the shape of the wings changing during different phases of movement. But you cannot examine an insect's flight movements. With insects, even the wings of the slowest fliers are blurred, while the paths of some insects through the air are so rapid and fluctuating that it is impossible to keep track of them at all.

In flight, a bird is a graceful creature, but insects, in their own way, are equally beautiful. Photographically speaking, insects have even more to offer than birds, with their vast numbers of species and far greater diversity of structure. Most have four wings rather than two, which they beat at up to one thousand times a second. It is hardly surprising that I was curious to learn what an insect was really doing during this frenzied activity of flight.

Despite my various photographic experiments with all manner of bizarre equipment, this most intriguing aspect of an insect's life continued to elude my camera. There seemed no means of observing the exact way in which an insect used its wings to make the incredible manoeuvres we take for granted. There simply was no technique capable of stopping an insect with absolute clarity in free flight, and clearly it was up to me to develop one.

Solving the technical problems

The difficulties I had to overcome were quite severe. The first problem was size – a small object such as an insect requires a much higher image magnification to achieve a reasonable image size on the film. In macro-photography depth of field decreases rapidly as image magnification is increased, and so the smaller the insect, the more difficult it is to get it in overall sharp focus. This is aggravated by the fact that greater depth of field is required for a flying insect than for an immobile one (for reasons explained in the next chapter).

The second problem was a more serious one: insects' erratic flight-paths. Not only do they fly at relatively high speeds, but the flight of most insects, unlike that of birds, is totally unpredictable. How often do you see an insect flying in a straight line? Try following the bobbing flight of a cabbage white butterfly as it flits over the cabbage patch, or a blow-fly frantically trying to escape from the kitchen. They zig-zag all over the place without apparent rhyme or reason. Somehow the creature had to be persuaded – at this stage the means of persuasion was far from clear – to fly along a predetermined path and through the exact point of camera focus, where, at this point and no later, the shutter and flash had to be fired. To achieve this I would have to develop an optical-electronic system for detecting the insect in a precise plane of space, and a further device for opening the camera shutter at the exact moment of detection.

Detection is in principle a relatively straightforward matter. A beam of light or infra-red is focused on to a light-sensitive cell, and when the beam is broken by the insect, the photo-cell feeds the information to an amplifier. In practice, things are not quite so simple, as a fairly refined optical system is

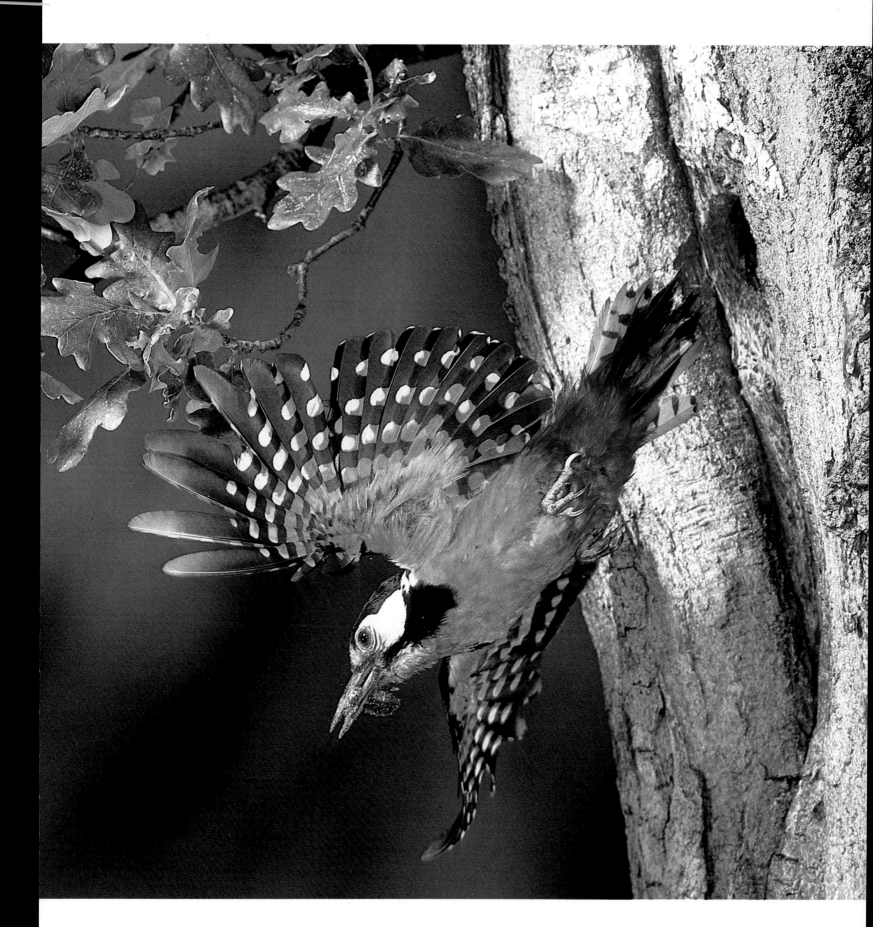

5 Greater spotted woodpecker
Rather than erecting a hide to photograph the bird's comings and goings at its nest-hole, I kept an eye on progress, hidden some thirty yards from the nest.

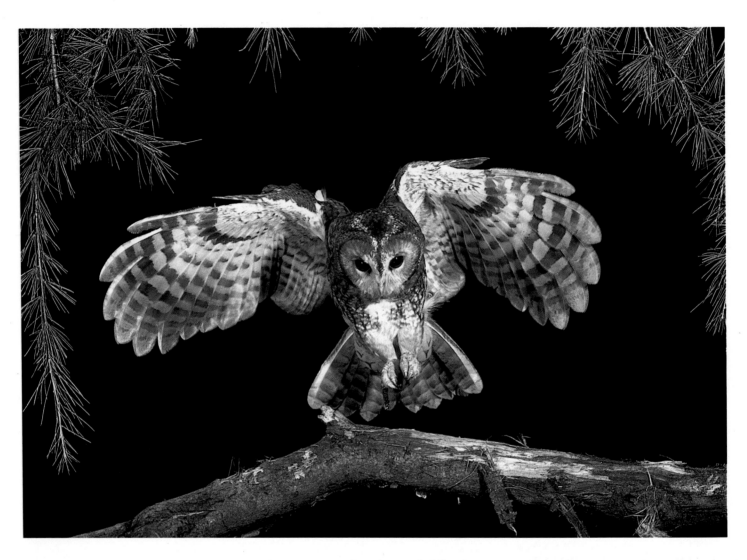

needed to detect creatures such as midges or greenfly. The real difficulty, though, was the shutter. A conventional shutter of a single-lens reflex camera takes a surprisingly long time to open – about a tenth of a second. This means that if an insect is flying at, say, five yards (about 5 m) a second, it will have moved 20 inches (about 50 cm) past the point of focus during the time the shutter takes to open – not very encouraging when depth of field is measured in small fractions of an inch! One simple solution would be to do away with the shutter for synchronizing the flash, and work in the dark with open flash technique. This is fine for owls and bats, but when working in bright light it is out of the question. The only real answer would be to bypass the camera shutter by leaving it open, and to design a special rapid-opening shutter to clamp in front of the lens. Ideally the new shutter had to be capable of opening and firing the flash within 1/1000 second, a tall order, putting it beyond the range of any practical commercial product. The success of the shutter was, of course, imperative to the whole project.

The third and most obvious problem was to eliminate image blur caused by the insect's rapid movements. My original intention was to show the insect 'frozen' in mid-flight apart from a slight blurring of the wing-tips. Unfortunately, the degree of wing movement is impossible to control: the

6 Tawny owl
This photograph holds a special place in my memory for two reasons: first, the owl, though totally free, was quite tame and I grew very fond of it; and secondly, the picture represents my first attempt at in-flight bird photography. The operation was carried out in an old barn using a large-format plate camera, press-type flash gear (duration 1/1000 second), and a Leitz projector as a light source to activate a primitive triggering system. The fact that the owl was braking prior to touch-down rather than flapping its wings has enabled me to get away with a slow flash speed.

flash speed would have to be adjusted not only to suit the different species of insect (the wing-beat frequencies of which vary from about 8 to 1000 cycles per second!) but also to the actual phase of the wing-beat cycle. A wing is moving at maximum speed at its mid-position, while at the top and bottom of each beat it is stationary for a fraction of a second. Tests also revealed that when I deliberately introduced wing-tip movement, then a very slight but perceptible overall blurring of the entire image could be seen in the photo. Apart from the obvious loss of 'information', the fuzziness also reduced the impact of the picture. So total freezing and hence high flash speeds it had to be. Most commercial flash equipment has a flash speed of between 1/400 and 1/1000 second – far too slow for stopping insects' wings. I needed at least 1/20,000 second.

The so-called 'computer' flash units which were then coming on to the market, although capable of high speeds, do not deliver enough power at those speeds. (For non-technical readers: the more light required, the longer it takes to discharge and hence the slower the flash speed.) The photograph of a humming-bird (p. 127) was taken with four computerized guns, and to obtain sufficient light (on 64ASA Ektachrome), I had to operate at one-third power. This produced a speed of about 1/3000 second – faster than average but still relatively slow – hence the wing movement. For insects, computer flash units need to be switched down to one-sixteenth power or less before operating at useful freezing speeds. It is possible to increase power by combining several 'switched-down' units into a single flash-head, but this would have been an expensive and clumsy solution.

Inquiries in England, the United States and the Continent confirmed that there were no commercial electronic shutters or flash units which met my requirements. Nobody made rapid-opening shutters, and though a few companies manufactured flash equipment for specialized scientific purposes, none was suitable for insect photography. One very expensive unit produced speeds of 1/1,000,000 second, while others needed power supplies the size of a dining-room table, but none was powerful enough, and they all suffered from various other disadvantages.

Building the equipment

It was now clear that if I was ever to take the sort of photographs I had in mind, I needed to design radically new equipment. It dawned on me that the sole suitable item I possessed was my lens, and I would have to begin from the beginning.

One electronics company offered to do some experimental work but wanted a huge advance, and was not very hopeful of success. The National Physics Laboratory at Teddington (Middlesex) lent me a sympathetic ear but was unable to give me any practical help. Numerous other possible sources of assistance also proved abortive. Finally I ran into some luck. Somebody had suggested that a visit to the Royal Aircraft Establishment at Farnborough in Hampshire might be worthwhile – it seemed a long shot, but at least it was a good excuse to look at some interesting aircraft.

My visit to the RAE proved to be a somewhat cloak-and-dagger affair – special security clearance well in advance was necessary. Early one spring morning I piloted a light plane through miserable visibility to a radar-assisted

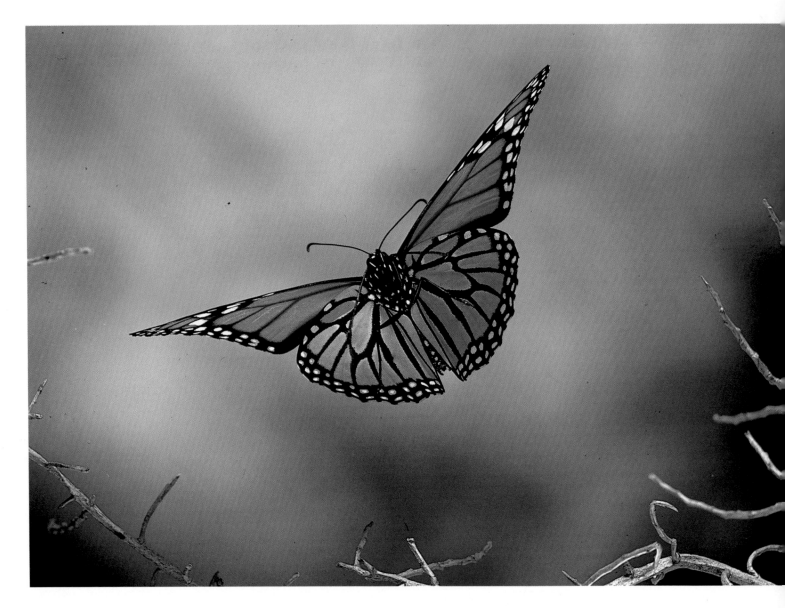

landing at an unfamiliar airfield. I felt that such an arrival was an appropriately stylish way to appear for my interview, but it failed to impress the security police, who painstakingly searched my briefcase and made me complete endless forms before clearing me. Eventually I was escorted to a meeting with Ron Perkins, an electronics engineer with a keen interest in birds and photography. It was not long before I realized that he was sympathetic to everything I was hoping to achieve, and after he offered to help me, I flew home scarcely able to believe my luck.

A week later I was at Ron's home discussing basic design specifications of the flash unit such as size, weight, mains versus battery operation, number of flash-heads and reflector design. I had already worked out speed and power requirements, based on my stipulation that 25ASA Kodachrome was to be used for the project. This was essential for the definition and colour fidelity I wanted. Unfortunately, as this was the slowest colour film on the market, a great deal of light output would be required if the film was to be sufficiently exposed at the small apertures necessary to obtain adequate depth of field.

7 Monarch
One of the first insects fed through the flight tunnel on the expedition to the Everglades was the well-known monarch or milkweed butterfly.

8 Emperor moth
One of the few silk moths to be found in Europe, the emperor is most often found on heath and moorland. It is a member of the *Saturniidae* family, which includes some of the largest moths in the world such as the Atlas and Hercules moths (with up to ten-inch (25-cm) wingspans).

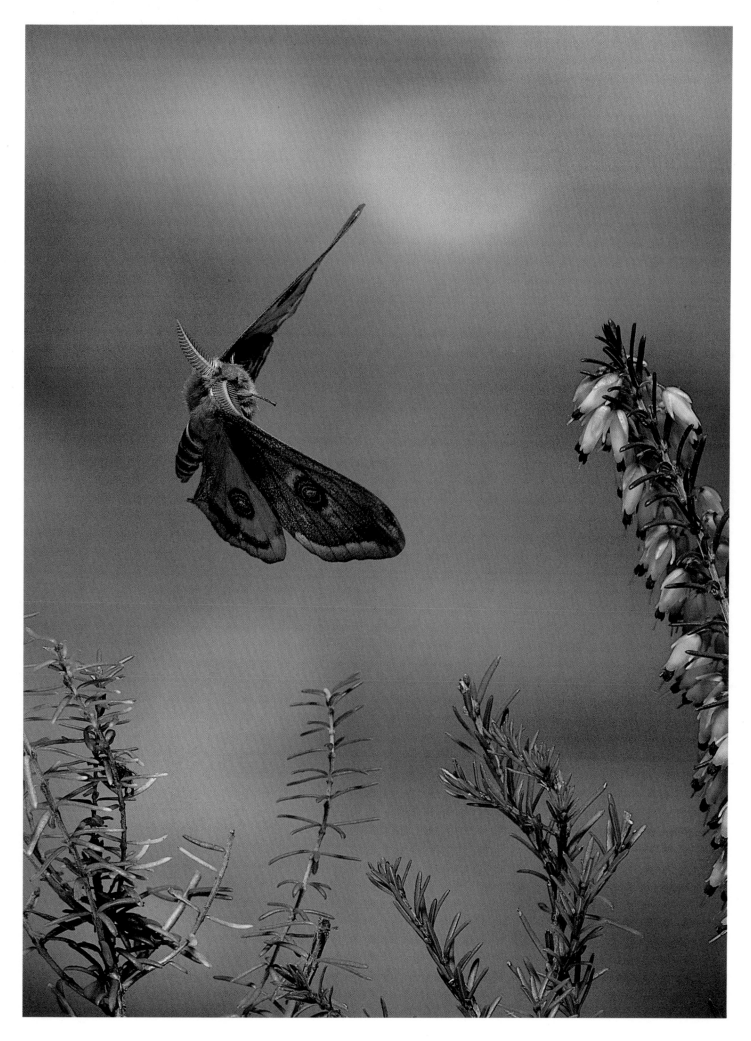

This power problem was aggravated by the fact that the higher the image magnification the more light is needed.

The flash specifications I stipulated were ambitious by any standards, and were as follows:

1. Duration no slower than 1/20,000 second.
2. Light output from a single flash-head held 18 inches (46cm) above the subject sufficient to expose Kodachrome 2 film at f/16 at an image reproduction ratio of 1:1.
3. Unit to be capable of operating up to four flash-heads.
4. Whole apparatus to be portable.

9 Spurge hawk
The spurge hawk is one of the loveliest hawk moths to be found in Southern Europe. This particular insect was caught late in the afternoon while hovering as it sipped nectar from oleander flowers. When released two hours later it took off from my hand and flew into the dusk.

10 Robin
As this robin was nesting on the ground, careful observation of the parents' take-off behaviour was essential before the beam and photocell could be placed in position – unless the birds took off in exactly the right spot, they would be out of focus.

Let us look back for a moment at the history of high-speed photography. It may come as a surprise to learn that high-speed flash is almost as old as photography itself. As far back as 1860, experiments were conducted at Woolwich Arsenal, London, using electric sparks in an effort to record the behaviour of projectiles in flight. The spark was produced by discharging a high-voltage capacitor across a spark gap. The projectile was directed between the spark and the camera, and a silhouette of the object was recorded on a photographic plate. As the duration of the spark was in the order of an incredible one millionth of a second, theoretically an extremely sharp shadowgraph could be obtained. But photography was in its infancy in

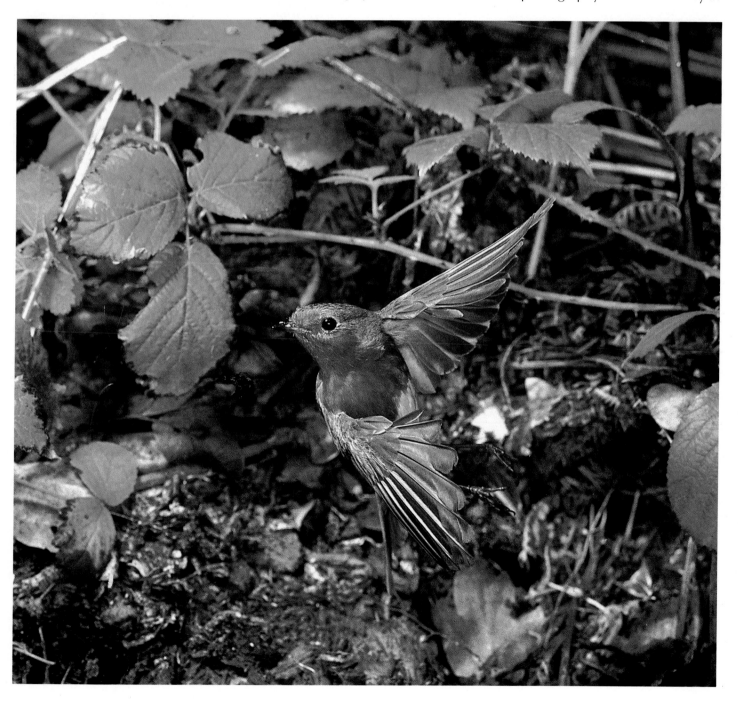

11 Nuthatch

This attractive little bird habitually makes its nest in the abandoned hole of another bird, and adjusts the hole to the required size by cementing it with mud. It keeps the nest clean by carrying out detritus and the droppings of its fledglings in its beak.

In this photograph I wanted to prevent the background from appearing black, so I introduced several branches of alder foliage – it was necessary to immerse the stems in jars of water to keep them fresh. As there was a strong wind blowing, securing the foliage in the right place proved to be somewhat trying.

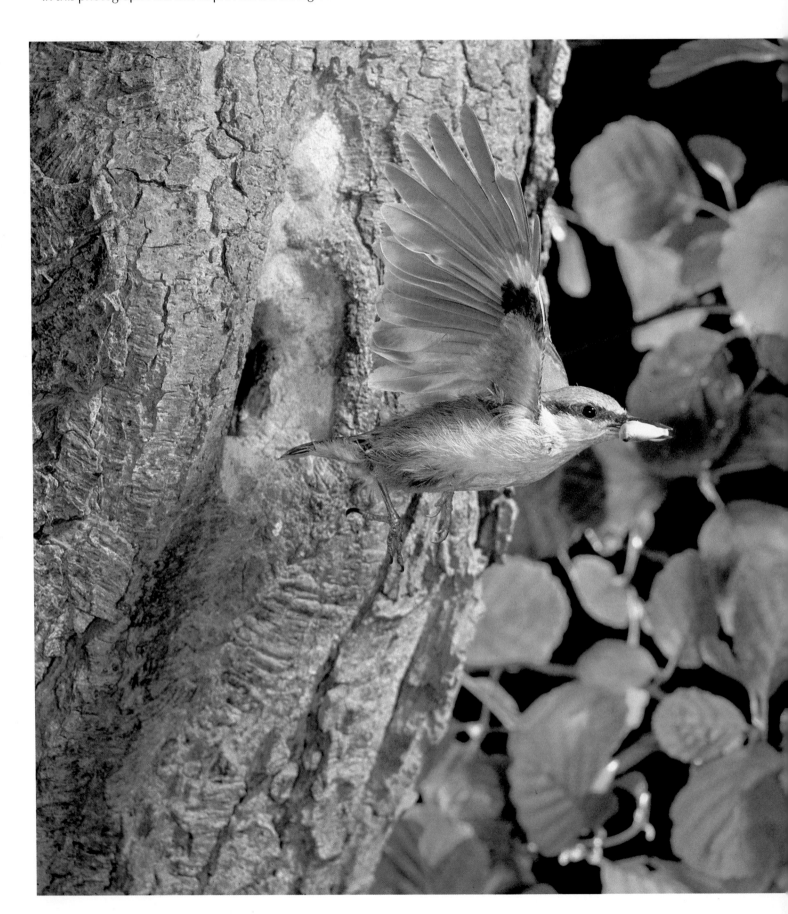

those days – only very low-sensitivity wet plates were available – so these pioneering attempts were not altogether successful. Later in the century Ernst Mach in Austria (of Mach Number fame), and Sir Charles Boys in England, made significant improvements in the technique, the basis of which is still in use today.

The chief drawback of spark photography was the extremely low level of illumination produced by the spark, and it was not until the 1930s, with the development of electronic flash by Professor Harold Edgerton, that this was overcome.

With electronic flash, instead of the energy from the capacitor (or condenser) jumping between two open electrodes, it is discharged through a rare gas such as xenon or krypton contained in a glass or quartz tube. The result is much more light output, but at the expense of a much longer discharge time. This underlines our problem. With all electronic flash, including computer flash, speed and power are in direct conflict. It is easy to design a short-duration unit with a low output, or a high-output unit with a long duration. Combining both speed and power is a different story.

The characteristics of electronic flash revolve around the capacitors which store the electrical energy, and the flash tubes through which this energy is discharged. The duration of flash, its power, the voltages required, and the size and weight of the apparatus are all keyed to these two components. The trick would be to find the right combination.

Basically the relationship between power and speed is quite simple. The larger the capacity of the capacitor, the greater the power. The voltage to which the capacitor is charged also affects power – the higher the voltage the greater the power. There is a simple formula for calculating power of electronic flash which is:

Power in Joules, $J = \dfrac{CV^2}{2}$ (Where C is the value of the capacitor in farads and V is its voltage).

Thus power is directly proportional to capacitance and directly proportional to the square of the voltage.

Flash speed on the other hand is governed by the size of the capacitor, and the resistance of the flash tube and its circuit. Again there is a simple formula:

Duration in seconds, $t = \dfrac{CR}{2}$ (Where R is resistance of the tube and circuit in ohms, and C is the value of the capacitor in farads).

So the larger the capacitance and the higher the resistance, the longer it takes for the energy to be discharged – quite logical really.

To obtain short duration, it would therefore be necessary to select a tube with a low resistance, and to use a small-value capacitor. The only way to get a reasonable output for such a combination is to use high voltage, and high voltages dictate the use of paper capacitors.* The early flash equipment

* Electrolytic capacitors are used in modern commercially available flash units. These are smaller, lighter and cheaper than paper capacitors and cannot tolerate a charge much higher than a few hundred volts.

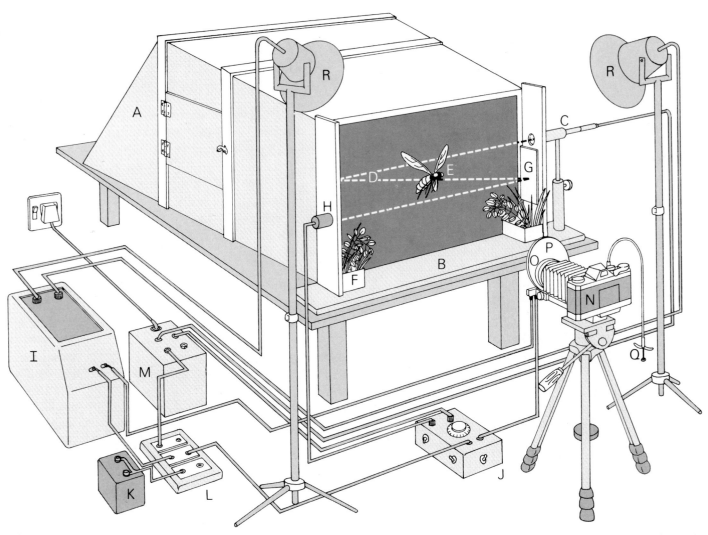

which appeared on the market shortly after World War II used heavy and bulky paper capacitors of a comparatively small capacity. For anything like enough light to be obtained from them, they needed to be charged to about 2,000 volts. But they had one advantage – a highish flash speed of around 1/5000 second – quite acceptable for anything except the most agile of creatures. The photograph of the barn owl on page 98 and the swallow returning to its nest on page 115 were taken with such equipment. However, these old flash units did have their snags. Apart from weight and bulk, they were unreliable, they consumed an enormous amount of battery current and they were sometimes dangerous. Besides, I needed more power and ideally more speed.

After months of experiment with different combinations of tubes and capacitors, Ron and I finally developed some equipment which exceeded my wildest dreams. Its speed of 1/25,000 seemed fast enough to stop any living thing, and yet it had ample power. Furthermore it was portable, and so could be carted about outside over moorland and through forests for bird photography. Later on, an important refinement was the development of the multi-flash. This device permitted a sequence of flashes to be fired with an adjustable time delay between each, so that a series of images could be recorded on the same piece of film. The technique was not only capable of

Diagram of flight tunnel
A Flight tunnel
B Optical bench
C Light source
D Light beams
E Insect
F Plant in container
G Mirror
H Photocell
I Flash power-pack
J Photo amplifier
K Battery
L Junction base
M Power supply and battery charger
N Camera
O Lens
P High-speed shutter
Q Cable release
R Flash-head

12 Leaf beetle
Multiflash photography comes into its own when used for recording take-off and landing techniques. Here a Venezuelan fifteen-spot leaf beetle is taking off from a twig. Bearing in mind that the time interval between each successive flash was 30 milliseconds, it is interesting to calculate that the beetle increased its airspeed from about eighteen inches (half a metre) a second to a yard a second within 1/10 second – a low rate of acceleration for an insect. But notice too that the beetle has rotated its position through 90° during this time. An aircraft would break up in these circumstances.

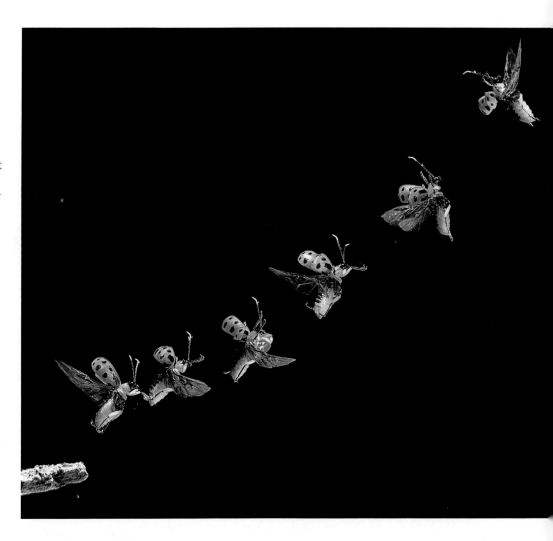

recording different wing positions within a relatively short space of time, but also made possible the study of behaviour never seen before, such as take-off and landing.

Now that I had the flash, I was more determined than ever to solve the remaining problems. The optical detection system was already functioning well: a pencil beam of light from a quartz-halogen bulb was carefully aligned and focused onto a photo-electric cell, which in turn was coupled to a sensitive amplifier. Eventually the system was so finely tuned that it responded to a human hair passing through the beam as fast as I could move it. If a 'flying' hair could be detected, then an insect's antenna would also be picked up. Before testing the detection system on living insects, I needed to devise a way to encourage insects to pass through the light beam. It seemed logical that most insects would fly towards light, so I constructed a tunnel through which they could make their way to freedom. Tests soon proved that the idea was sound, albeit subject to the idiosyncrasies of an insect's temperament. At least I was heading in the right direction.

The project had already taken over eighteen months, and its final stages were particularly frustrating as I could not start serious photography until I had developed a rapid-opening shutter. I wanted to accelerate the opening time from 1/10 second to 1/1000 second – a hundredfold improvement!

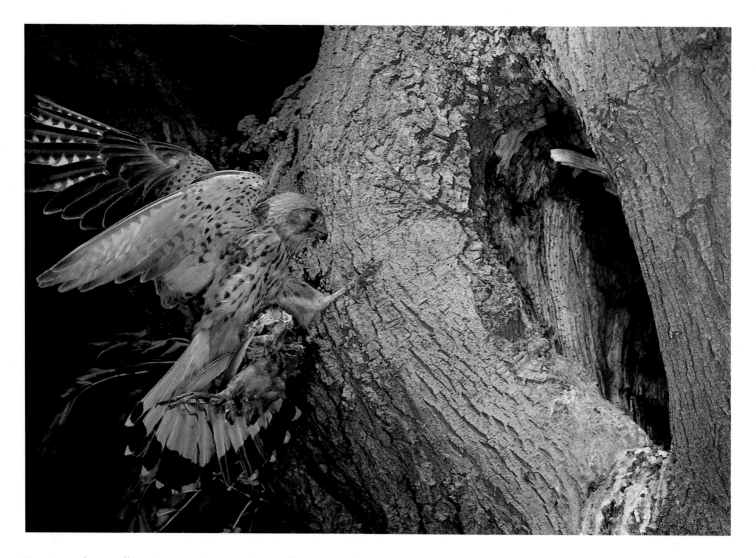

Ron's and my efforts in attempting this ambitious task contrasted with the electronic wizardry employed in the solution of the flash problem. We reverted to basic engineering principles. A system of elastic bands, not surprisingly, proved cumbersome, inelegant and inefficient, so we tried a somewhat more drastic means – a small charge of dynamite. In a sense this did work, but the cost per exposure, the severe vibration to the camera, the slow resetting time and the limited shutter life, not to mention the noise and smoke, forced us to abandon this idea too. Ultimately we had to compromise on speed and produced an electronic shutter with an opening time of about 1/400 second – but it has proved fast enough for all but the most rapid of small flying insects.

So, finally, I had all the equipment necessary to begin photography in earnest. The next few months were very exciting as I tried out my equipment and techniques on a wide range of insects. The flight tunnel gulped insects by the score as my natural impatience got the better of me. It is difficult to describe my feelings as I witnessed for the first time what insects were really doing on the wing. Imagine my excitement, while thumbing through freshly processed Kodachromes, at seeing that a moth is shedding wing-scales during take-off, that the twisting of a fly's wings is so extensive that the

13 Kestrel

In retrospect I realize that this kestrel should have been left alone, as the hen bird only visited the nest once or twice a day. The root of the problem was that there were only two youngsters, which were being fed on large fledgling starlings instead of their more usual diet of small voles, mice and earthworms. One starling was sufficient to keep the chicks quiet all day.

I also had great difficulty in persuading the hen bird to fly into the hole at the right angle – in spite of trying a variety of tricks, I never got what I was after. The ten tedious days of being cooped up in a pokey hide during an exceptionally cold, wet and windy July did, however, prompt me to invest in a motorized camera.

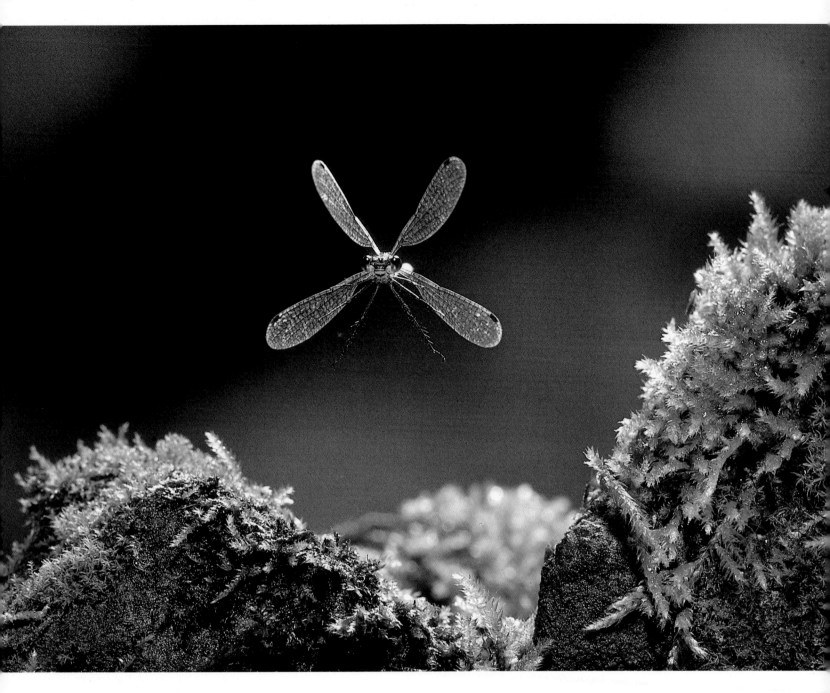

14 Green lestes damselfly

For ten days I tried to get this shot, slopping about in a small pond in Ashdown forest in Sussex to collect a few good specimens. Not wishing to disturb their breeding, I returned them to their pond at the end of each day's photography.

I wanted the damselfly head-on in the centre between the stones with its wings in the × position, and exposed some 250 frames of Kodachrome before I was satisfied. The blurring at the wing-tips is not the result of wing movement, but a restricted depth of field – the forewings have reached fully forward in front of the insect's head and the hindwings right back over the abdomen. The photograph clearly demonstrates the half-cycle phase difference between the beating of the fore and hind wings.

leading edges face backwards, or that a lacewing-fly has performed a complete loop.

Over the next few years, I gradually refined the equipment and techniques, photographing nearly two hundred species of insects, and consuming some 50,000 frames of film. More recently I have extended my range to the high-speed activities of birds, bats, amphibians, reptiles and spiders, the pursuit of which has taken me and my equipment to exotic and not so exotic locations in the United States, Europe and South America.

When I originally set out to do flight photography my intention was to achieve two things. First, I wanted to record flight behaviour and wing movements which had never been seen before – to show every twist of the wing, every scale, hair and feather in critical detail. Secondly, and just as important, I needed to create real pictures, of creatures flying free in natural and attractive settings. Now I am finding that an increasingly important driving force behind my work is the need to convey some of the excitement and exquisite perfection of nature. I hope that in a small way this book fulfils this intention. The photographs included are a personal selection of a range of creatures found over three continents, and they capture a mere 1/25,000 of a second in the life of each.

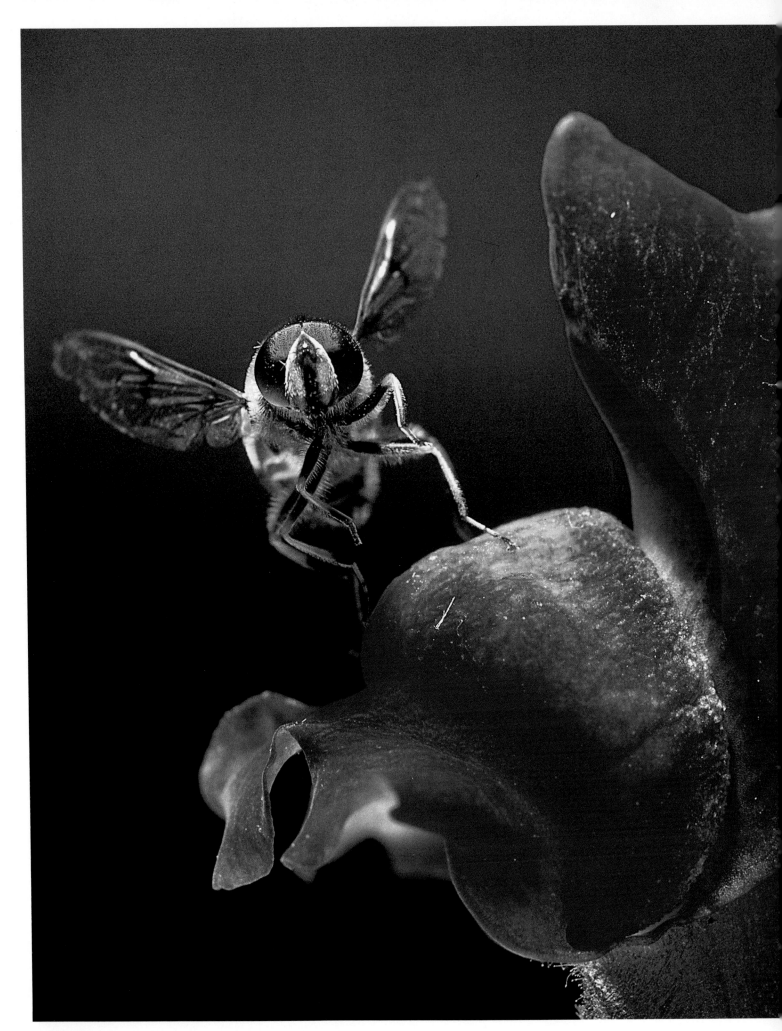

15 Hoverfly
Hoverflies are among the most spectacular and versatile of all flying creatures.

Insects

From a photographer's point of view the sheer unpredictability of insects sets them apart from birds and other vertebrates. The flight-paths of birds can often be controlled to a certain extent, but with a few exceptions those of insects cannot. Furthermore, unlike a bird which generally flies in a straight line, an insect's apparently demented flight-path perpetually fluctuates according to the creature's whim.

This erratic behaviour, coupled with the severe limitations of a very narrow depth of field, means that it is almost impossible to photograph most insects in flight in their natural habitats. Imagine trying to picture a certain beetle flying over a particular leaf – you could wait in vain for seventy years. The only practical answer is to catch the insect and photograph it under controlled conditions in the studio.

The best way to persuade an insect to fly from one area to another is to make use of its instinctive reaction to fly towards light. If the creature is confined in a dark box with a single exit facing the light, there is a fair chance that it will fly out. Some insects ignore the exit totally and buzz around the box indefinitely, some prefer to crawl out, while others will just sit inside and sulk, all depending on insect species and the mood of the individual. Uncooperative ones can sometimes be coaxed to take to their wings by using direct sunlight as an attracting source, or perhaps less subtly by prodding or application of gentle heat. Many insects such as beetles and flies prefer to crawl up a ramp of some sort before launching themselves into space. Frequently they take off only to alight at the mouth of the flight tunnel, where, after preening themselves, they fly off at a tangent, avoiding the light beam altogether. As in all wildlife photography, success not only depends on some knowledge of the insect's habits and behaviour, but trial and error, patience, and a fair measure of luck.

Even with cooperative insects, the chances of instant success are, quite frankly, slim. There are several reasons for this, most of which are related to depth of field. Depth of field (i.e. distance from nearest to furthest point in acceptable focus), or rather its absence, is the bane of the insect photographer's life. Those unfamiliar with the subject should consider the following facts.

Imagine photographing a tortoise 8 inches (200mm) long so that the size of the image on the film is about half an inch (10mm) – the image magnification would be $\frac{1}{20}$ or 1:20. At an aperture of f/16 the depth of field (for critical work) would be about 12 inches (300mm), more than sufficient to get two tortoises side by side in sharp focus.

Now imagine photographing a 10mm-long ladybird (ladybug) – a creature similar in shape to a tortoise – at a magnification of $\frac{1}{2}$ or 1:2 (image size 5mm). The depth of field at f/16 diminishes to about 5mm, nearly enough to cover the insect from its near to its further side. At a magnification of 1 or 1:1 when the image and object are the same size, depth of field shrinks to 1.5mm, sufficient only to get some of the insect's side in focus. At a magnification of 2 or 2:1, the depth of field is whittled away almost entirely – to a quarter of a millimetre, which for our purposes is almost useless, as it hardly covers the depth of the claw at the tip of the foot!

Clearly, then, there is no problem in photographing a tortoise, but there is with a ladybird (ladybug). The smaller the aperture, the greater the depth of field, so to cover the whole width of the insect at 1:1, the lens would need to

16 The flight tunnel in action: a simple construction that works very well.

be stopped down to about f/90. Even if the lens could be closed down to such an extent, we would run into real trouble. To begin with, to compensate for such a small aperture the power from the flash would have to be increased by a factor of 32. A more sinister by-product of small apertures is 'diffraction'. In photography, diffraction occurs around the edge of the lens diaphragm and is a consequence of wave motion. In practical terms it impairs image definition – the smaller the aperture and the higher the magnification, the worse the diffraction.

So an extensive depth of field is not the solution after all. Insect photographers are trapped between two evils: large apertures provide insufficient depth of field, while small apertures ruin the overall image quality. It is usually more important to retain fine detail within a limited depth – 'depth of detail' is perhaps a more suitable term. Very often the best way to increase depth of detail is by simply reducing image magnification at the camera, and enlarging the negative or transparency later, rather than by a further stopping down of the lens. Somehow a balance has to be struck between these two options.

An added complication with insect flight photography is that greater depth is necessary to photograph an insect on the wing than an immobile one. If the creature is flying towards the camera, the region of sharp focus should extend from the tip of the antennae to at least the wings' hind

margins; if it is flying from one side to the other, the fact that its wings are outstretched demands greater depth. There is thus no margin for error – if the insect is not located exactly in a predetermined plane then one extremity or the other is likely to be out of focus.

Armed with some understanding of these pitfalls, the photographer can set up the 'flight unit' in such a way as to minimize their effects. The size of the exit hole depends on the size of the insect and the magnification required to provide optimum depth of detail. Once these are determined, the light-beams are set up and adjusted. A single beam can be used but the insect could easily fly over or under it. A series of beams reflecting from mirrors on each side of the exit can often help matters by reducing the 'dead area', but multibeams have disadvantages, the accurate positioning of the insect within the frame being one. Cross-beams, too, usually create more problems than they solve.

It is always difficult to know which part of the insect's anatomy will break the beam first – antenna, head, body, wing or leg – but unless this is anticipated the chances are that the image will be unsharp. The optical and electronic sensing system can be set up to cope with most situations. With the help of lenses and diaphragms the optics can be adjusted to respond to either relatively large objects such as bodies and wings or small appendages only, such as antennae and legs: further controls on the amplifier permit adjustments to be made so that detection depends on the speed of the object. Thus the body of a slow-moving bumble-bee may be invisible to the sensor, but its rapidly moving wings fire the system.

Finally, there is the question of shutter delay. With very large slow-flying insects, such as bulky beetles and bumble-bees, it can be ignored, but not with rapid movers such as horseflies and the faster butterflies and moths. Some compensation in focus is particularly important if the insect is flying towards the camera – even a delay of 1/400 second can make a difference of about half an inch (10mm) in the position of the insect.

The point at which the camera lens is finally focused depends on all these variable factors – although I am often tempted to ignore the lot of them in the hope that they will cancel one another out!

In spite of the assortment of electronic and optical aids, and the care taken in setting up the equipment, you will find that all manner of things can still ruin the picture. The chances are low that the insect will end up at the right place, be in critical focus with its wings in the 'right' position, be correctly exposed and well lit, and that the photograph will have the necessary pictorial qualities. The only real answer is to take dozens or even hundreds of exposures and hope for the best.

Some insects, such as flies, are perfectly happy to wing their way through the tunnel time after time, while others are less obliging. Bees soon run out of energy, and need frequent refuelling with sugar or nectar. Dragonflies generally grind to a halt after a very short period of activity, so have to be released, and replaced with another individual if available. Butterflies and moths lose wing-scales and rapidly look tattered as a result of repeatedly being manhandled and flying into things, so an abundant supply of specimens is helpful.

One of my most memorable experiences with insects was initiated by chance. I was gazing into the tunnel waiting for some obstinate moth to

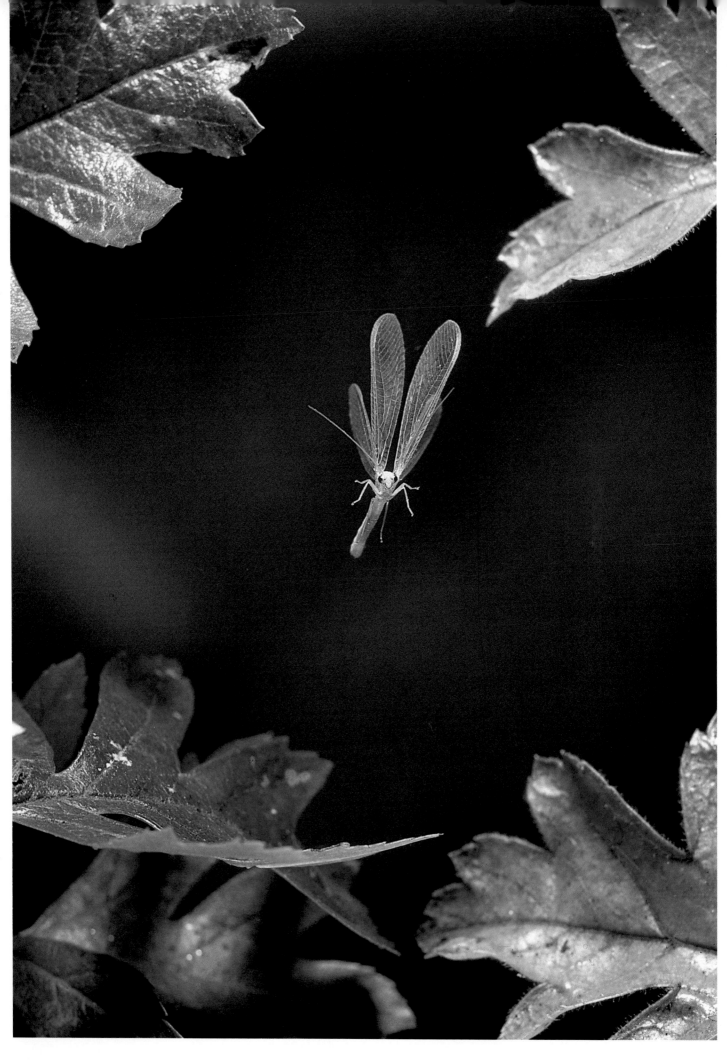

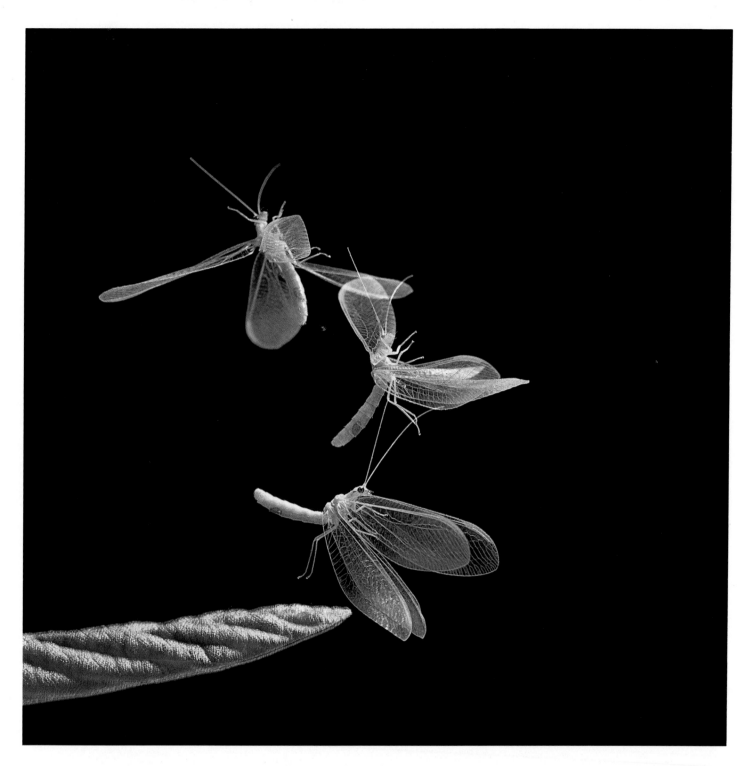

17, 18 Green lacewing fly
The weak fluttering flight of the lacewing appears haphazard and uncontrollable, and seems at the mercy of the slightest puff of wind, yet multiflash photography revealed that the creatures were capable of amazing aerobatics, such as looping the loop. Why they engage in these manoeuvres is not clear, but I suspect it is probably to foil predators.

appear, when suddenly a green lacewing-fly materialized from the black void and landed on a hawthorn leaf about two inches below the light beam. After a minute or so while it preened its antennae, there was a loud crack and a blinding flash as the equipment fired. Although I could not see what had happened, I realized that to break the beam the insect must have made a vertical take-off, and this was confirmed when I developed the film. But even more surprisingly, the body of the insect was perpendicular to the leaf with the four wings arched above like an umbrella blown inside out.

So intrigued was I by the aerial antics of this lovely insect that I was determined to recreate the situation and photograph the phenomenon by means of multiflash. I wanted three sharp images on one frame of the lacewing taking off vertically, with one in the sequence showing the inside-out-umbrella effect. The chance of success was slim, as lacewings do not regularly perform vertical take-offs, and when they do, it is unlikely that all three images will be sharp – the creatures do not appreciate the problems of

19 Zebra butterfly

The zebra is one of the most exotic butterflies of the Everglades, being a member of the tropical group of Heliconiidae, of which only three species are found in the United States. Their colouring and pattern help them to blend in with the broken patches of sunlight in which they are generally to be found. When alarmed they rapidly vanish into the shade of the undergrowth.

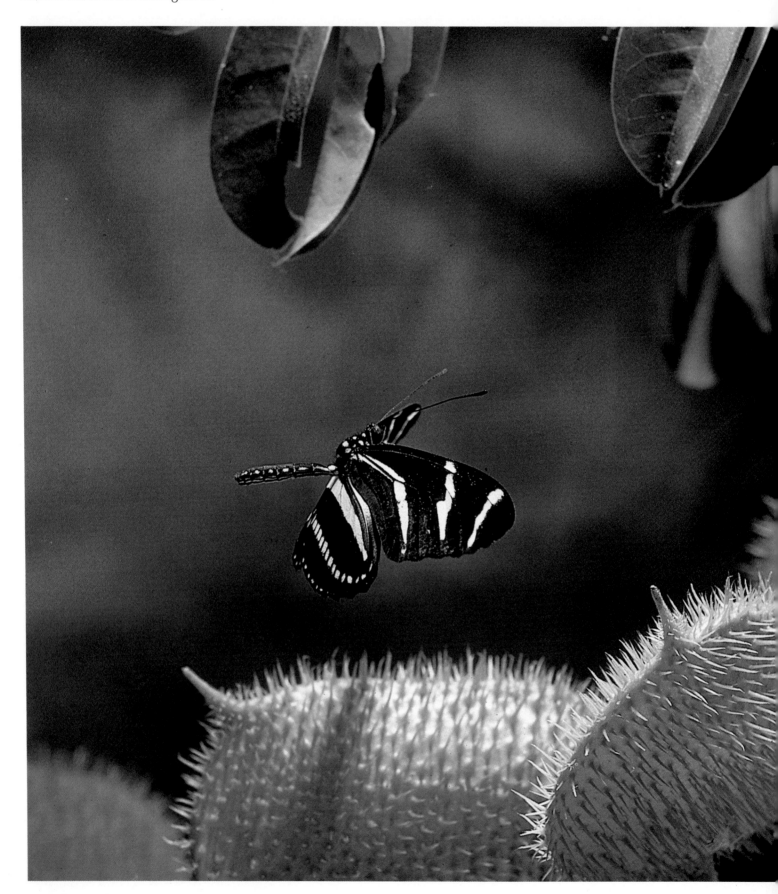

depth of field. Also the likelihood of one of the flashes firing at the moment the insect adopted this position was even more remote.

I spent about three weeks on the project. Fortunately there was a plentiful supply of lacewings in a small birch-wood at the bottom of my garden. In all some 900 frames of film were exposed (2,700 flashes), and although I never got exactly what I was after, I discovered much about the lacewing's flight.

The effort devoted to the lacewing was in contrast to that spent on a dragonfly a few days later. By fluke I caught the insect between thumb and forefinger some fifteen miles from my home and took it back with me wrapped in a handkerchief. After making up a suitable set with reeds from my garden pond, I spent an hour or two coaxing the insect to fly down the tunnel. Finally I took three exposures, and by some extraordinary stroke of luck one was perfect – the insect was beautifully positioned and in sharp focus (page 34). On the original transparency even the individual facets of the compound eyes can be discerned.

The first opportunity to try my equipment abroad arose in 1973 when I was commissioned by Readers' Digest in New York to photograph some of the semi-tropical insects of the Florida Everglades for my book *Borne on the Wind*. Such a venue provided an exciting hunting-ground for the wildlife photographer. Apart from a multitude of insects new to me, the swamps abounded in magnificent rare birds, snakes, centipedes and alligators.

During my six-week visit, I took about a thousand pictures. I would search for insects amidst the hammocks (islands in the marsh) and the subtropical vegetation in the early morning and evening, and spend the hottest time of the day photographing them in air-conditioned comfort. I had set up my studio in the bedroom of my motel at Flamingo Bay, at the southern tip of Florida. The array of equipment somewhat dismayed the cleaning lady, whose daily routine had to be revised. That anybody should travel three thousand miles to photograph the pests of the swamps seemed to her quite incredibly futile.

One of my most vivid recollections is the sight of about two dozen zebra butterflies dancing lyrically around the ceiling of my bedroom. I spent many hours enticing these creatures down the flight tunnel in an effort to capture the graceful movement of their slow fluttering (Plate 19).

I try to evoke a mood which captures the feeling of my subject in its own surroundings, so before getting down to photography I find it invaluable to watch the insect flying about in its natural habitat, noting such things as the characteristics of its flight and the vegetation it frequents. Aesthetics apart, it is essential to select foreground plants which are biologically appropriate.

Another haunting memory from the Everglades is the large dragonfly sometimes known as the 'devil's darning needle'. These splendid insects are common locally in hammocks and pine forests. Although not very active during the day, as dusk approached they would begin a steady patrol of the woodland rides, hunting mosquitoes. Sometimes they would fly only a few feet off the ground, their thin chocolate-brown bodies and amber-tinted wings merging with the gloom of twilight, so that the only clue to their presence was the rustle of membraneous wings as they flew close by. As the light faded they flew higher and higher until they could be seen silhouetted against the darkening sky, dodging the gigantic webs of the golden orb spider and weaving between the branches of the tall pine trees. The photograph I

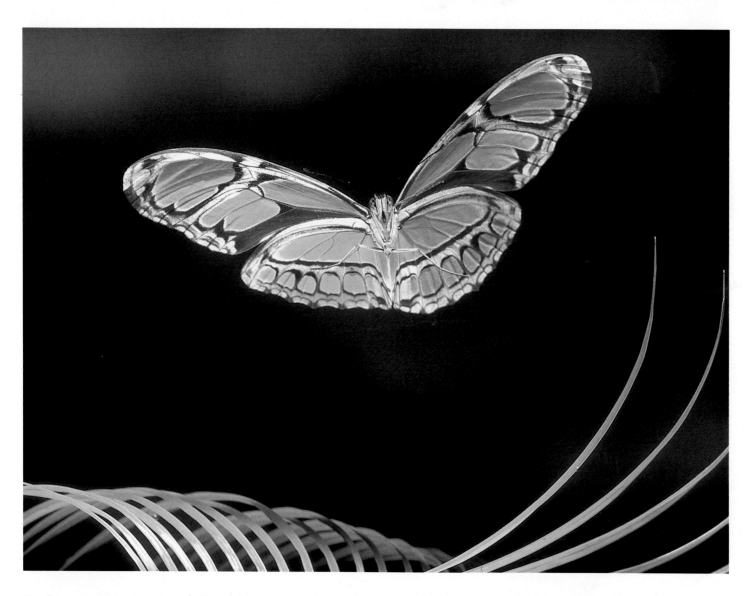

finally got within the four walls of that cramped motel room symbolizes for me the freedom of flight, and brings back the memory of that evening.

I did not have another chance to come to grips with exciting and unfamiliar insects again until 1978, when BBC television was making a film about my work for their *World About Us* series. They asked me whether there was anywhere in the world I would like to exercise my high-speed camera, to which my unhesitating reply was 'yes, South America'. On this occasion we chose the most exotic location I could think of, Venezuela – the very name conjures up lush tropical forests teeming with gorgeous butterflies and humming-birds as well as gigantic spiders and poisonous snakes.

In truth I came face to face with very few spiders and snakes, but the variety and quantity of spectacular insects were intoxicating. Once again, the high-speed equipment was set up in the relative comfort of a hotel room, and the mornings and early afternoons were spent in the nearby cloud forests looking for suitable specimens. To me the place was paradise – humming-birds hovered around the treetops in air that was heavy with tropical scents and filled with mysterious and tantalizing noises. Butterflies were everywhere, the commonest being members of the Heliconid and Ithomid families. As my wife, Liz, and I ambled from one forest glade to another, dozens of these butterflies arose at our every step into the shafts of sunlight, only to settle again in the next patch of light a few yards on. I make no apologies for including a number of photographs of them here (pages 46–49). My favourite is the Green Heliconid (above). It may not be the most gaudy butterfly, but it is one of the most beautiful. In my attempt to capture the subtle shades of silver and translucent green I used backlighting but somehow photography can

20 **Heliconid butterfly**
A member of the family described more fully in the caption to Plates 32–36.

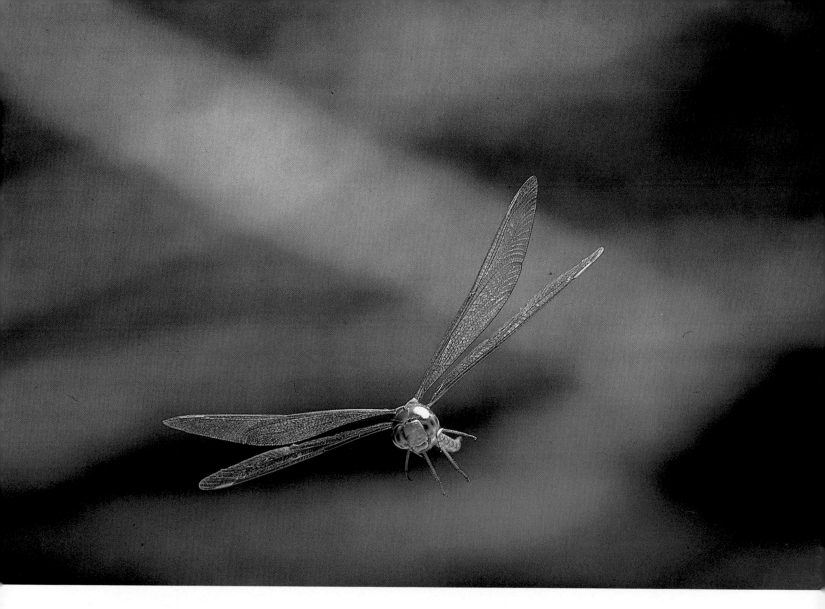

21 Devil's darning needle
Netted in an Everglades woodland fire-break, this large dragonfly was taken back to a makeshift studio in my motel bedroom. Dragonflies generally are not very enthusiastic fliers once placed in the flight tunnel, as they like hot sunshine to incite them to action. This one, however, performed well at dusk, its best hunting time.

hardly do this exquisite insect proper justice.

One of the most bizarre insects we stumbled upon was a harlequin beetle, 'Boris' as we affectionately named him (page 72). It is one of the largest and most awesome insects in the world, with its long spider-like legs, vicious-looking mandibles and immensely long antennae. The creature also had the unnerving capacity to generate a surprisingly loud rasping sound when upset. As Boris was too large to pass through the flight tunnel, I decided to photograph him outside in the hotel corridor, firing the camera shutter manually. Beetles are slow, clumsy fliers at the best of times, particularly when taking off, so I thought this should not prove too difficult. Moreover, the long empty corridor would provide me with the black background I needed to reflect the nocturnal flying habits of the insect.

Peter Bale, the producer, was quick to realize that the exercise might well provide some interesting footage for his film. The idea was to film me photographing Boris as he took off from a tree stump, but nobody was quite prepared for what happened at that first attempt. After much warming-up activity, typical of beetles, Boris launched himself into the air with a menacing buzzing, and made a beeline for the producer's assistant, who happened to be standing between the stump and the window. The huge creature landed spreadeagled on her bosom, promptly dug its long sharp claws well into her blouse, and began gnashing its jaws and rasping. Paralysed with fear and utterly speechless, the young lady watched as six of us dashed to her rescue, and – one for each leg – painstakingly extricated Boris.

Successive attempts proved less dramatic. Both Peter Bale and I managed to get the shots we were after, and the programme turned out successfully.

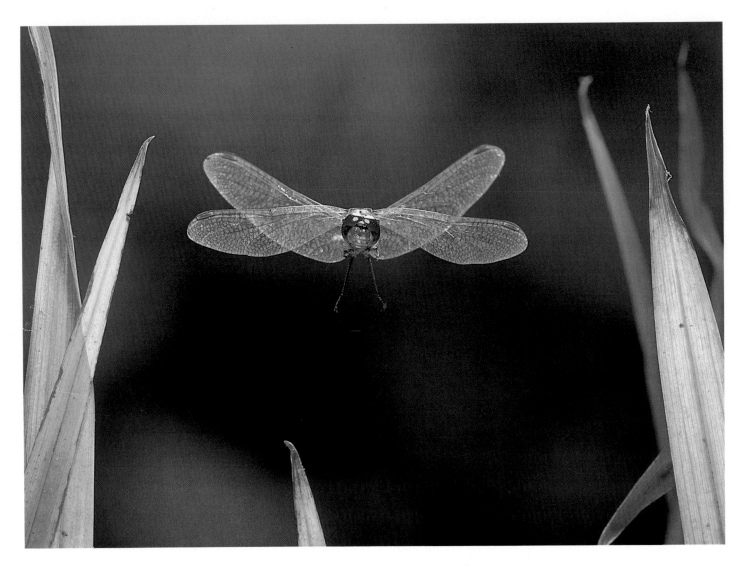

22 **Common sympetrum**
In spite of spending a couple of hours attempting to persuade this dragonfly to fly down the flight tunnel to the right spot, I was able to take only three exposures. But by some stroke of luck one of the three was perfectly positioned and pin-sharp.

Like most members of this family the common sympetrum is extremely restless, returning again and again to the same perch after short and rapid flights.

23 **Common coenagrion damselfly**
Like dragonflies, damselflies are carnivorous, though they seldom catch prey on the wing, preferring to pick up gnats, midges, and other small insects when they settle nearby. The common coenagrion damselfly hovers low over ponds and streams where it rests frequently on floating vegetation, or searches for food or a mate among reeds and ferns at the water's edge. This is a European species.

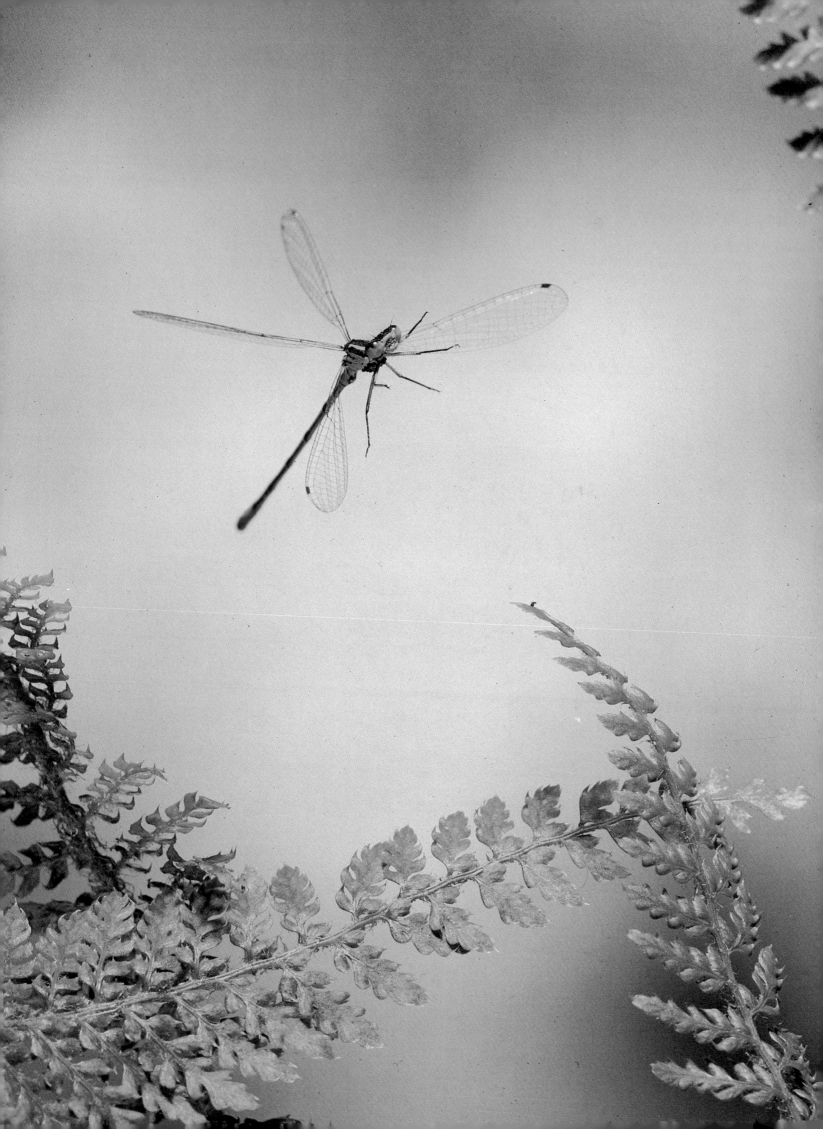

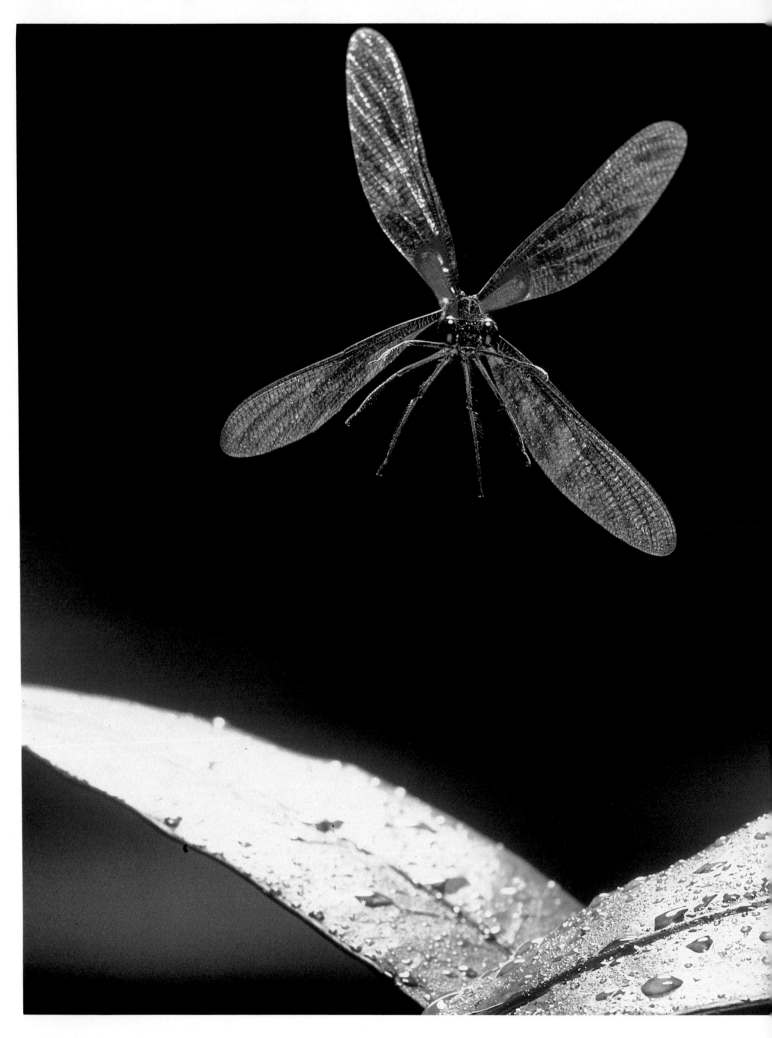

24 **Hetaerena damselfly**
These insects are very common near the fast-flowing mountain streams of the Venezuelan tropical forests, the brilliant red bases of their wings making them extremely conspicuous as they bask in the patches of bright sunlight penetrating the dense forest canopy.

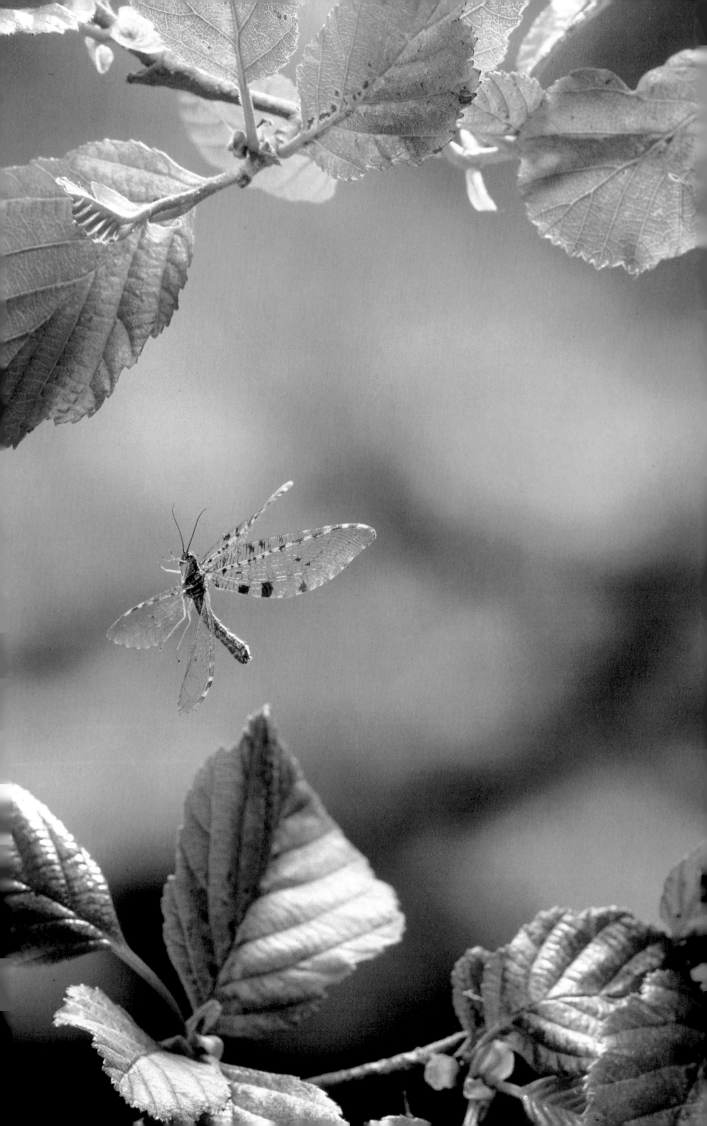

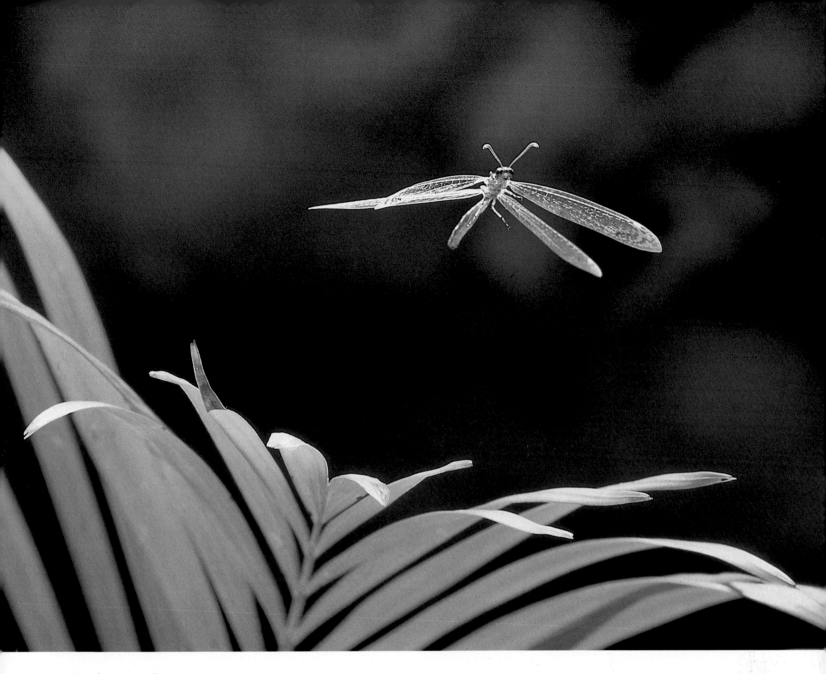

25 Giant lacewing fly
The giant lacewing is even more delicately built than the green lacewing, possessing larger and flimsier wings – it has a two-inch (5-cm) wingspan. The largest British lacewing, it is a relatively uncommon insect, found near ponds and streams where its larvae lead a semi-aquatic existence around the water's edge. The adult is mainly active during the summer nights.

26 Ant-lion
I found this ant-lion at the edge of a Venezuelan jungle, and took it back to the flight tunnel set up in my hotel in Maracay. The elegance of this little insect belies its earlier, fiercer larval existence, in which it ambushes hapless ants by making a trap in the form of a deep cone-shaped pit. The larva, after impaling the ant on its huge curved mandibles, then sucks the body juices from its victim.

The adult needed little persuasion to take to its wings, and its very weak flight is captured in this photograph as it floats over a tropical palm leaf.

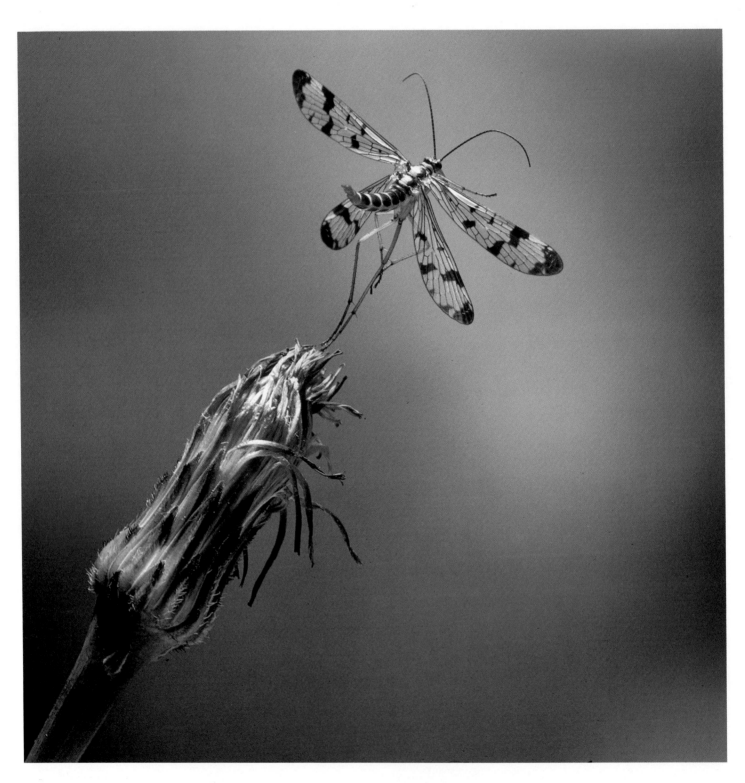

27 Scorpion fly
Caught a split second after its hind feet have left its perch, the scorpion fly wings its way skyward. This is a female; the male has the scorpion-like tail which gives the insect its name. A diurnal creature, it lives on dead insects and other carrion.

28 Desert locust
Locusts are reluctant to use their wings until some distance after take-off, which is initiated by a powerful hop with their hind legs. Their directional control is not very accurate until they are actually flying; the full length of the flight tunnel therefore had to be used for take-off, allowing them to build up airspeed before flying out.

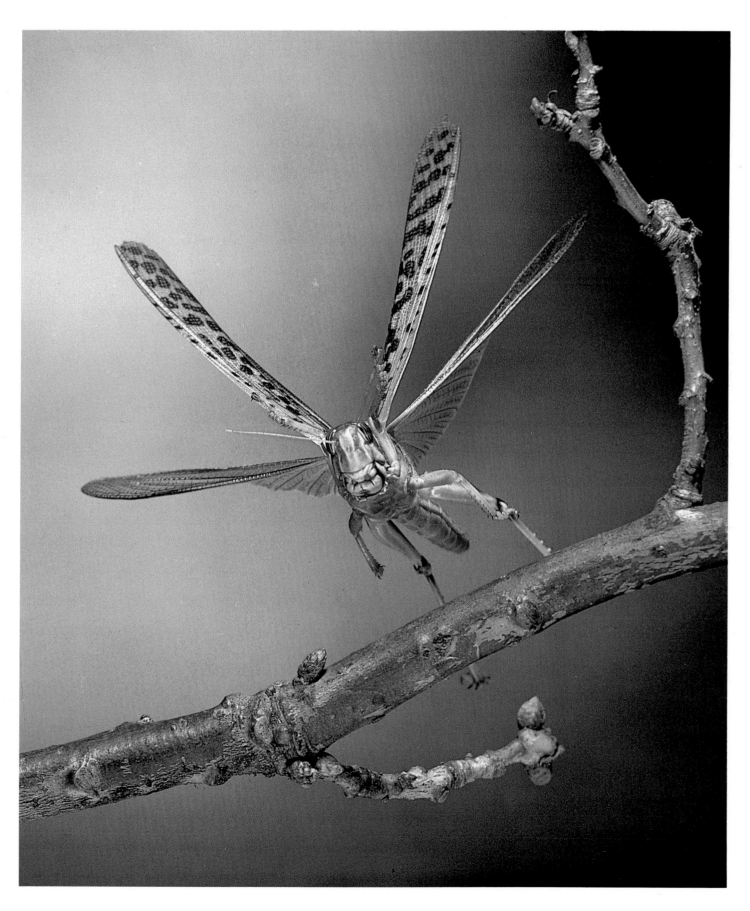

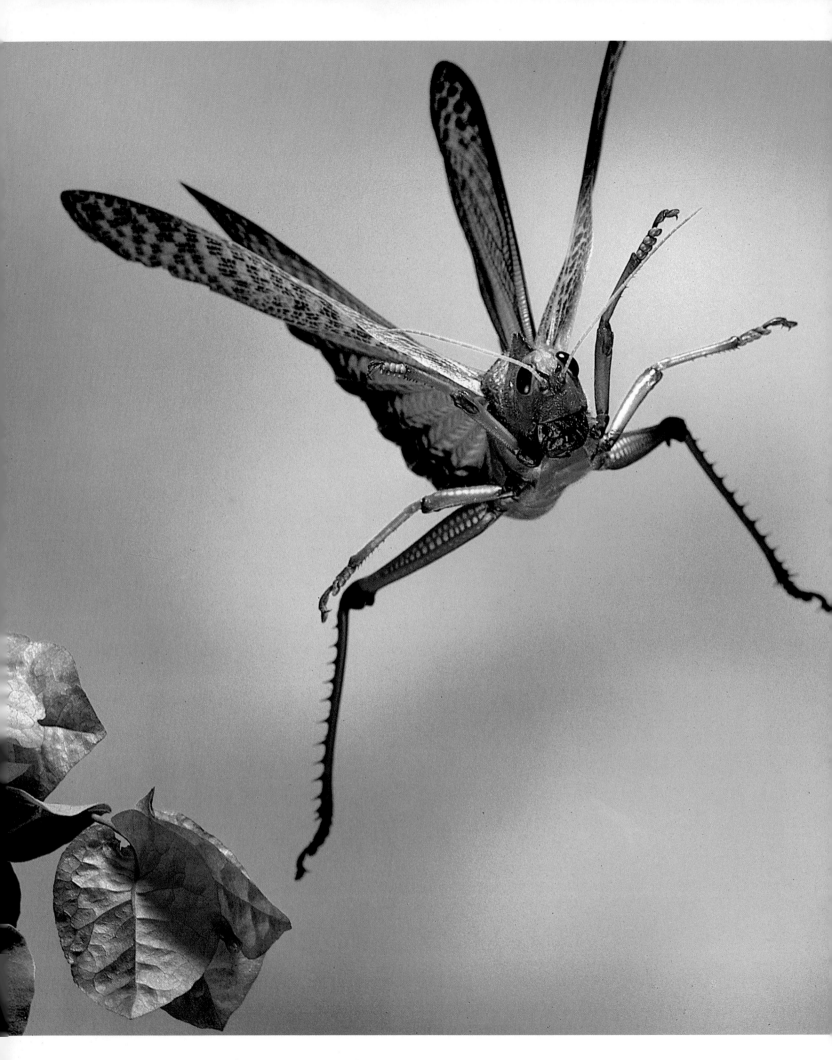

29 **Grasshopper**
A large and handsome tropical grasshopper shortly after take-off, flying between branches of bougainvillaea. This Venezuelan insect is about four inches (10cm) in length. Its leathery forewings contrast with the thin membraneous hindwings.

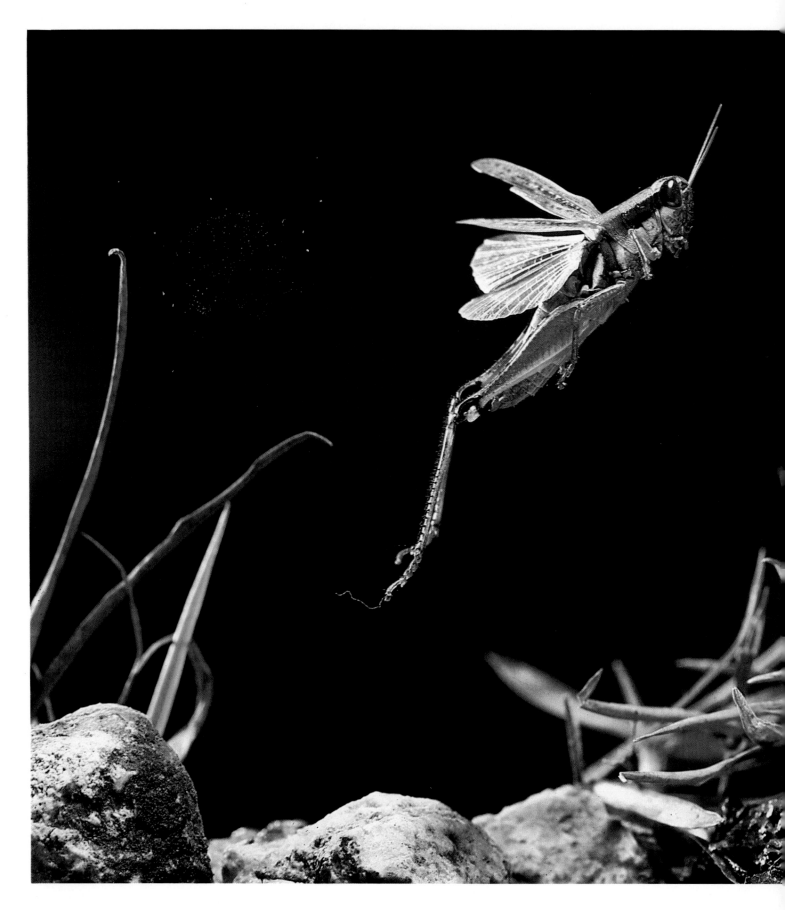

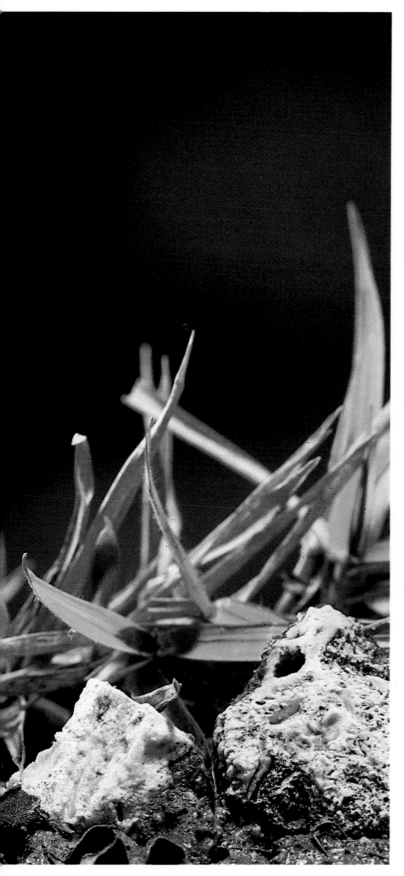

30 *Left* **Short-horned grasshopper**
A split second after leaping off from a stone this grasshopper
has brushed past some grass and knocked off a cloud of
pollen which is left hanging in the air like a cluster of stars.
The photograph was taken on my trip to Florida, and
demonstrates the creature's long muscular hind legs.

31 Greenfly
Small insects are not the easiest of creatures to photograph
in flight, due chiefly to lack of depth of field at high
magnifications. However, this greenfly took its own picture by
chance while I was photographing hoverflies. The camera
fired for no apparent reason, and it was not until the film
came back from processing that I discovered a tiny speck in
the centre of the frame which turned out to be a greenfly.
The blow-up here is a minute few-millimetre-square portion
of the transparency.

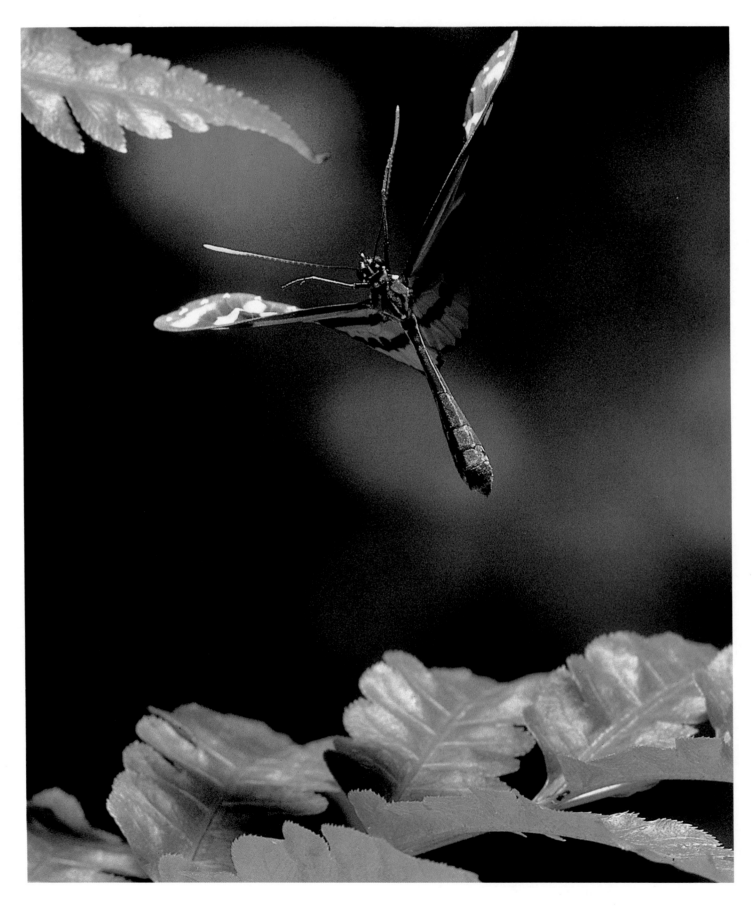

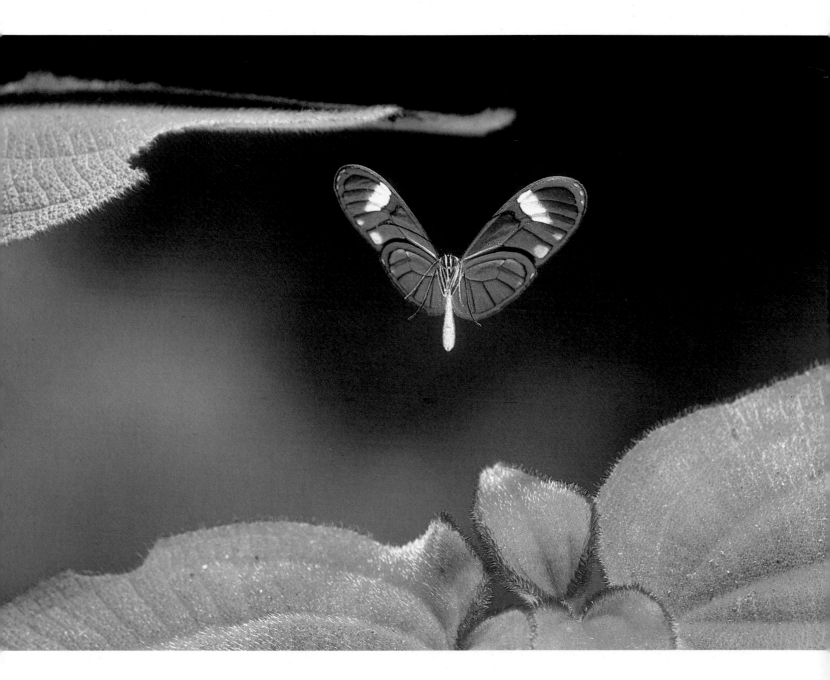

32–36 **Heliconid and ithomid butterflies**

The heliconids and ithomids form perhaps the most highly evolved groups of butterflies. They are limited to the tropical regions of the New World and are famous for their mimicry of other species. As they generally have distasteful odours and body juices, and exhibit distinctive bright colours and bold patterns, they are well protected from predators.

 These two families of butterflies were one of the most alluring features of the Venezuelan forest. Wherever I came across a forest glade or a small patch of sunlight breaking through the canopy, there would usually be several of these lovely insects.

The insect in Plate 33 above is known as a skeleton butterfly because its wings are almost transparent – the blue colour in the photograph is the effect of the lighting – and there are scales on the brown, white and black areas only.

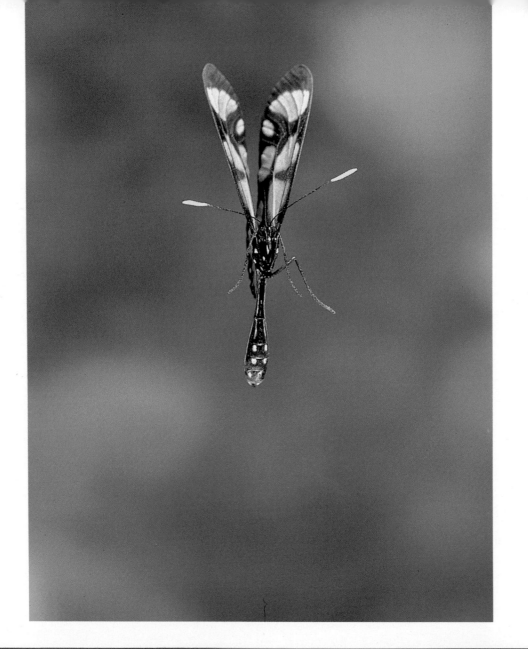
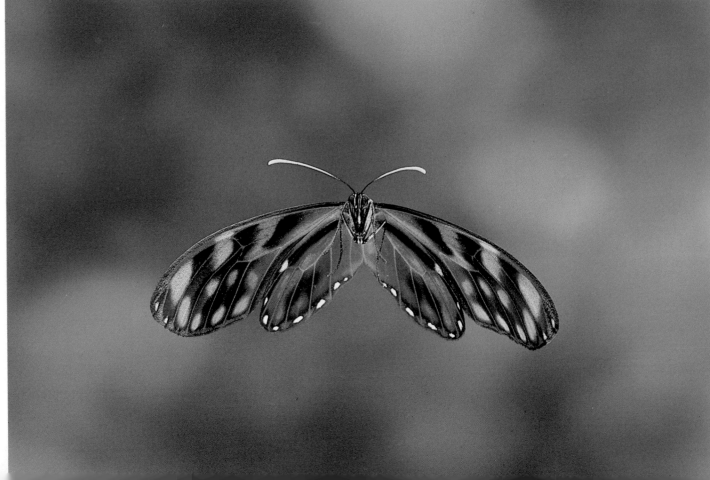

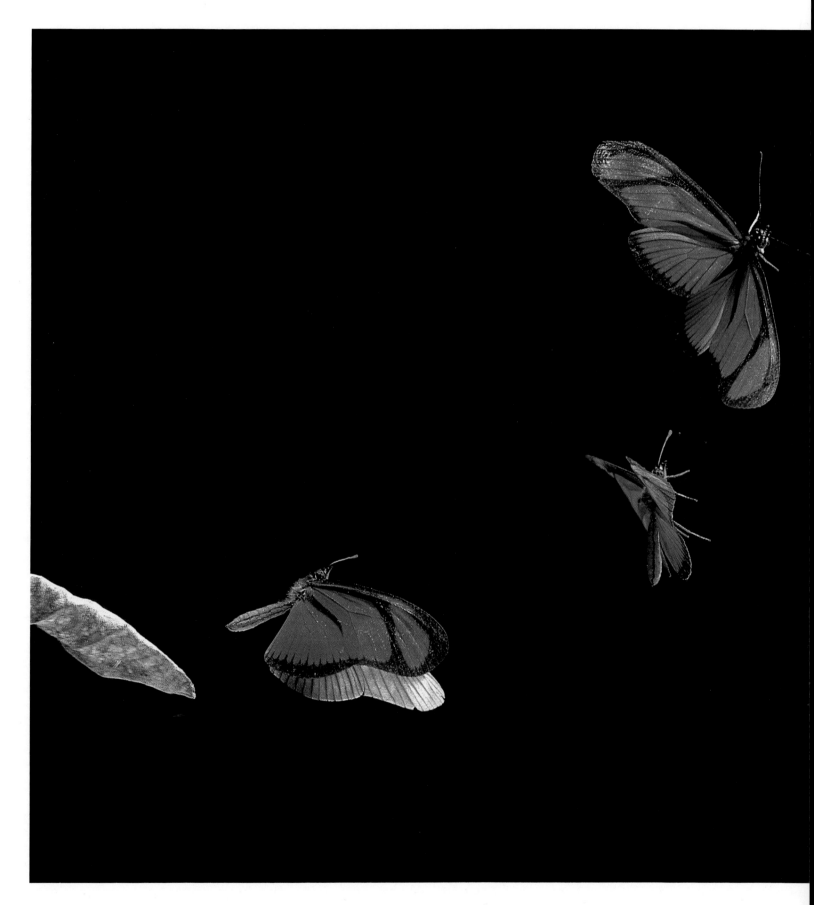

37 **Gulf fritillary**

The gulf fritillary, another heliconid butterfly, could regularly be seen flying around a patch of flowers and cactus within fifty yards of the motel where I stayed in Florida. The butterfly is not related to the European fritillaries, yet unlike typical heliconids it is fast on the wing. It is a large insect, measuring usually about two-and-a-half to three inches (6–7.5cm). Its performance in the flight tunnel was exemplary.

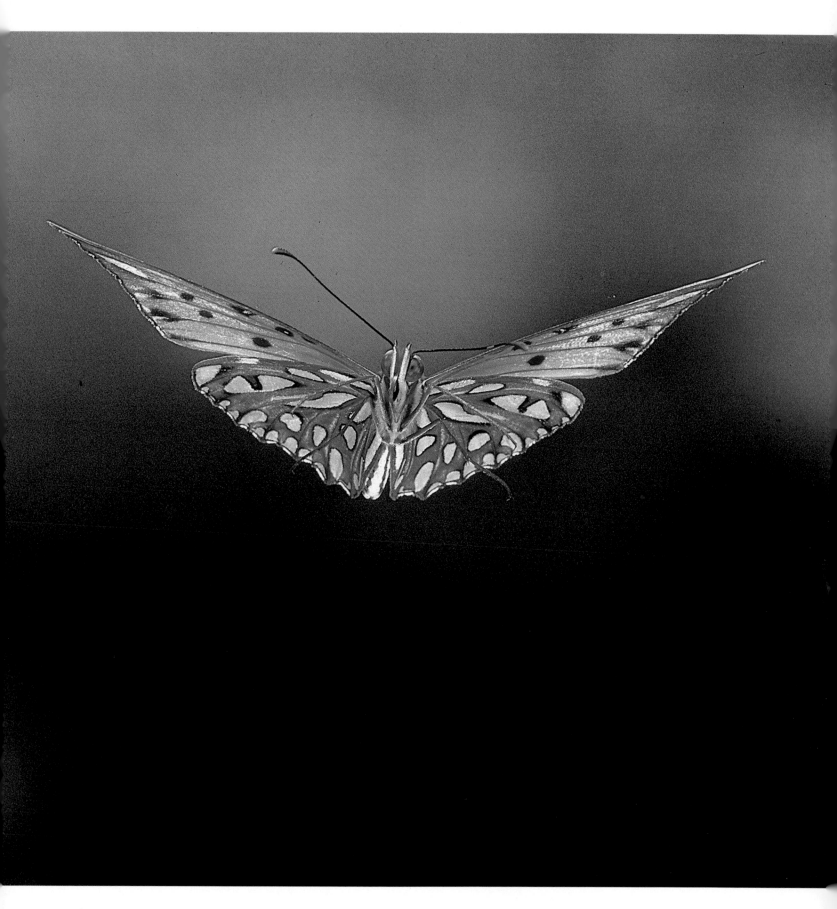

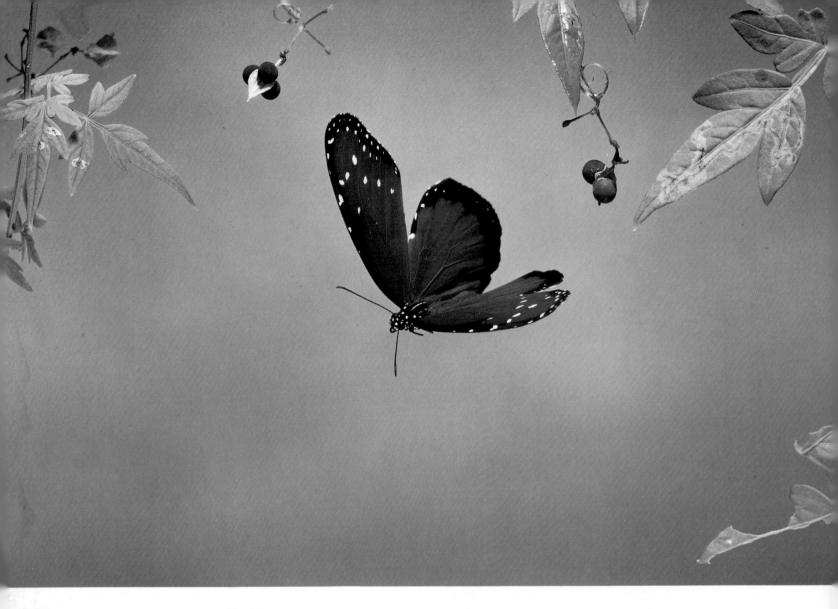

38 Queen
A butterfly found quite commonly in the south-eastern part of the United States, particularly Florida, though rarely elsewhere. Like the monarch, the queen is a member of the milkweed family of butterflies, and is distinguished from its relative by its darker, more crimson colour. The queen too has a distinctive manner of flight, gliding or sailing slowly along.

39 '89' butterfly
A small but eye-catching butterfly from South America with metallic colours on its upper side and a striking pattern on the underside. The '89' butterfly, which belongs to the same family as the red admiral and fritillaries, could be seen in large numbers drinking at the water's edge of the rocky mountain streams around Rancho Grande.

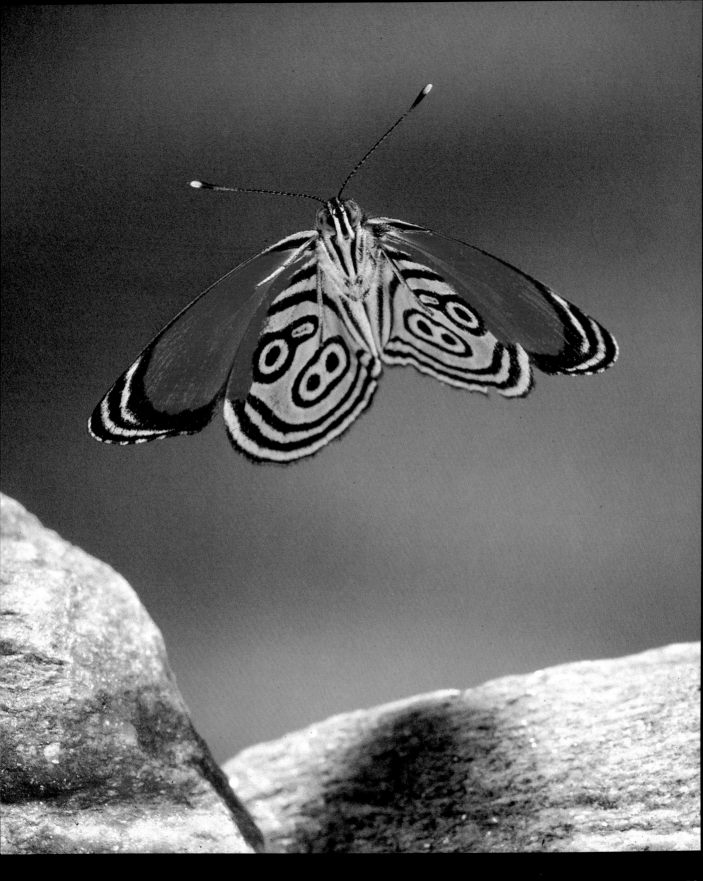

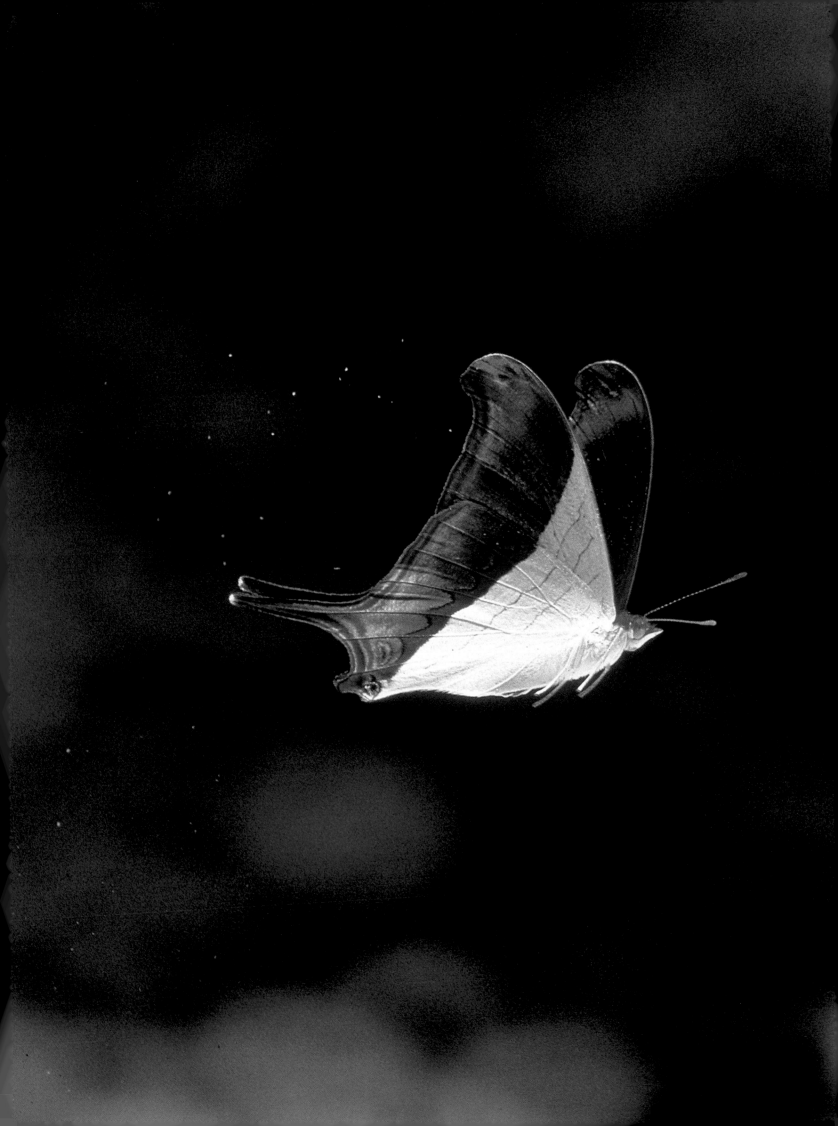

40 The waiter or daggerwing butterfly
This insect, so named because of its
resemblance to a waiter in tails, belongs
to the same family of butterflies as the
red admiral and small tortoise-shell. I
found that it was impossible to catch
this very rapid and highly
manoeuvrable butterfly in mid-flight, so
I waited until it landed to drink at the
edge of a mountain stream before
netting it.

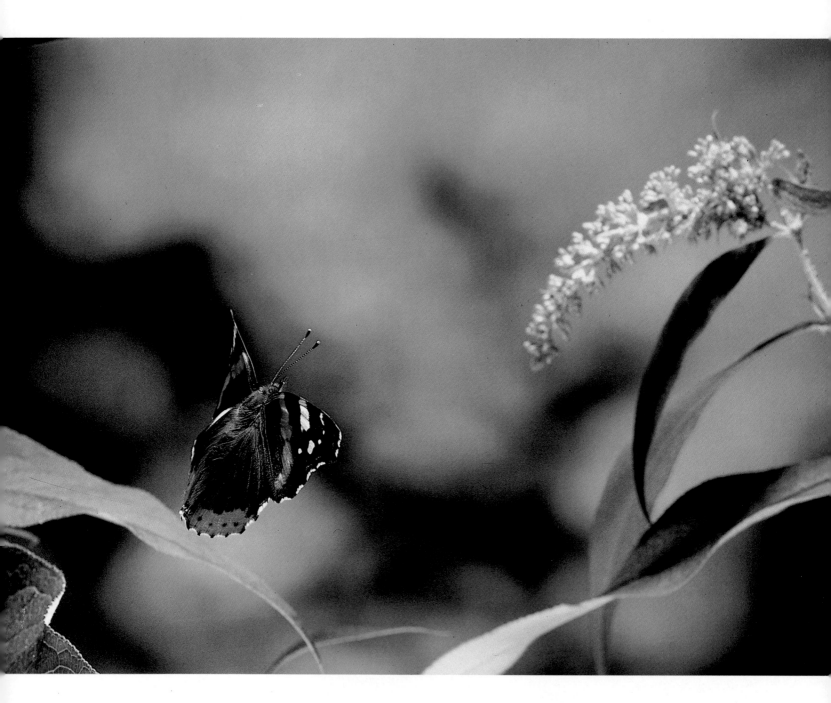

41 **Red admiral**
Possibly one of the best-known butterflies in the world, found on both sides of the Atlantic, this insect is an exceptionally fast and powerful flier. It is well able to cross the English channel, and in autumn many which have bred in England make their way south towards the Mediterranean, often flying at night.

This particular butterfly was flying around some pink buddleia bushes in my garden, so to prevent a clashing of colours I chose an unopened flower for the foreground.

42 **Small tortoise-shell**
The subtle sombre browns on the underside of the wings of this familiar butterfly are displayed here as the wings approach the end of their backward stroke. One of the commonest of all butterflies in Britain and Europe, it is particularly fond of old farmyards, where its food plant, the stinging nettle, abounds.

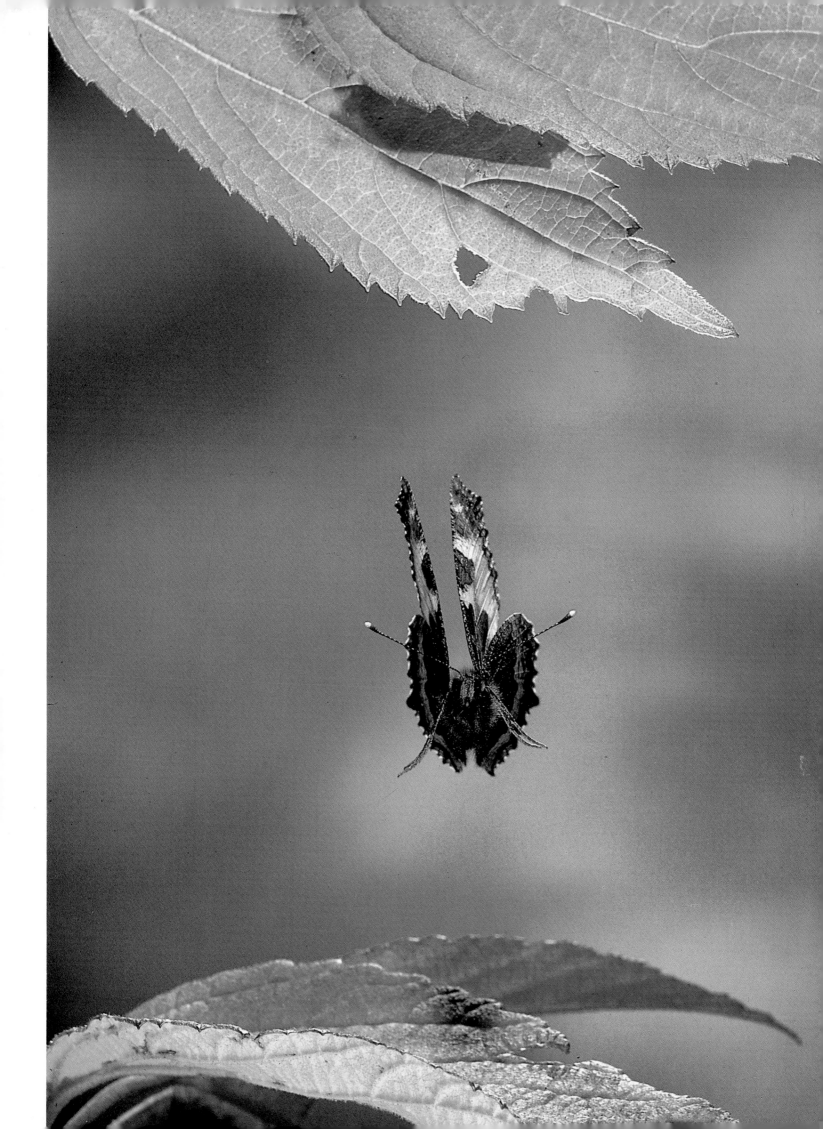

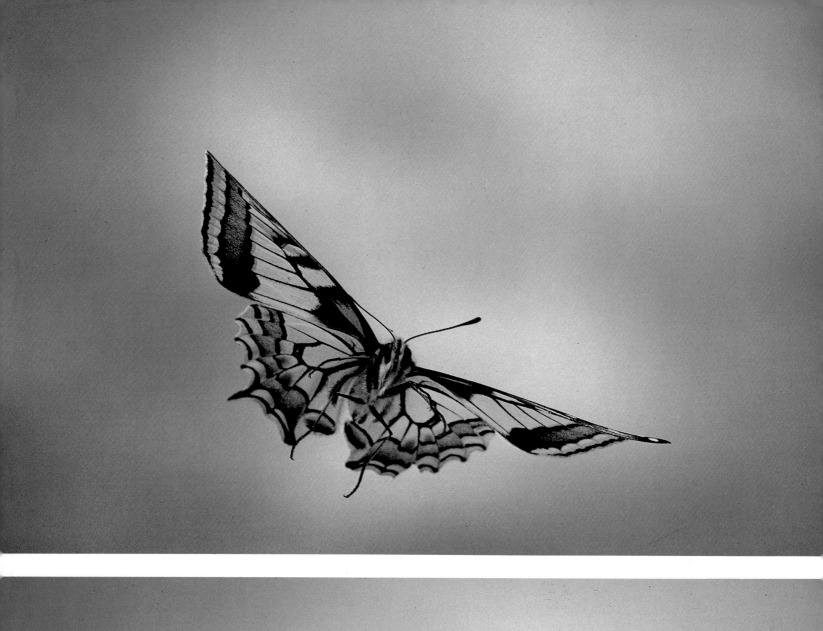
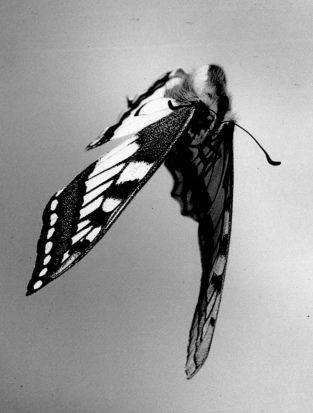

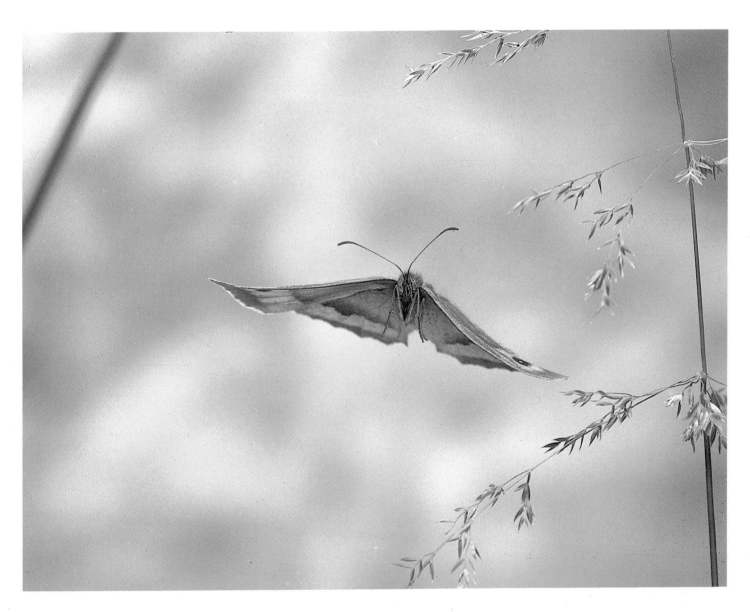

43, 44 Swallowtail
The swallowtail family embraces some of the largest and
most spectacular of all butterflies. Among these are the
birdwings, whose beauty in flight is quite indescribable. The
less showy European swallowtail, shown here, occurs
throughout Europe, North Africa, Asia and North America,
flying at altitudes of up to 15,000 feet.

The photographs show two different phases of the wing
movement.

45 Meadow brown
The meadow brown has always seemed to me a somewhat
lethargic butterfly in its natural habitat of rough grassland
and woodland clearings, so it was hardly surprising that it was
particularly reluctant to take to the wing in the flight tunnel.
This insect is one of the most common and widespread
butterflies in the British Isles, although it is not found in the
United States.

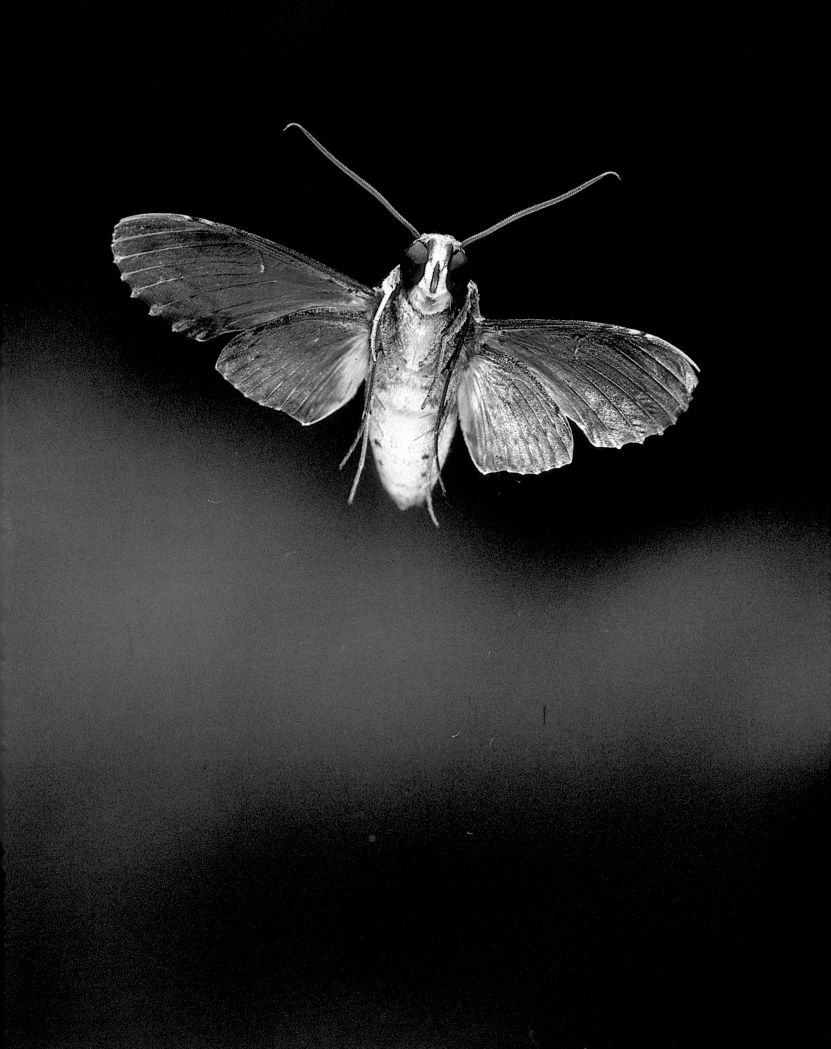

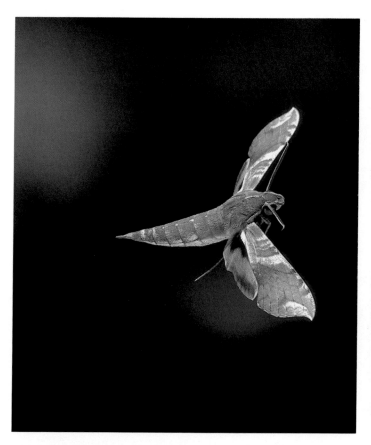

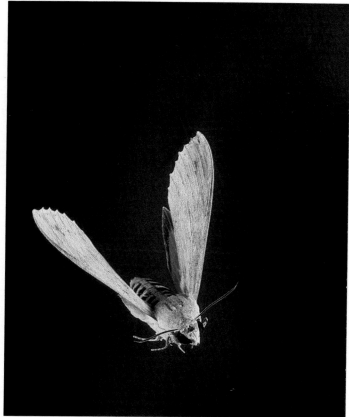

46–49 **Hawk moths**

I remember as a child the thrill at finding a hawk moth. These insects must be the most spectacular of all moths: not only gorgeously coloured, they have thick and beautifully streamlined bodies which are packed with powerful flight muscles. For sheer power and speed hawk moths are unsurpassed.

Rancho Grande, perched high up in the cloud forests of Venezuela, is a paradise for the hawk-moth addict and boasts of more species than anywhere else in the world. During some evenings when conditions were right, the ultra-violet light of the moth-trap attracted them by their hundreds. The variety of species, their diversity of size, shape and colour, and the subtle beauty of some were simply overwhelming.

Unfortunately hawk moths are not the easiest of insects to photograph in flight. As well as frequently 'beating' the high-speed shutter, they also had an infuriating tendency to fly uncontrollably all round the flight tunnel, only rarely emerging from the exit in the right place.

I make no apologies for including a series of pictures of these splendid and noble insects.

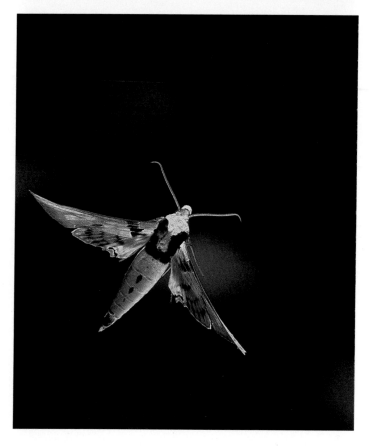

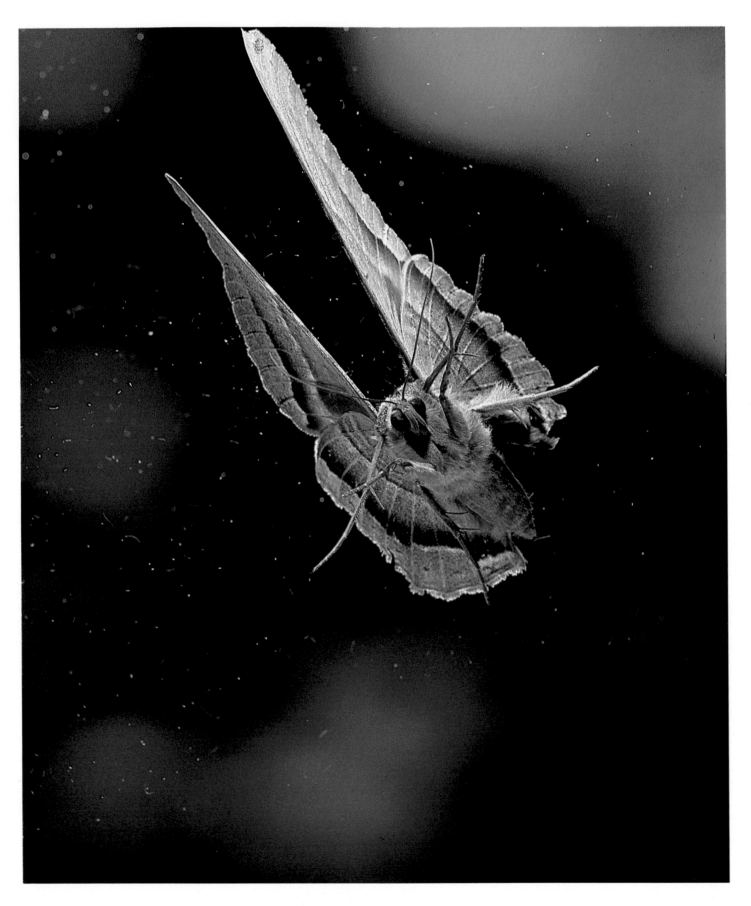

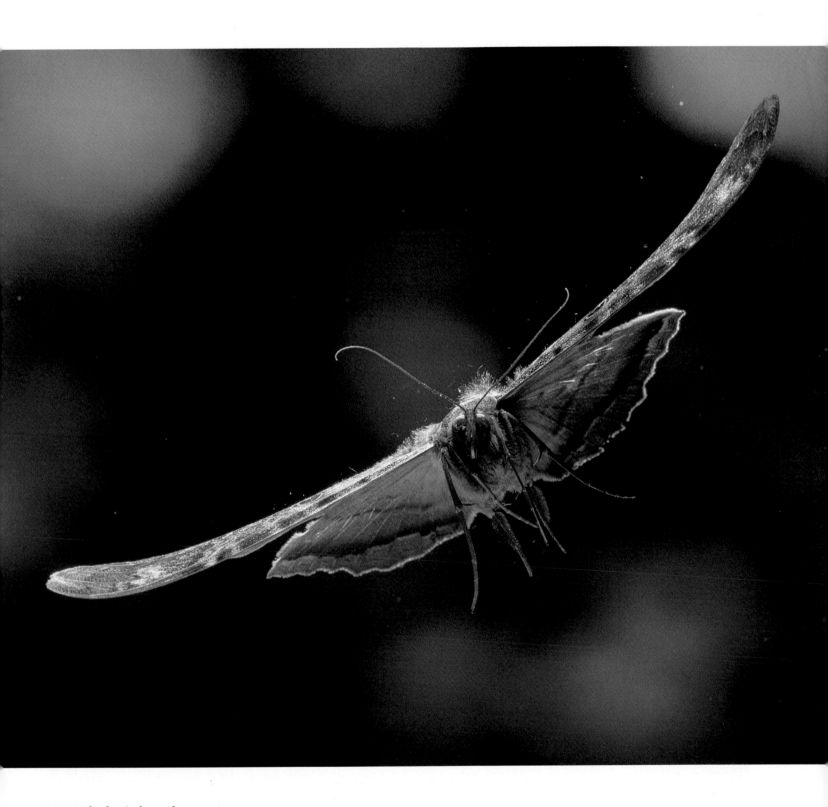

50, 51 Black witch moth

Difficult though it is to believe, this creature with its wingspan of eight inches (20cm) comes from the same family as our modestly proportioned noctuids or owlets such as the yellow underwing. Caught in the Venezuelan cloud forests around Rancho Grande, where it is common, it is seen here shedding wing scales shortly after take-off. *Left*, the wings are approaching the end of their backward stroke. In the picture above the wings are halfway through their backward stroke. The black witch moth is also found in the United States.

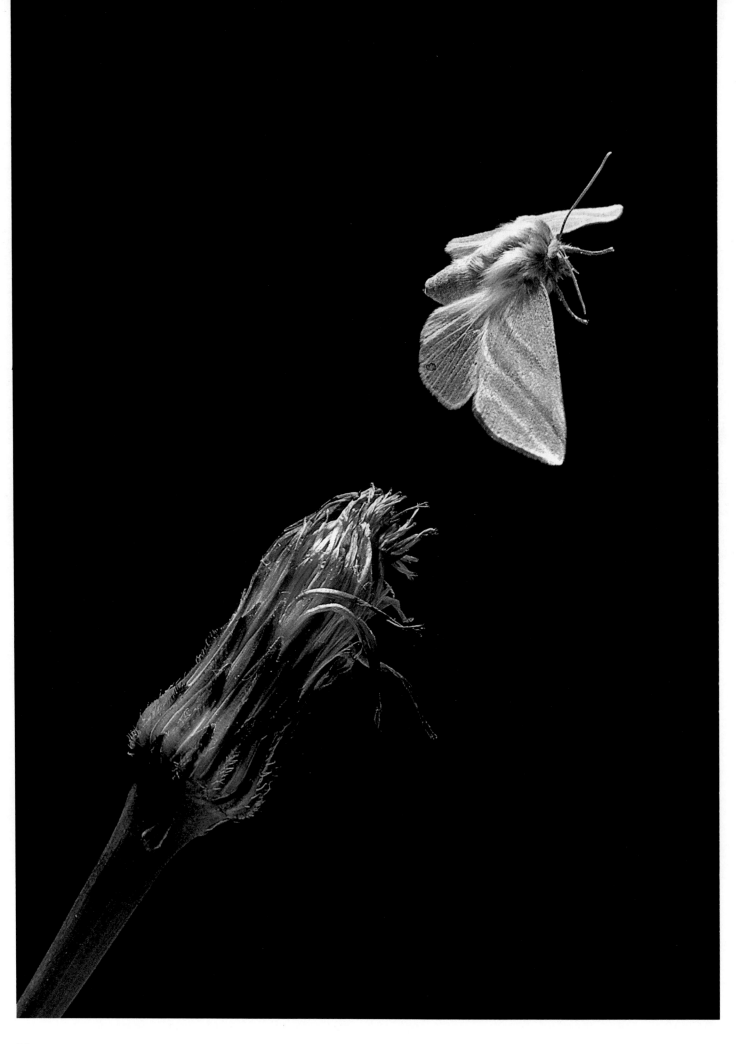

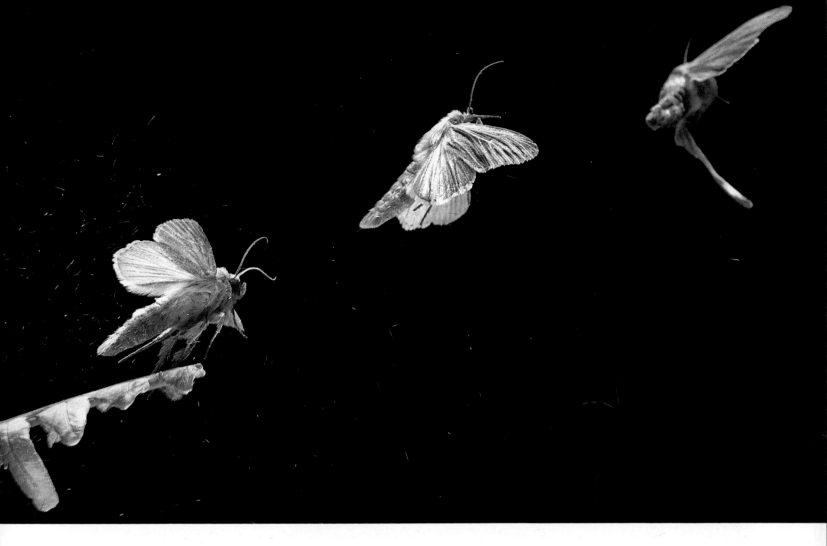

53 Shoulder-striped wainscot

One interesting and hitherto unknown phenomenon revealed by high-speed flash photography is scale-shedding by certain moths, particularly among the noctuid family. It occurs during take-off especially, as is evident in this multiflash picture of a shoulder-striped wainscot, a fairly common European variety. Nobody has provided me with a sound biological reason for this yet.

52 *Left* Green silverlines

This lovely moth, delicately shaded in green and silver fringed with pink, has launched itself from a dandelion. The green silverlines is locally common in Europe and flies by night in and around woodlands.

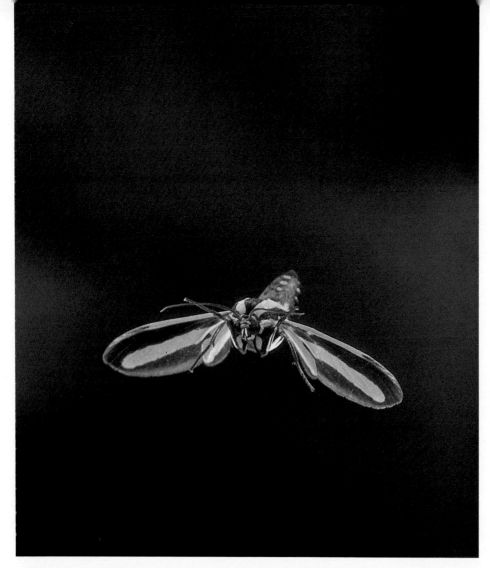

54 Tiger moth

The tiger moths are a large group containing an enormous variety of very brightly coloured and patterned species from the tropics, particularly South America. Hundreds were attracted to the Rancho Grande lamp at night. The wings of this one adopted an extraordinary position as they sliced upwards through the air.

Tiger moths can not only take avoiding action when they hear the ultrasonic squeaks of oncoming bats but, incredibly, they are capable of producing squeaks of their own to jam the bat's 'radar' system.

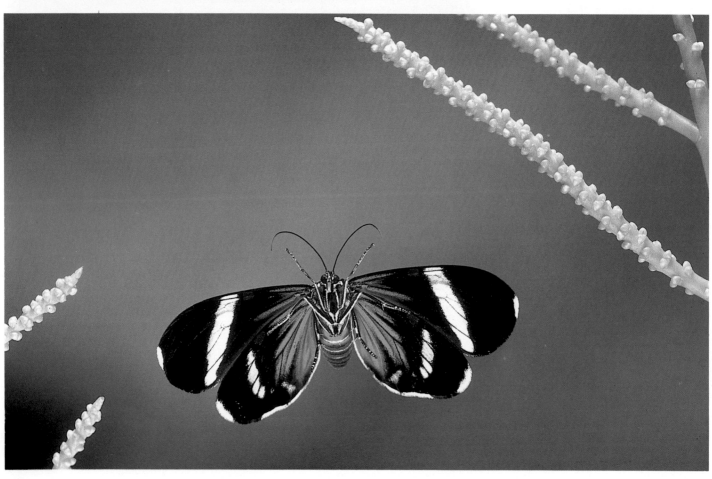

55 Pericopid moth
Left A pericopid moth from Venezuela flaunts its inedibility by displaying red, white and blue warning colouration as it launches itself into the air.

Although pericopids are essentially day-flying moths, I caught this one at twilight, whereupon it shammed death by curling its legs and body up and folding its wings backwards in a very un-mothlike fashion. The insect then proceeded to ooze a yellow foamy liquid, simultaneously making a bubbling noise. Once in the flight tunnel, however, the creature proved surprisingly cooperative.

56 Pericopid moth
Above An entirely different species of pericopid moth, this time from Florida, which mimics the heliconid and ithomid butterflies – compare this moth with the butterflies in Plates 32–36.

The multiflash sequence shows the insect shortly after take-off. The delay between the flashes was about 25 milliseconds.

57 **Plume moth**
A plume moth departing on a nocturnal
foray from a bud of the bright yellow St
John's wort. These delicate little insects
have a pathetically weak and slow flight
which belies their remarkable hardiness
– species are found even in the bleak
15,000-foot environment of the Andes.
The common clothes moth is another
member of the same group.

58 **Micro moth**
The chances of this moth's
exceptionally long antennae firing the
camera before the arrival of the moth's
body can be reduced or eliminated by
'tuning' the optics of the light source
and photocell.

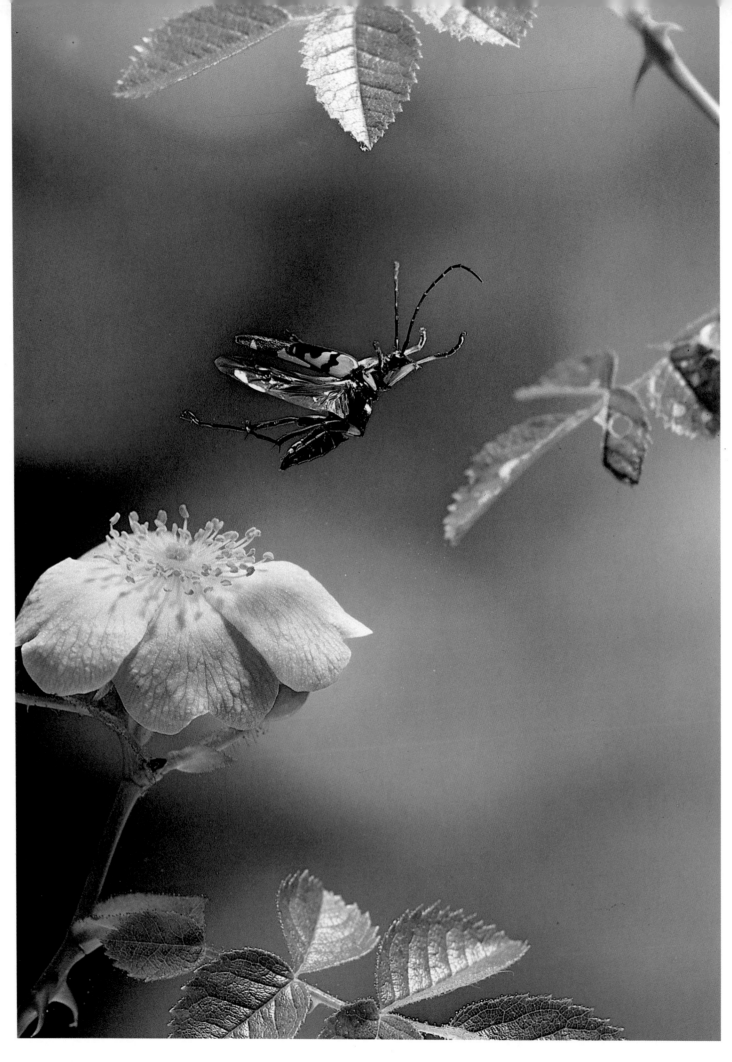

59 **Longhorn beetle**

Trying to photograph beetles in flight is often frustrating, as most species are extremely reluctant to take to their wings, and even when they do become airborne they often lack directional control. The spotted longhorn is a strong flier and will readily fly in sunshine. This one was found feeding on the nectar of a wild rose, and I persuaded it to fly in captivity by exposing it to the hot afternoon sunlight coming through the studio window.

60 **Ladybird** (Ladybug)

In legend this insect has a somewhat disturbed home life. As this one begins her hurried homeward flight, she leaves behind a shower of yellow pollen. Both adult and larval ladybirds feed on aphids, and so should be encouraged in the garden.

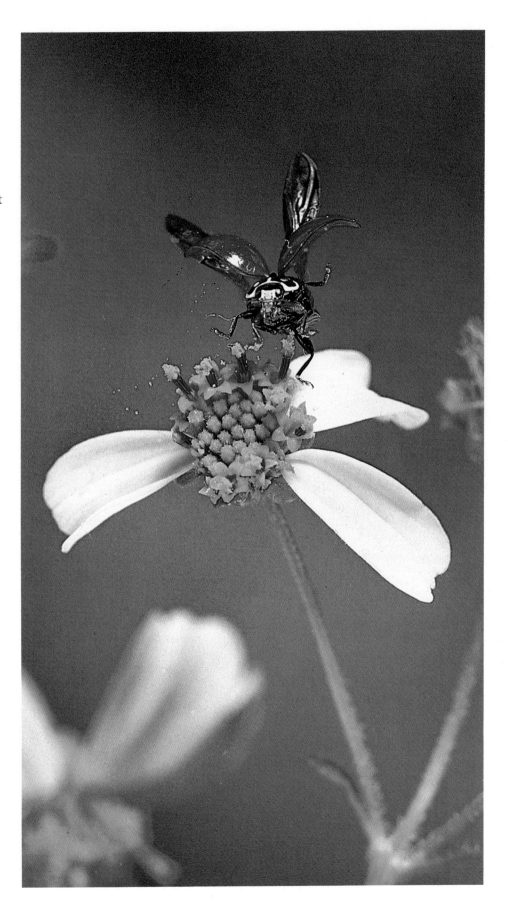

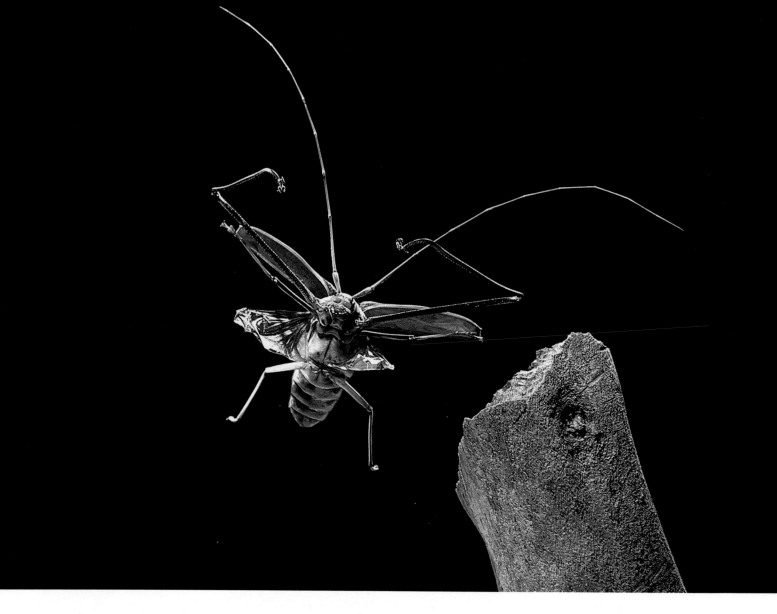

61 **Harlequin beetle**

Too large and cumbersome an insect to fly down the light tunnel, the harlequin beetle had to be photographed in the corridor of the plush hotel Maracay, much to the consternation of some of the hotel guests. Added excitement was provided by a BBC TV camera team who were recording the event for a *World About Us* film. An idea of its size can be gauged by the fact that its antennae alone are about five inches (12cm) long. Another curious fact about the harlequin beetle is that it harbours 'false scorpions' under its wing-cases, which probably act as scavengers.

62 **Housefly**

I photographed this in the middle of winter when insects are difficult to find. This housefly, rising from a loaf of wholemeal bread, was obtained from a local pest research laboratory. I soon found that these laboratory-bred flies were reluctant to fly at all, as their wing muscles had had little exercise due to the confined conditions in which they had been living. They had a frustrating habit of running and jumping instead of flying. The only answer was to release them in the kitchen for a few days to enable them to become suitably agile for flight photography.

Friends who visited the house looked horrified when they saw my kitchen seething with flies, and my observation that these laboratory flies were probably cleaner and less contaminated than my visitors was not readily accepted.

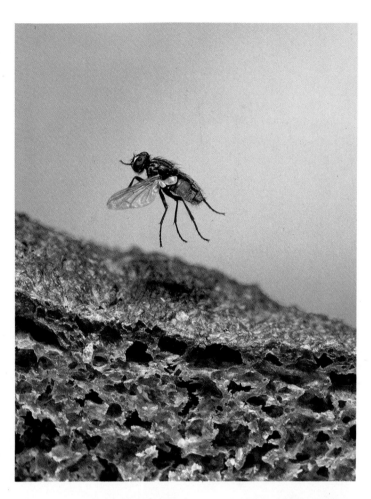

63 **Greenbottle fly**

As blowflies and greenbottles are extremely fast and erratic on the wing, getting them in sharp focus, even with the aid of a high-speed shutter, can be tricky. As this insect was flying about seven millimetres past the beam during each run, the 1/400-second lag had to be taken into account when composing the picture. Fortunately focus was not affected in this case as the fly was moving at right angles to the lens axis.

As well as imbibing the juices of rotting flesh and other unsavoury deposits, the greenbottle also feeds on a wide variety of blossoms. It is particularly partial to umbelliferous plants such as cow-parsley and is seen here darting from one blossom to the next.

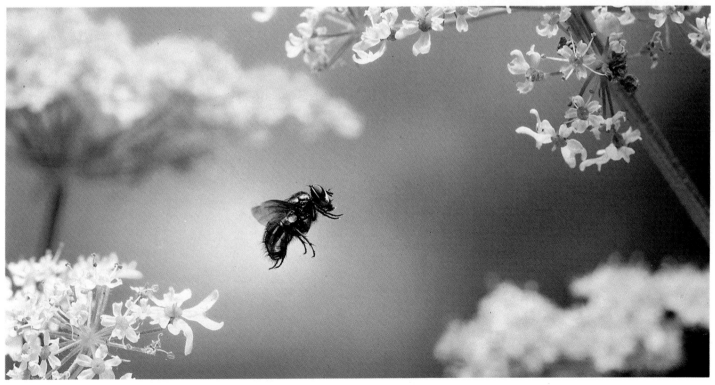

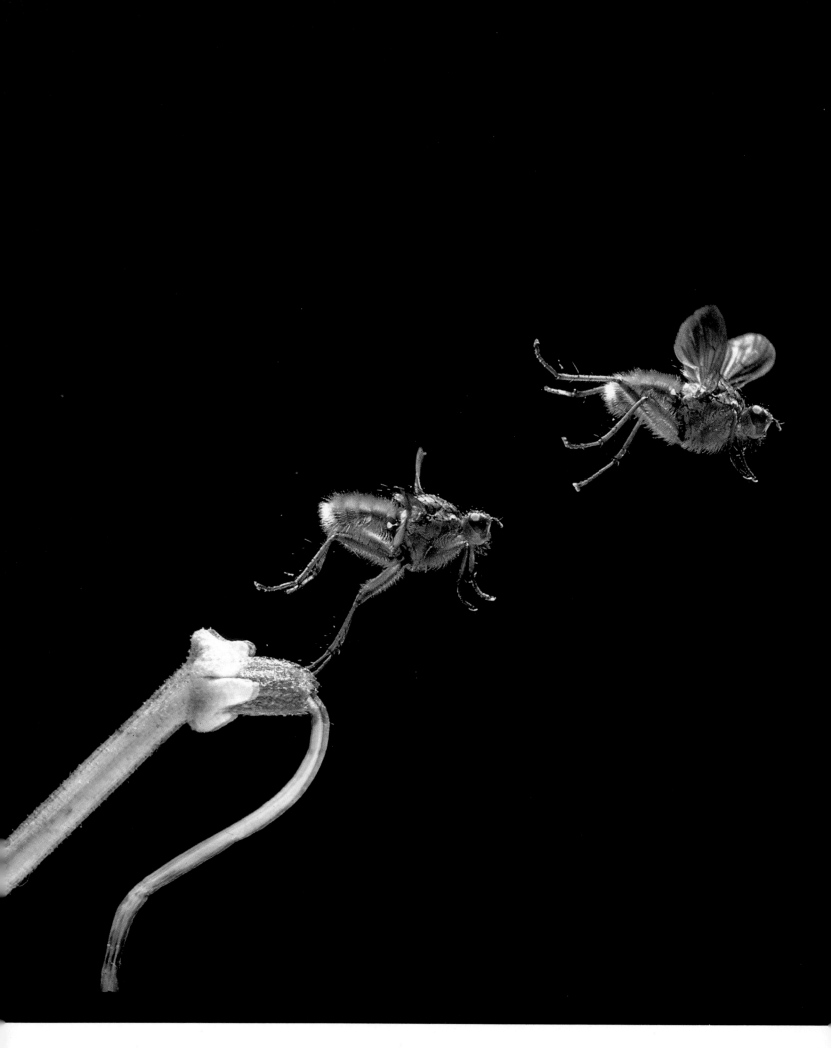

64 **Yellow dungfly**

Using its back two pairs of legs for springing into the air during the initial stages of take-off, the yellow dungfly departs from a rhododendron seed. Observe the three images of this vibrating launch pad.

Although the adult visits flowers to drink nectar, it also has the malevolent habit of attacking other insects, sometimes even its own kind, cutting the nerve cord of their necks with the sharp teeth at the base of its proboscis.

65 **Crane-fly**

The daddy-long-legs or crane-fly normally flies at night and is often attracted indoors by artificial light. During the daytime they can frequently be disturbed from long grass and hedgerows, when they make off with their characteristic low dancing flight, their long legs dangling beneath them.

66 **Hoverfly**

Hoverflies are capable of a bewildering range of aerial manoeuvres, including flying backwards, upwards, downwards, and sideways. They can accelerate or change direction almost instantly, and remain hovering at a fixed point in gusty conditions. It is hardly surprising that scientists are still at a loss to explain their performance in aerodynamic terms.

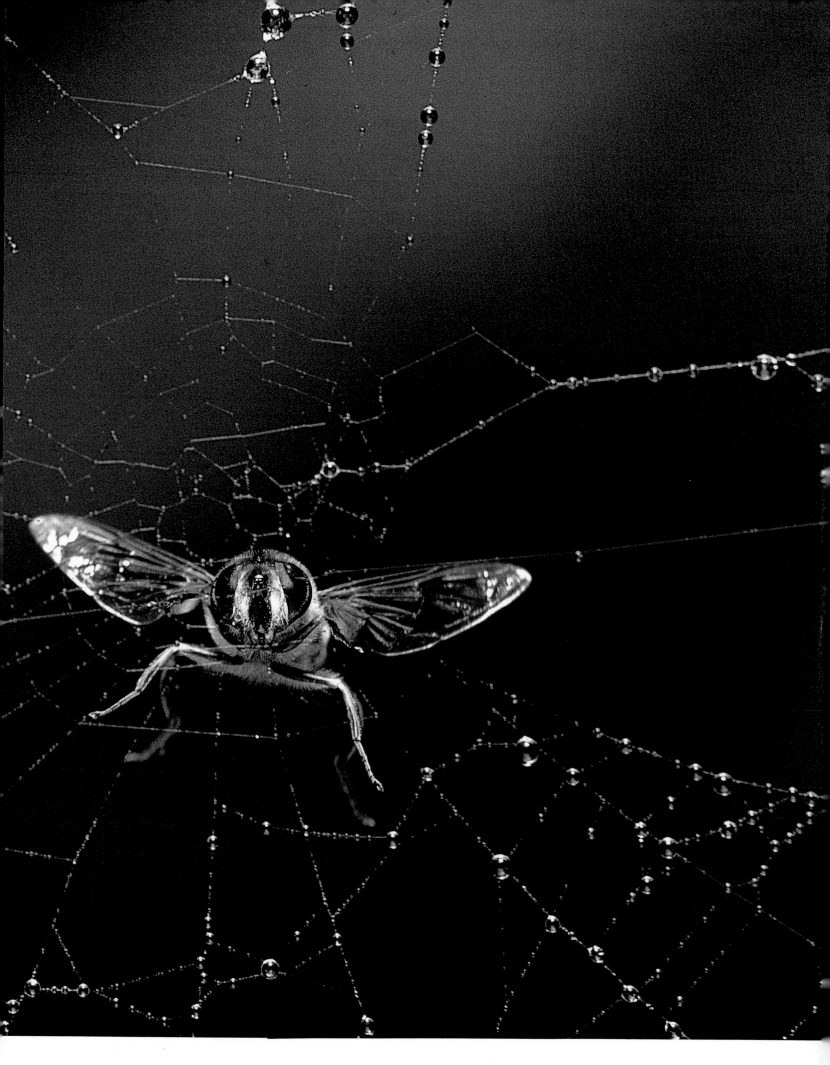

67 **Hoverfly**
In spite of their aerobatic abilities hoverflies are one of the easiest of insects to photograph on the wing. Although perfectly capable of putting on a turn of speed when the need arises, in the flight tunnel they almost always fly slowly and deliberately, gaining their freedom with the minimum of fuss.

68 **Hoverfly taking off**
Many people find multiflash photography puzzling – they ask questions like 'are they different insects?', 'was it done with a ciné camera?', or 'was it fiddled in the darkroom?' Actually the principle of multiflash is simple. Three or more consecutive flashes are produced by three separate heads. The time interval between the flashes can be varied and is controlled by a delay circuit. A few trial exposures soon determine the most suitable delay – the longer the interval and the faster the movement, the greater the image separation. Obviously the shutter has to remain open during the total period of the flashes. In this picture of a hoverfly taking off, the delay between each flash was 40 milliseconds, so to accommodate all three flashes I had to select a shutter speed of 1/10 second (i.e. 100 milliseconds).

An important point to remember when using this technique is that backgrounds have to be kept jet black and ambient light has to be kept extremely low, otherwise contrast and colour saturation suffer, or worse still, the background becomes visible through the subject.

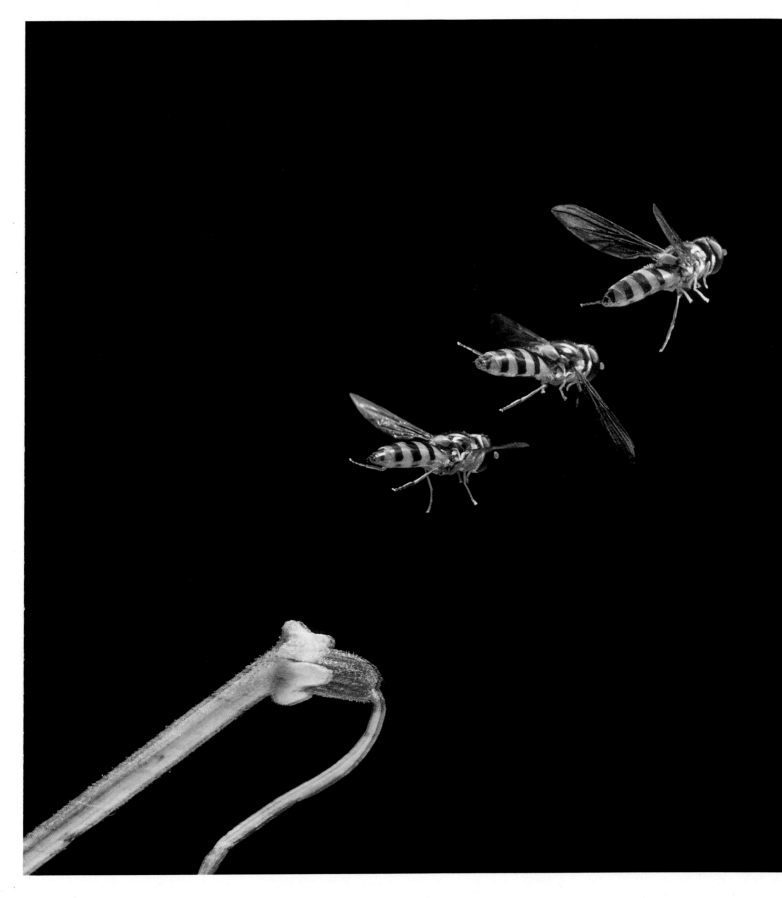

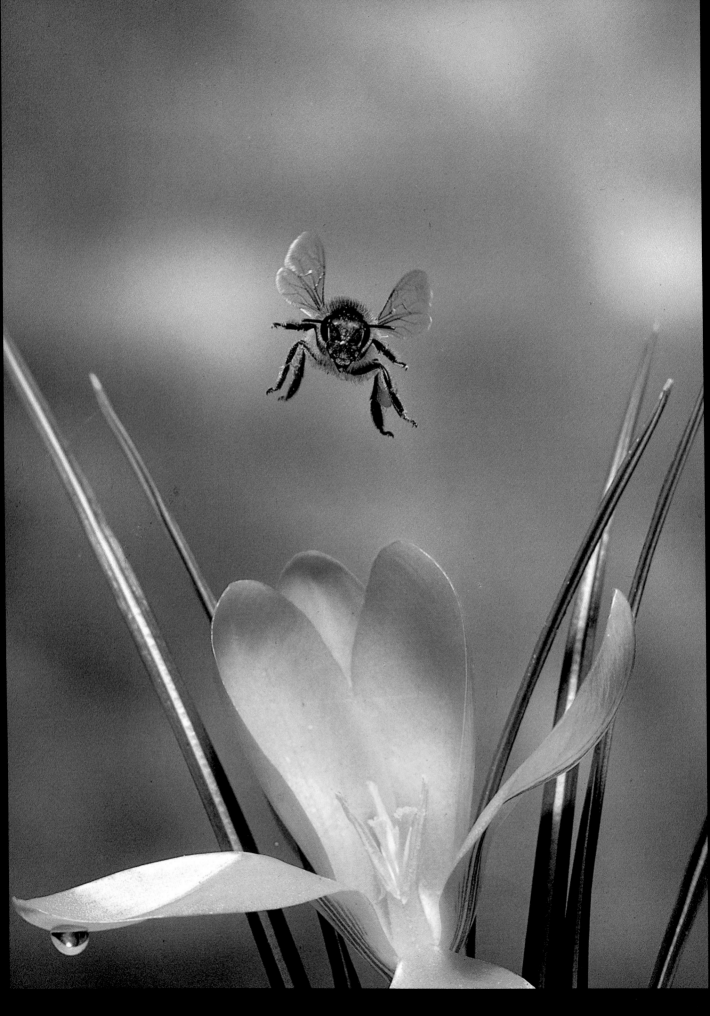

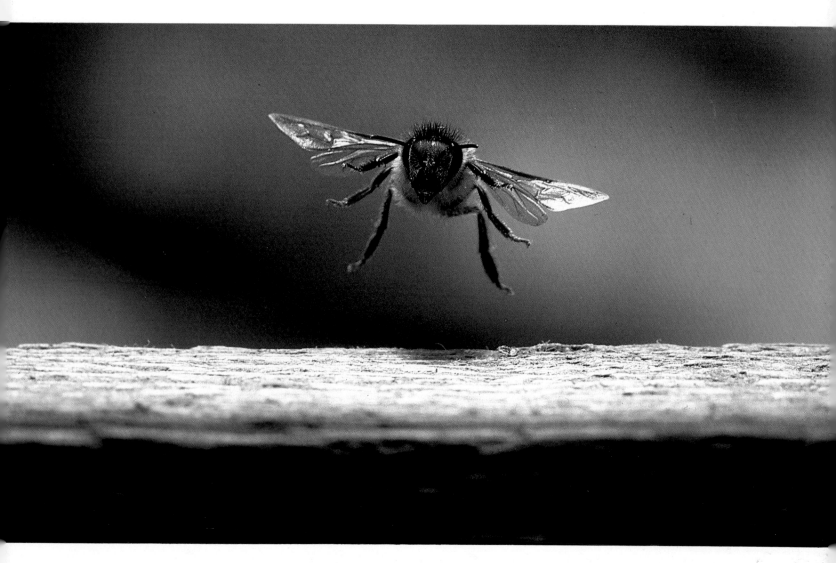

69 **Honeybee over crocus**
As bees soon run out of energy for flight, a convenient bee supply is a great help for flight photography. This worker is laden with yellow pollen collected from a bank of spring crocuses in my garden. Having completed its stint in the tunnel, the jaded bee was released among the flowers for rest and refuelling before flying off back to its hive.

70 **Honeybee at hive**
A honeybee about to land on the alighting board of the hive after a foraging expedition. Worker bees live for only about six weeks during the summer. They have to look after the queen, which lays the eggs, and tend the larvae when they hatch. They also keep the hive clean and defend it from marauders such as wasps. Constant forays are necessary to collect supplies of pollen and nectar.

71 **Bumblebee approaching thistle**
Overleaf: Like some beetles, bumblebees tend to be clumsy on the wing, particularly when flying slowly immediately after take-off, often bumping into objects and falling. Yet, in spite of this, they can frequently be seen flying on cold, wet, windy days, visiting one blossom after another with dogged determination, long after all other insects have been grounded.

 This worker is near the end of its life, its wings tattered from constant use.

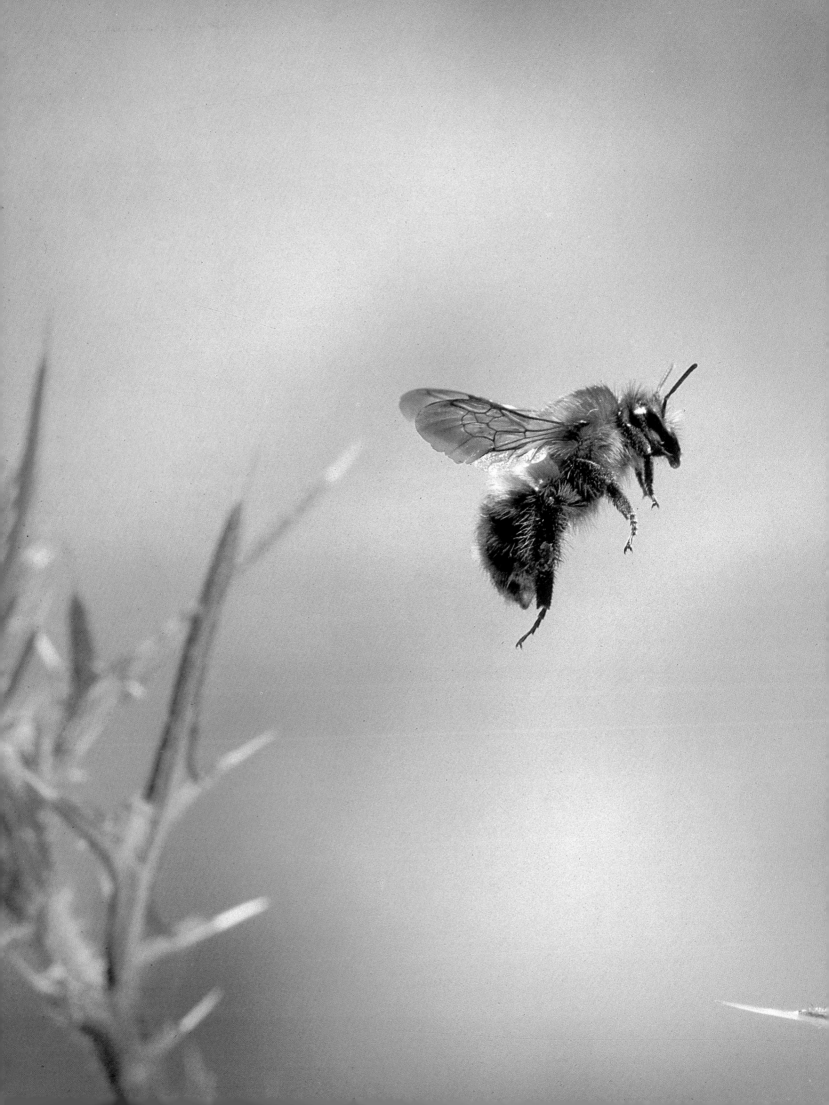

72, 73 Common wasp or yellow jacket
The common wasp is the most widespread species of social wasp in Europe; it occurs in North America and has also become established in New Zealand. The colonies build their large round papery nests underground, in hollow trees or in attics. Wasps have much shorter tongues than bees, and so can only suck nectar from shallow flowers, but the juices from fruit such as a fallen apple provide an ideal source of food for this insect.

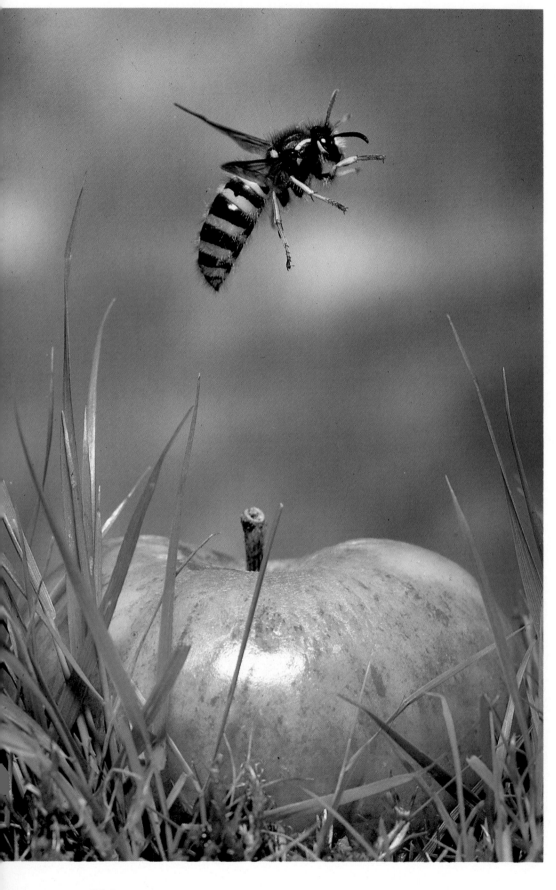

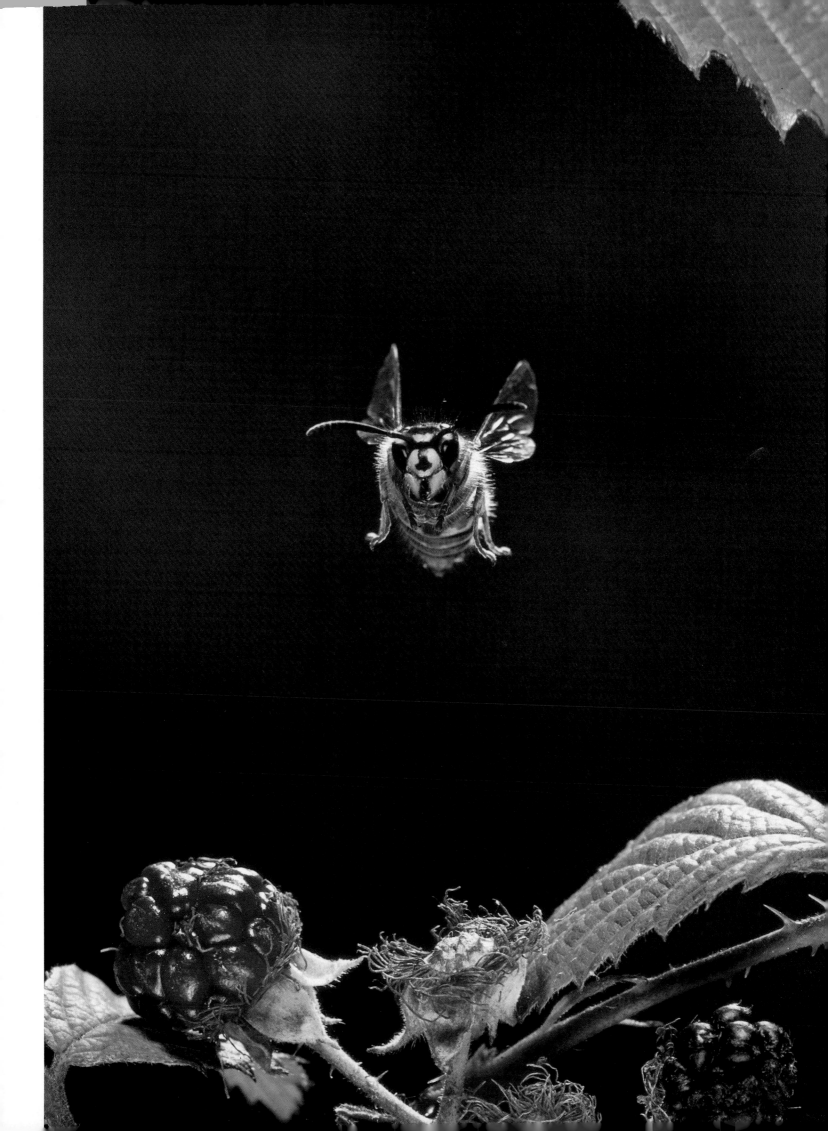

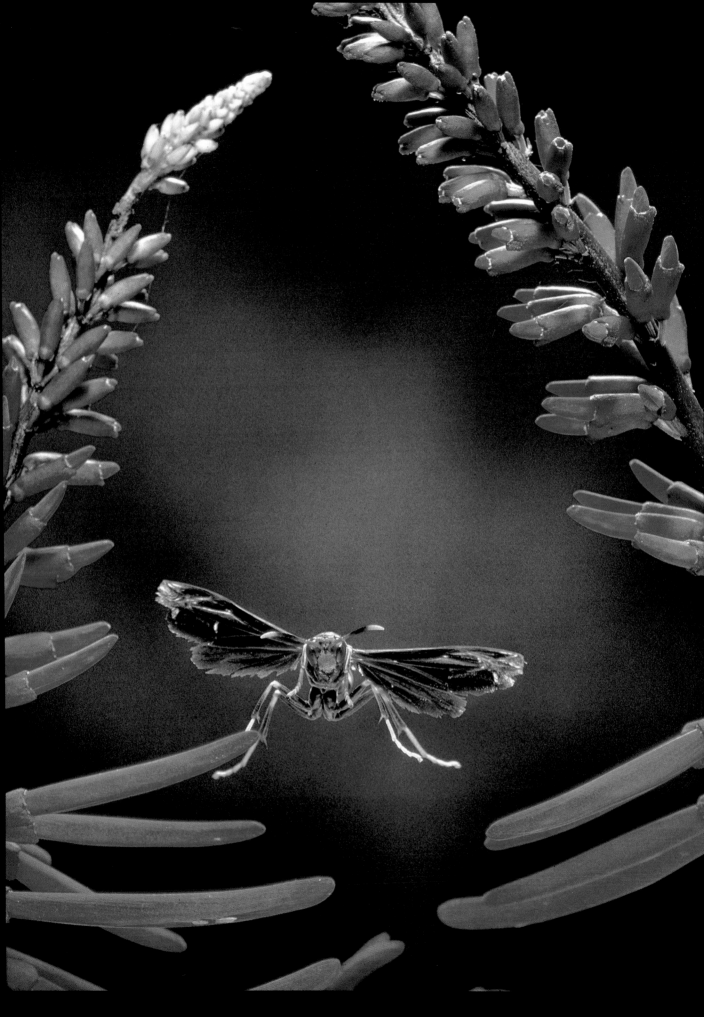

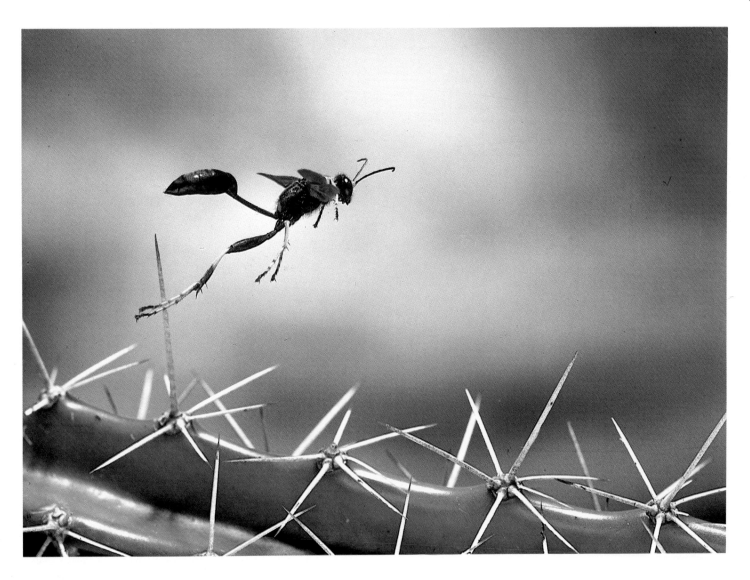

74 Paper wasp
Wasps, like flies, are efficient fliers and perform well in the flight tunnel. Despite their aggressive appearance, most paper wasps are good-tempered and sting only when severely provoked – this individual from the Everglades put up with my attentions for at least an hour without attacking me. They are so called because of the paper-like material with which they create their nests.

75 Mud-dauber wasp
The mud-dauber wasp, unlike the social wasps, leads a solitary existence. After making a nest, the female flies low over the ground or vegetation hunting for spiders on which to feed its larvae. The spiders are first paralysed and then killed. The injected venom from the sting has antiseptic properties which keep the prey from deteriorating for several weeks; the larvae are thus provided with a supply of fresh protein until they reach maturity.

76 Ichneumon wasp

In a billion years' time, when life has long since ceased to exist on this planet, this picture of an ichneumon wasp will still be travelling through space. The photograph was selected by the Center for Radiophysics and Space Research at Cornell University, to be included on board the Voyager spacecraft. The Voyager record is the first attempt by man to present himself to other civilizations in space. But why this particular picture was chosen is something of a mystery.

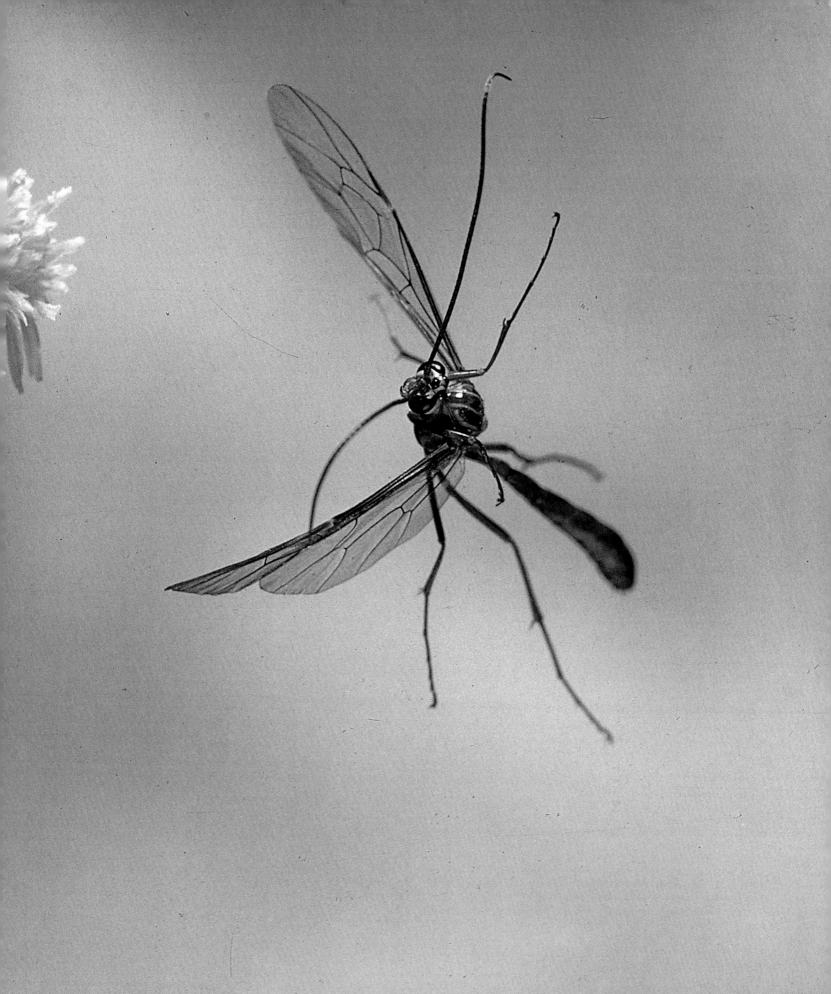

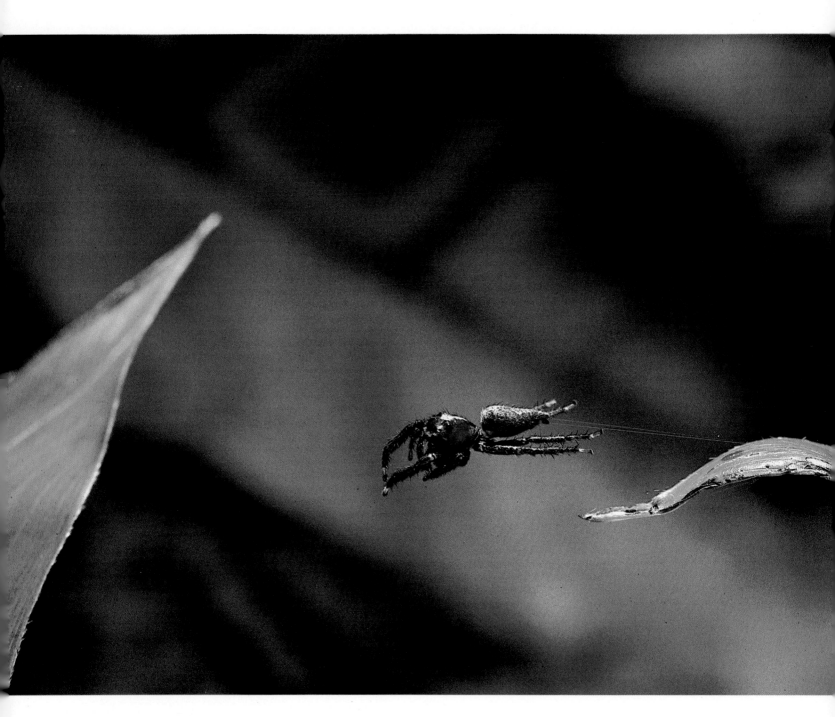

77 **Jumping spider**
I have always had a special affection for jumping spiders. These tiny creatures with their nimble rubber-like bodies are perpetually on the move in search of small insects. Once the spider has detected prey with its exceptionally sharp eyesight, it stalks it to within a few inches, and then leaps on to its victim, burying its poisonous fangs into the tissues.

The actual jump, which is exceedingly rapid, is not effected by muscular power at all, but by a hydraulic action within the legs. Before jumping, the spider deposits a blob of web at the take-off point, and as it launches itself into space, a trailing band of silk is extruded behind it.

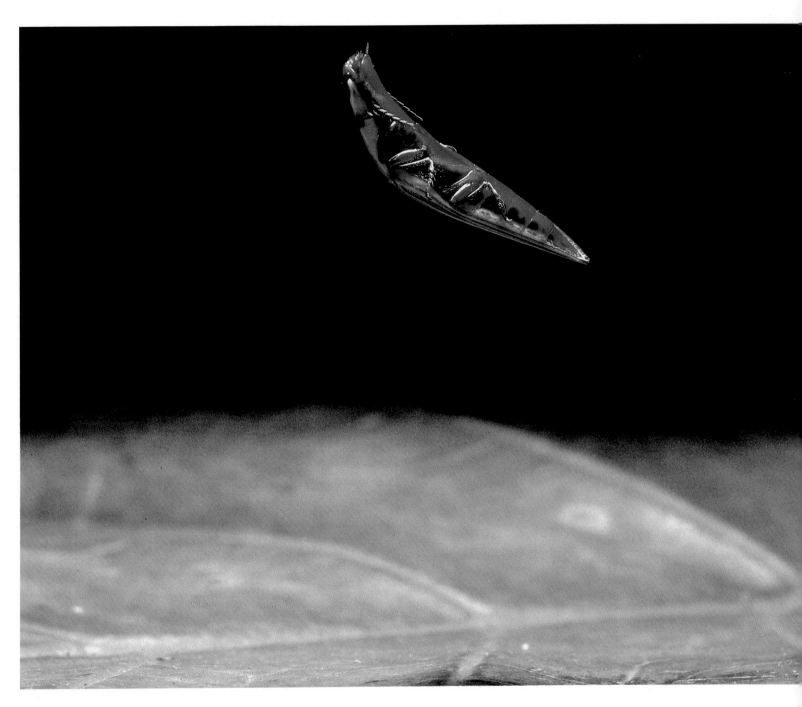

78 Click beetle
This bizarre beetle from the jungles of Venezuela is not only
capable of baffling its enemies by leaping six inches or so into
the air with a loud click, but can also flash bright yellowish-
green lights at the front and rear ends of its body. At nightfall
these creatures make a weird sight floating about the dark
forest on buzzing wings with lights blazing.

It is said that, during the construction of the Panama
Canal, a doctor performed an emergency operation by the
light of a number of these beetles, all other sources of
illumination having failed.

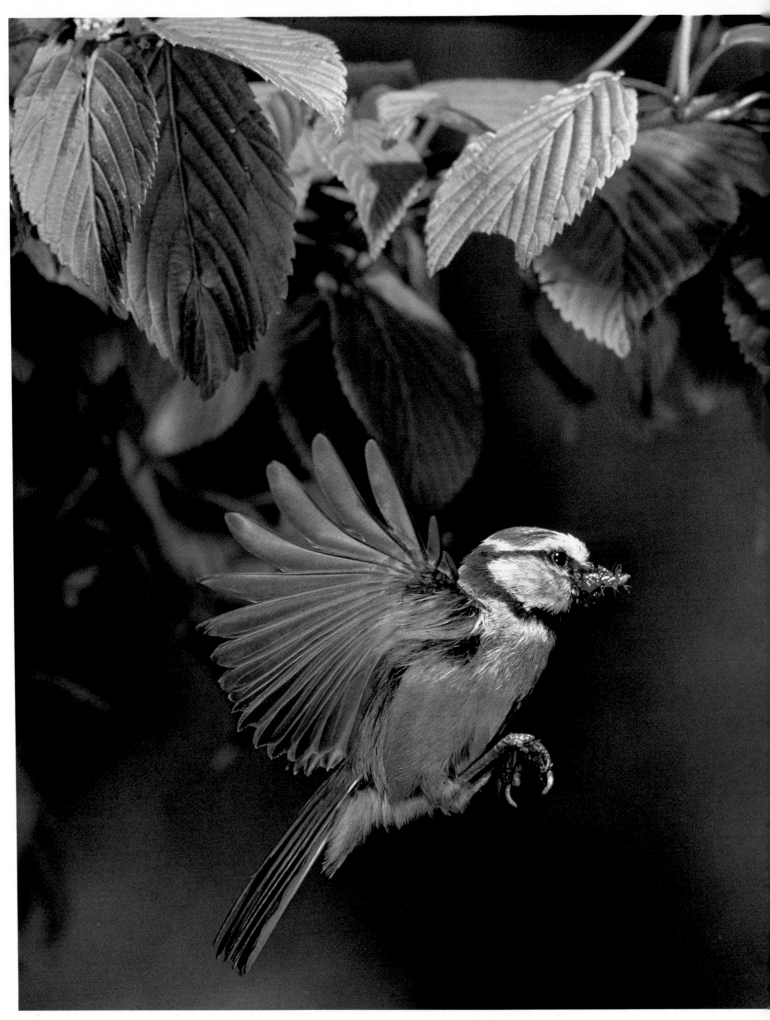

79 **Blue tit** This blue tit decided to make its nest in the side of a dilapidated sixteenth-century chimney in my neighbour's garden a few feet from the boundary hedge.

Birds

My introduction to bird photography was very exciting. One hot June day when I was about fourteen my father sought to satisfy my inquisitive nature by confining me to a hide in the middle of a stream set up outside the entrance to a kingfisher's nest. My instructions were to keep quiet and to wait for the bird to land on a stump barely three feet away from my peeping eye, and then to press a button. Crouched in that secret place, beside an antiquated plate camera mounted on a mammoth tripod, I eagerly awaited my quarry.

Within a quarter of an hour the resplendent blue bird swooped into view, and I excitedly pressed the release. The resulting image was a complete blur, but the experience was enough to whet my appetite. Years later I spent many more June days in the same spot photographing these lovely birds on the wing (pages 108–9).

There is nothing new about high-speed bird photography. Eric Hosking and others were photographing birds on the wing in the 1950s using the early high-voltage flash units, and although they were largely working in black and white, the results were impressive by any standards. The 1/5000-second or thereabouts flash duration of these units was fast enough to arrest the wing movements of all but the smallest birds.

Whereas flying insects are best handled in the studio, birds should ideally be photographed in the wild – clearly it is unethical to subject birds to unnecessary stress, or to upset their breeding routine by capturing them and photographing them under controlled conditions. Besides, there is no pleasure to be had from handling a terrified bird whose only thought is to regain its freedom.

When working with insects in the studio the photographer starts with a bare bench, and builds up the picture by the addition of foreground and background props such as foliage. He is in complete control of all the picture elements – the photograph is composed in the full sense of the word. With birds, nature composes the picture, albeit with a helping hand. The photographer can play with the framing and lighting, but he can make only comparatively minor adjustments to the vegetation in the picture area. What is crucial is the choice of site in the first place – I nearly always reject countless nests before finally discovering a suitable one to work on.

Flying birds are most easily photographed as they approach or leave their nests and young; alternatively they may be tempted by bait. In either case they generally fly along regular routes. As the air-speed and flight-paths of birds are so much more consistent than those of insects, it is unnecessary to use rapid-opening shutters. True, birds can fly a long way in a tenth of a second or so, but the actual distance flown can soon be determined by means of a few black and white or polaroid test exposures, and the light-beam can then be adjusted to compensate for this. Moreover, due to the lower image magnification, depth of field is far less of a problem than it is in the case of insects.

The most suitable shutters for in-flight bird photography are unquestionably blade shutters such as the Compur type. Apart from the shorter opening time, blade shutters can be synchronized with flash at any speeds up to 1/500 second. The drawback to focal plane shutters is that their highest flash synchronization speed of 1/60 or 1/125 second is fine when working in dull conditions, but risky in bright sunlight which is difficult to eliminate. The

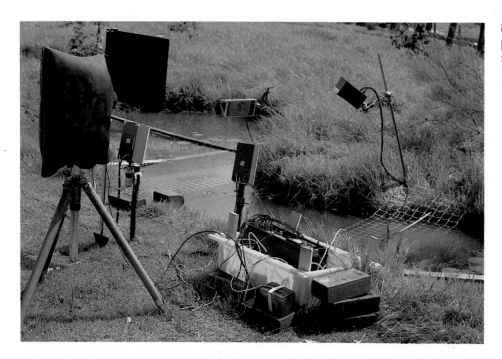

80 The pond with nets and camera in place ready to take the pictures of swallows which can be seen on Plates 104–108.

combined effect of the slow shutter-speed daylight exposure and short-duration flash can frequently produce weird effects such as ghost images, haloes or streaks. Those of us who prefer to use 35mm SLR cameras with focal plane shutters can get round the difficulty by attaching a between-lens blade shutter over the front of the camera lens, and locking the focal plane shutter open.

Backgrounds frequently pose a problem when using flash in the field. Unless it is lit separately, the further the background vegetation is from the bird the gloomier the background will become; black backgrounds are fine for nocturnal birds, but unnatural for day-flying species. Although I have seen high-speed flash photographs taken with bright daylight or natural sky backgrounds, I consider the results are disappointing. The background either looks under-exposed and artificial, or there are signs of that ghosting I mentioned above, or haloes around the bird. One solution is to import suitable foliage from elsewhere, but arranging it so that it does not resemble a tatty floral display and keeping it fresh can be a headache.

One of the keys to successful flight photography is to anticipate exactly where the creature is likely to fly, or failing this, to persuade it to use a route to suit the camera. Days can be spent setting up equipment at, say, a kestrel's nest high in an oak tree, only to discover that the flight path is not where you expected it, or that the bird has altered its approach pattern as a result of all the paraphernalia around its home. Generally speaking, the smaller the bird, the more amenable it is. Birds such as tits and wrens usually accept hides and flash reflectors with relative indifference, and with a little tactful persuasion fly more or less where they are directed. I particularly remember a pair of wrens which I had decided to photograph flying into their nest in the bank of a tiny stream a few miles from my house (Plate 81). I started setting everything up with my usual caution, but soon realized that neither bird was taking the slightest notice of me – they behaved as though photographers had been shuffling around their doorstep every day of their lives. Even as I was adjusting

81 **Wren**
This wren was such an endearing and cooperative little bird that I was able to operate without a hide and complete the photography inside half a day – a very unusual occurrence.

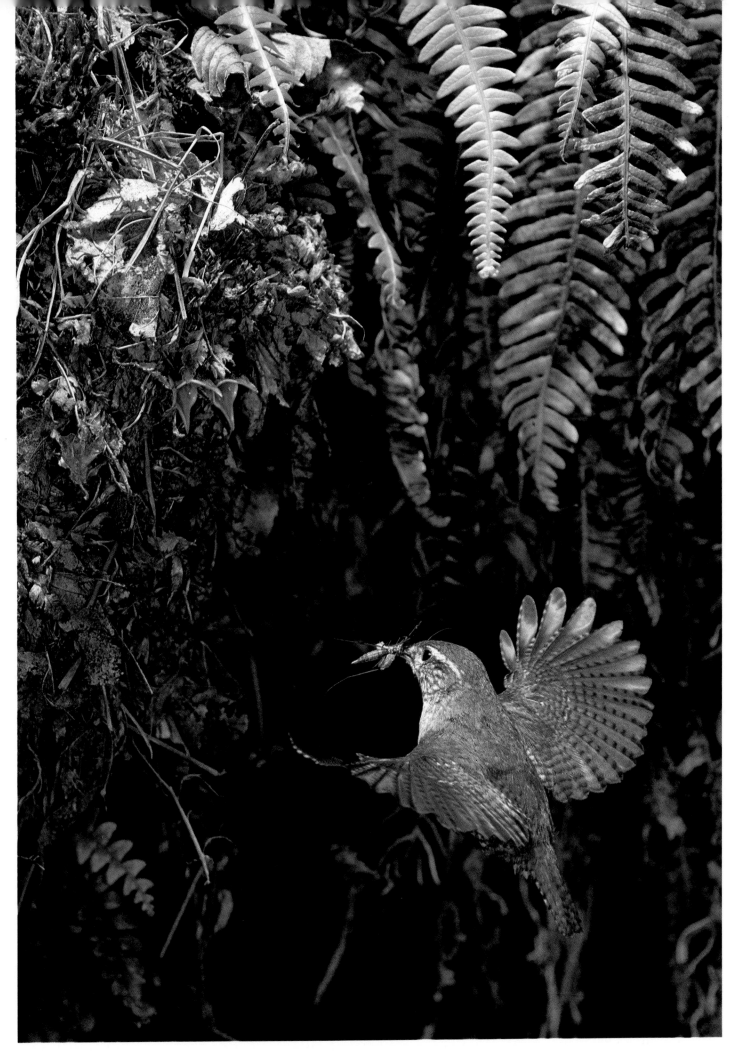

the light source within eighteen inches of the entrance hole, the little birds would cheerfully fly into their nest. I ended up by not using a hide at all, but merely stood in the water in my rubber boots, surrounded by flash-heads and a maze of wires, re-cocking the shutter every few minutes. I had arrived at the site soon after breakfast, and was packed up and gone by lunchtime.

Few birds are as obliging as the wren, however. One of my most energetic ventures took place in the early 1970s, shortly after I had constructed a prototype light-beam and sensing circuit for insects. The project was an ambitious one and would be more than I could cope with on my own, so I invited a friend, Andrew Anderson, to come and stay for a few weeks to help me. The whole operation serves to highlight some of the problems and frustrations which frequently beset the in-flight bird photographer.

Following a hint from the church warden, Andrew and I found ourselves crouching in the shadows of a country churchyard one summer night. Moonlight was shining brightly on the roofs and belfry. At each gable end of the church was a stone cross and on one transept stood a small ornate tower. In the distance the mournful baying of a pack of kennelled foxhounds was cut occasionally by the bark of a vixen, but much closer and above us was another sound – an eerie hissing and snoring. Suddenly a silent white form passed over the graveyard and came to rest on one of the crosses. After pausing there, it glided down to the tower and disappeared through a small arch in the side. After a crescendo of hissing, the white phantom re-appeared at the entrance and drifted away into the surrounding darkness. The domestic life of the barn owl was in full swing.

Owls hold a unique place in folklore and superstition. The barn owl roosts and nests in hollow trees, barns and derelict buildings. Its liking for church towers and old ruins, its nocturnal habits, its silent flight and phantom-like presence, its hissing, snoring and occasional spine-chilling screech have cast it as a bird of ill omen, and the owl and its haunts often feature in ghost stories and tales of the supernatural. We had found the ideal site to portray, in one picture, not only the barn owl, but the atmosphere surrounding it.

The following morning we sought and obtained the vicar's kind permission to transform his beautiful church into an eyesore for a few weeks with our hides, ladders, planks and ropes. Armed with permits from the Nature Conservancy to photograph this now rare bird, we set to work.

Our first problem was totally unexpected. The warden's bees had swarmed the day before and moved into a ventilator at the only point where we could position a ladder to climb onto the roof, and Andrew was stung right away. After this we borrowed anti-bee outfits. We constructed the hide and supporting platform over several days so that the parent birds would become accustomed to the change in their surroundings.

Lighting can make or mar the final picture. One of the secrets of photographing wild animals with flash is to arrange the lights in such a way that the picture looks as though it is lit with natural daylight, or in this case moonlight, avoiding the tell-tale flat and lifeless results typical of much flash photography. Lighting this scene would be critical, not only to give the owl and the tower form and shape, but also to create a spooky moonlight effect. With this in mind we built a miniature cardboard replica of the tower and used small spotlights to determine the exact position of the four flash-heads. Unfortunately my high-speed equipment had not been developed at this

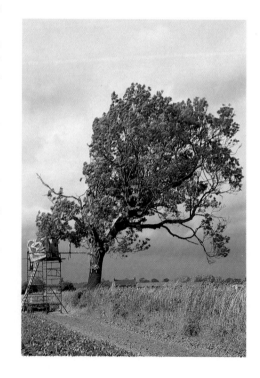

82 Hide and scaffolding erected beside a kestrel's nest twenty feet up in an ash tree.

83 The barn owl exercise: the church tower with the various pieces of apparatus fixed round it.

stage, so we had no option but to use some old and dilapidated commercially made high-voltage units. Their speed of 1/5000 second was fast enough for owls but the two units we had at our disposal were entirely incompatible. Getting both to work together proved a major headache, as when coupled they had an alarming and expensive tendency to blow up the shutter contacts, but eventually the problem was overcome. Another drawback with this flash gear was that it required a large twelve-volt car battery to run it for any length of time, which had to be hauled up and down the church roof each day.

The octagonal tower had an arch on every side, any one of which the owls could use to enter their nest. We wanted them to use only one so that they would intersect the light-beam at the right point for the final photograph. To achieve this, we cut boards to the shape of the arches, painted them black, and fitted one a day. The owls accepted this until eventually, with seven holes blocked, they were happily using the remaining one each time. Fitting the boards and placing the flash-heads on their booms proved quite tricky. Andrew, who had a good head for heights, had to stand on the very end of a rickety ladder and, gripping the often loose masonry, stretch to the limit to put everything in position.

At last, after ten days of preparation, we were ready to start photography – so we thought. Every time we had the whole thing set up we would have a breakdown – the beam and sensor were the main culprits. We even tried taking the picture by opening the camera shutter as the owl approached the tower and firing the flash manually. We did finally get a photograph this way, but when the film was developed we found that the image was blurred. The film had not been lying flat in a camera magazine that had worked reliably for years. We had not considered ourselves in the least superstitious, yet we could not help feeling that something was working against us. Even the bees moving into the ventilator the day before we started seemed as though planned to obstruct us. At one stage the photo-electric triggering system would go off every time we turned on the power for the flashes. The two circuits were completely separate systems and were yards apart. It was like switching on the bathroom light and finding that the bath taps turned themselves on at the same moment.

Two days later, when this mysterious fault was rectified, everything appeared to be functioning perfectly. We set everything up and went off for a bite of supper feeling confident that at long last our first night's real

84 **Barn owl**

How I obtained this picture after three weeks' effort is described in the text. All I possessed was some antiquated high-voltage flash equipment with a speed of about 1/5000 second – slow as high speed goes, but fast enough for owls. Furthermore, its light output was uneven in distribution and low in power. As the whole tower was to be lit, two of the flash-heads had to be at least ten feet (3m) away, so to obtain sufficient exposure on Kodachrome 2 film, the lens, a 50mm standard, needed to be opened almost fully to an aperture of f2.8. Even with black and white on the large-format camera the lens was only stopped down to f5.6.

photography was about to begin. When we got back two hours later the whole triggering system had gone dead. Andrew decided to stay in the hide to attempt another picture by hand, while I went home with the photo amplifier to find the fault. When I eventually returned to refit the assembly at 2.30 am, the whole system started to operate seemingly by itself, the flashes firing even when there was no owl in sight. On developing the film the next day we were somewhat relieved to find that a pipistrelle bat was responsible for taking one exposure, and moths for the others. At least it was not a poltergeist breaking the light-beam.

The following night the owls visited their nest several times, but yet again the system failed to function. By now things were beginning to get us down – and the fact that neither of us had had much sleep over the last two weeks did nothing to help our mood. Nevertheless, we were determined not to be beaten.

By 12.30 the next night our despondency had turned to desperation, as neither of us had seen any sign of the parent birds. Yet the previous night the adults had been coming and going frequently. The weather was good, and we had always accompanied each other to the hide; we also felt sure that the owls were unaware of our presence. True, there was only one youngster, which obviously needed less food than a larger family, but not seeing the birds even flying around the churchyard was extremely worrying. Leaving the system switched on, we climbed down from the roof. At times like these the bird photographer starts to reproach himself, even though he may not be in any way responsible. To expend so much time and effort and not to get a picture is tough luck, but to damage or upset the birds is unforgivable.

We were just considering removing all our paraphernalia in the hope that it might save the situation, when we both saw it at the same time – an owl gliding slowly over the church. A few seconds later, after settling on the cross at the top of the tower, it slowly closed its wings and passed a dead rat from its bill to its talons. We had found that unless we kept our triggering system switched off until we actually saw the owl in the vicinity, within a few minutes a moth or bat would cut the beam and fire the camera, thus ruining any chance of getting a shot of the owl. By now we had been sitting in the car for at least ten minutes, so it was with gathering tension that we gazed at the owl and realized that we were well into borrowed time. Would owl or moth break the beam first?

The majestic white bird calmly surveyed its territory, and after what seemed minutes seized its prey in its beak and in one long glide descended to another small cross above the chancel. Once again it transferred the rat to its talons and paused. The suspense increased. Finally the owl picked up the rat by the scruff of the neck and slowly turned towards the tower. It hesitated a moment with its wings partly open, then launched itself from the cross. Suddenly, for a fraction of a second, the owl and the tower were illuminated by a dazzling light, then all was dark. The bird disappeared through the entrance to be greeted with hisses of delight. We let out our breath – we had got our first picture.

The barn owl exercise was an exceptional one. The two of us had devoted some three weeks of our time to it, working by day and night, but the couple of pieces of film we had to show for it in the end made the whole experience eminently worthwhile.

85 House sparrow
I have to admit that the house sparrow is not one of my favourite birds. In spite of their apparent attachment to humans and their habitat these birds become infuriatingly suspicious, windy and crafty as soon as any interest whatsoever is shown in their activities. Fortunately I managed to get the better of this one.

86 Tree sparrow
A tree sparrow suspended in mid-air for a split second before popping into its nest-hole in an old wall to feed its hungry young.

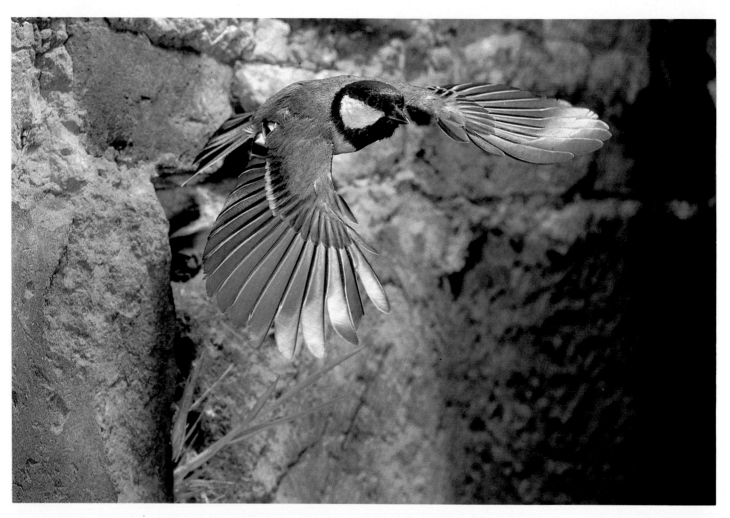

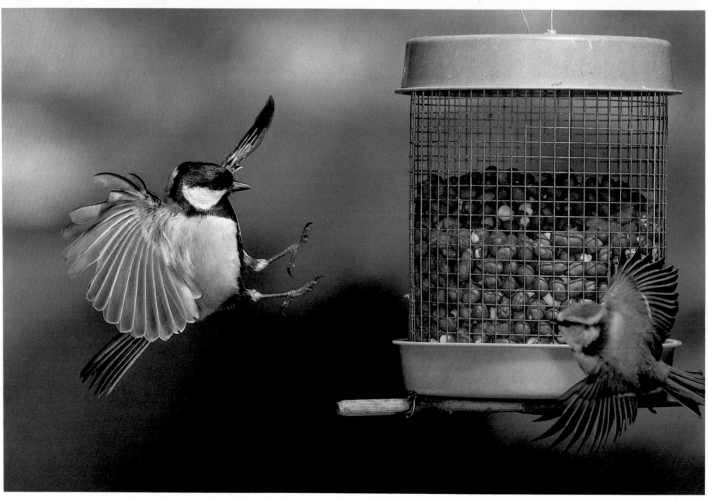

87, 88 Great tit, 89 **Blue tit**
There is nothing like a bird-tray to attract birds to a specific spot. By the strategic placing of a post and the bait, tits can be persuaded to fly exactly where you want them. In fact the main problem here was keeping them away – a bird-tray can be so popular during a winter cold spell that it can prove difficult to isolate a single bird in the picture at any one time.

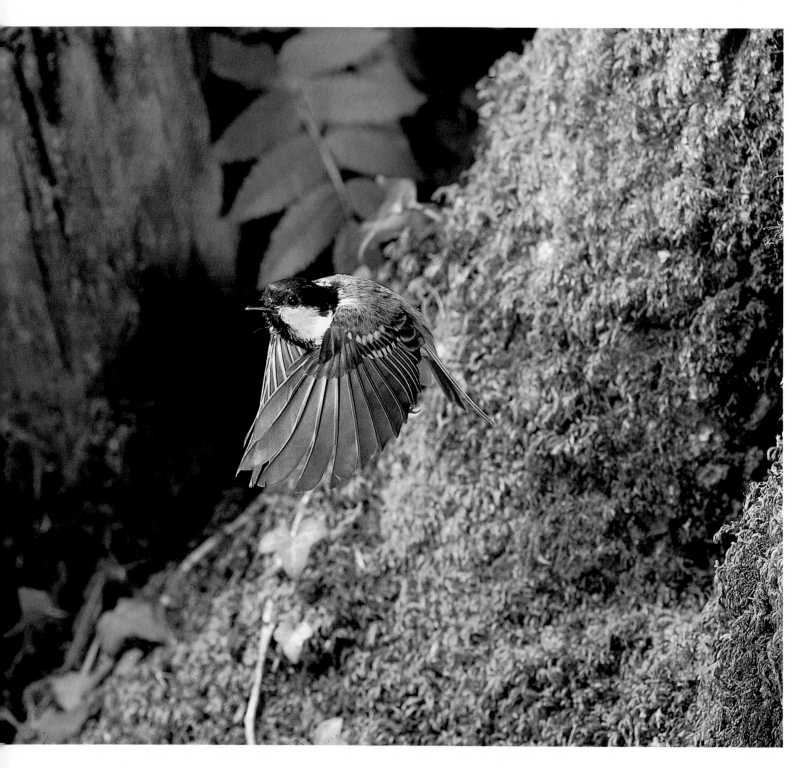

90, 91 Coal tit
The only successful pictures that I took on a recent
photographic trip to Wales were of a coal tit, a bird that I
could just as well have found in my own garden. The project
was completed with minimum trouble as not only was the
nest easily accessible, but the parent birds were obliging
almost to the point of being sociable – in one picture it looks
as though the bird is about to join me in the hide.

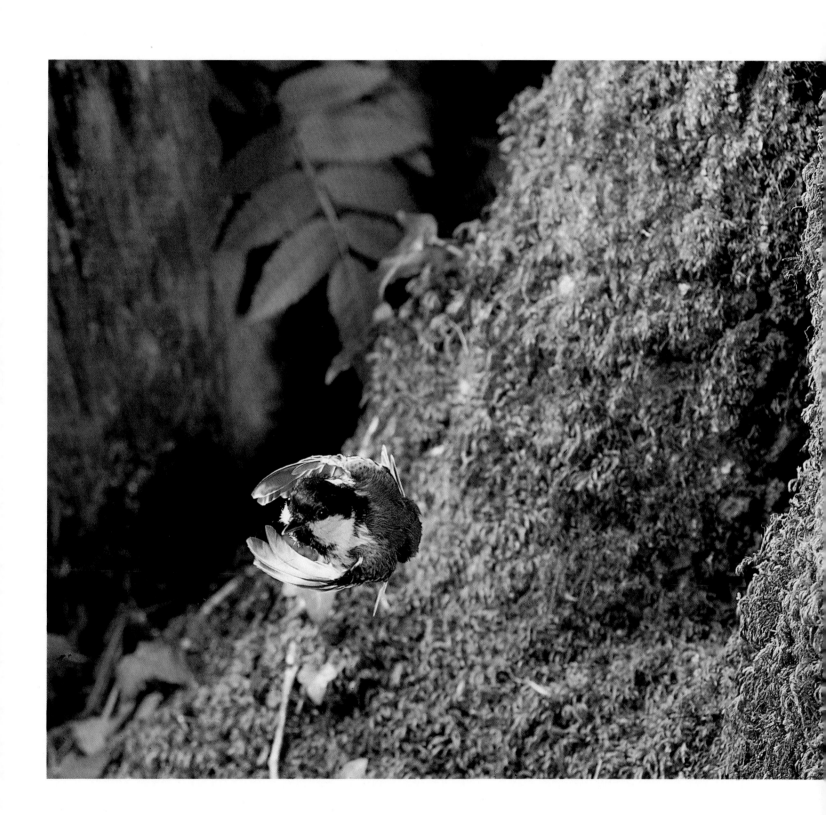

92 **Spotted flycatcher**
Although this bird was photographed en route to its nest, the light-beam was placed several feet away. Consequently the bird is caught flying at a relatively high speed and is only just beginning to slow up, as can be seen from the angle of its body.

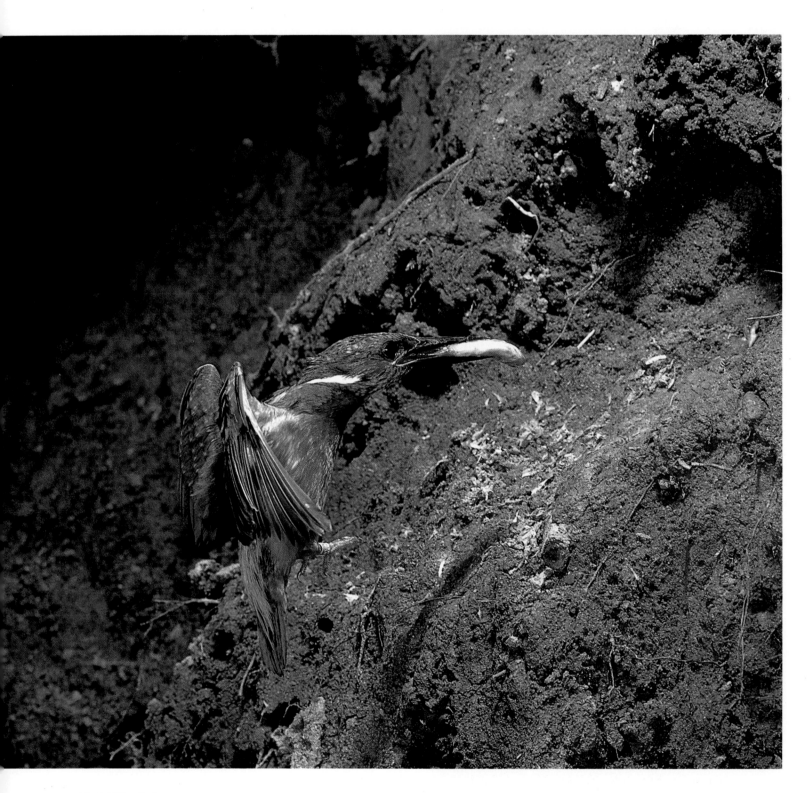

93, 94 **Kingfisher**

Of the countless hours I have spent in a hide, those watching the kingfisher have provided me with the greatest pleasure. In this case the nest-hole was some eight feet (2.5m) up in the bank of a shallow bubbling brook, while the hide platform was about eighteen inches (45cm) above the water's surface, in a position that allowed me to look upstream and photograph the bird at right-angles to its flight path.

As well as being able to view these spectacular birds at close quarters as they flew in and out of their nest-hole, I could hear their shrill cries as they darted backwards and forwards, and enjoyed watching them dive into a nearby pool to catch stickleback for their hungry offspring.

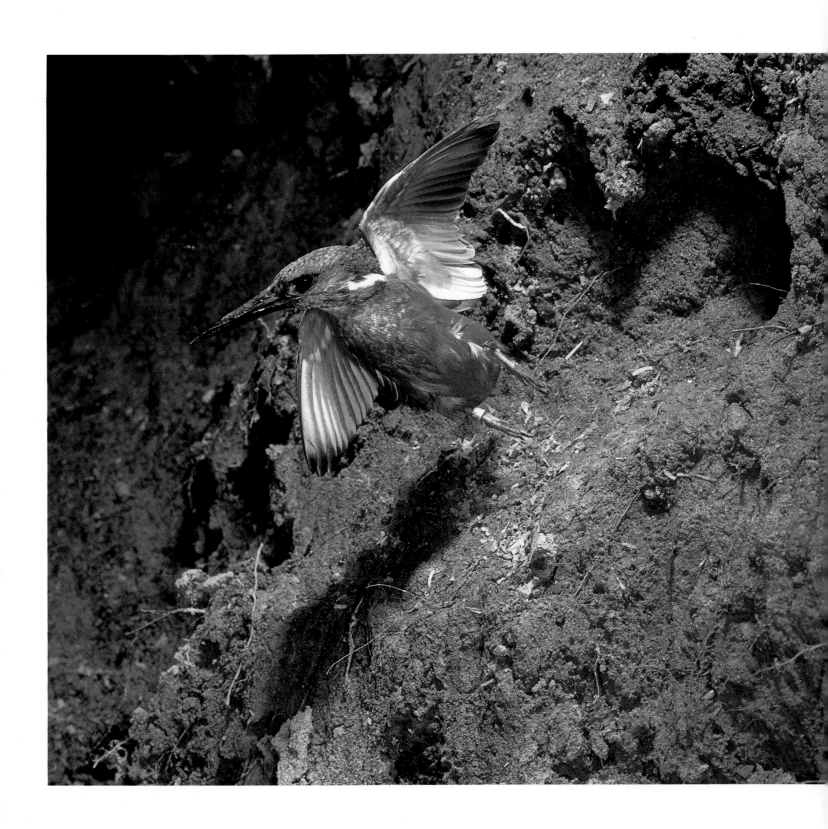

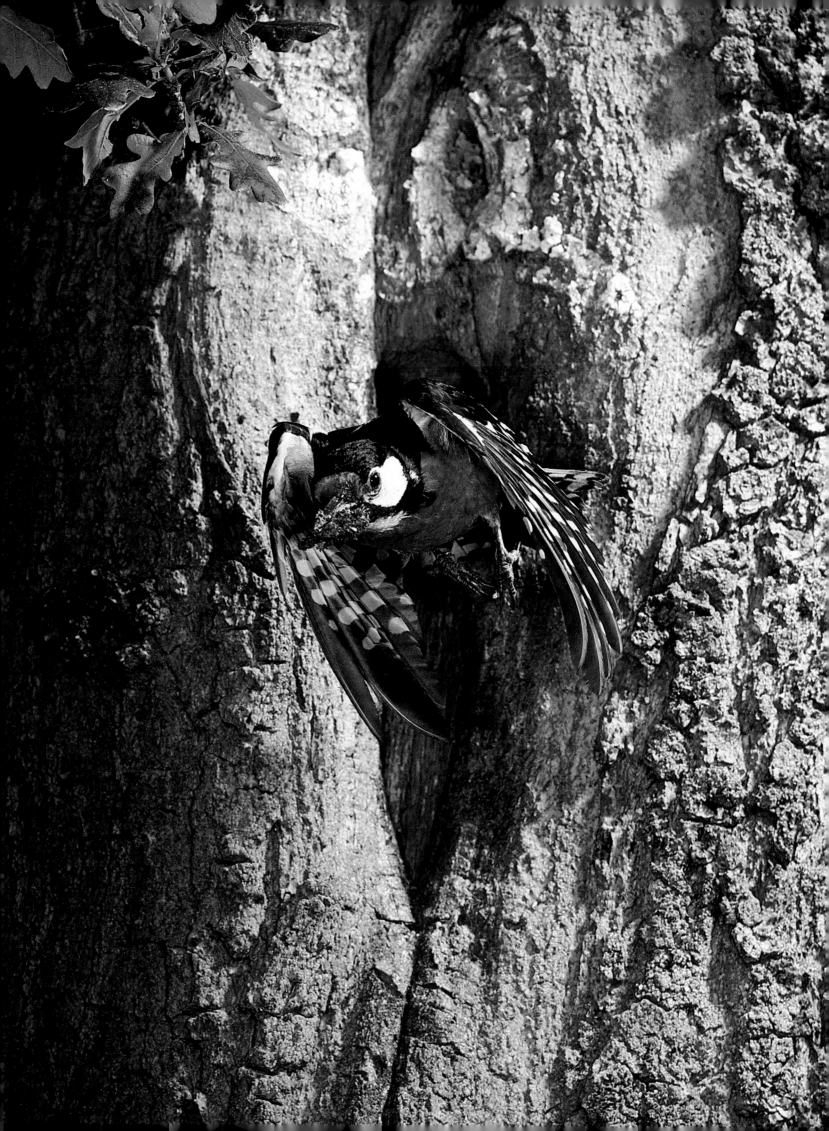

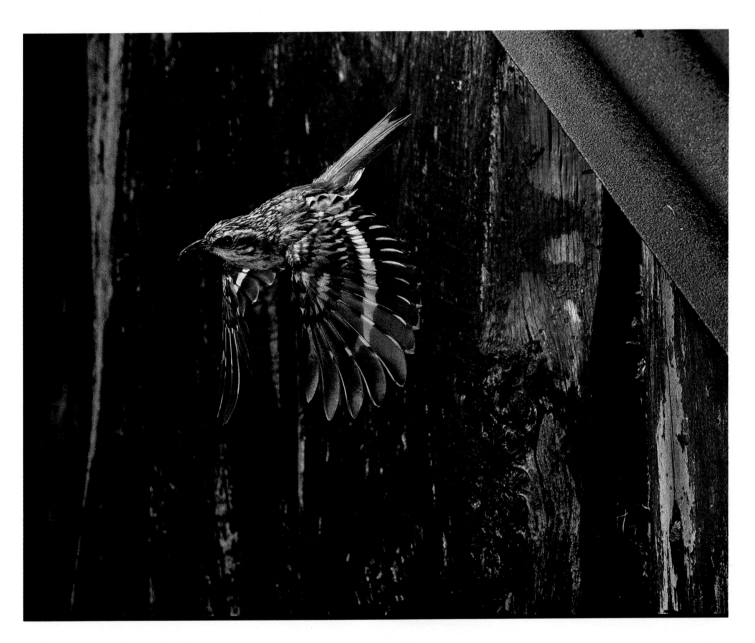

95 Greater spotted woodpecker
The nest-hole of the greater spotted woodpecker was exposed to very bright June sunlight, and even using a blade shutter at 1/500 second, it was impossible to eliminate completely the effects of the ambient light (as observant readers will notice).

96 Tree creeper
This bird was nesting in a tumbledown disused shed next to a pheasant-rearing pen. To reach the corner of the roof where the bird was nesting, I had to raise the hide on a small platform. The parent birds were very amenable and did not appear to object to my activities in the slightest.

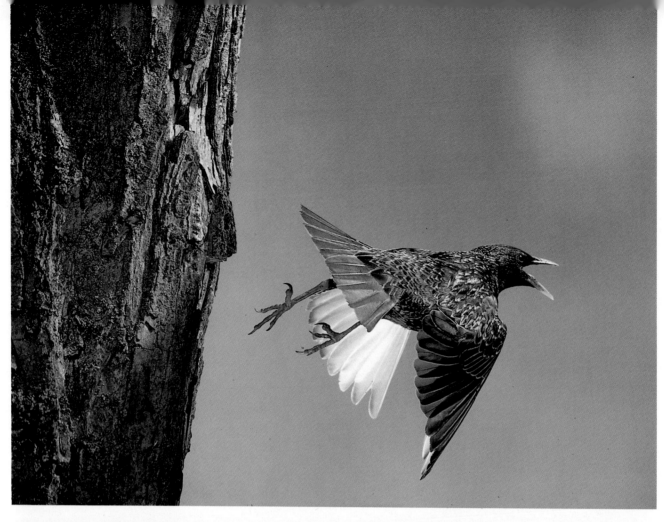

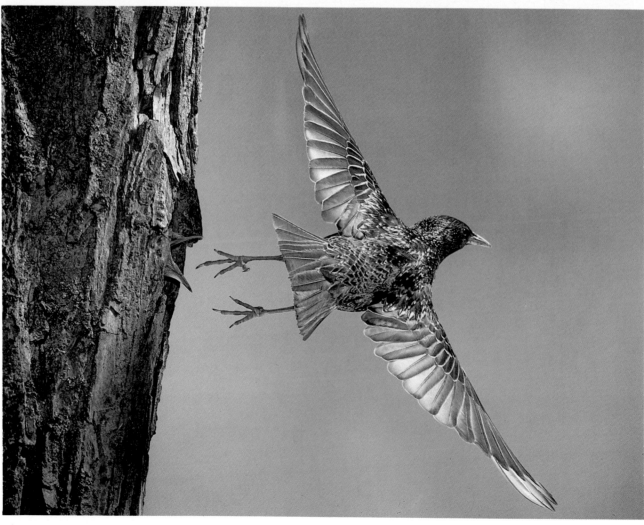

97–99 Starling

A long and hazardous trek across a swamp was necessary to get to this starling's nest twelve feet up a rotten willow tree. To prevent the background from going black and to eliminate 'ghosting' from the natural sky, a backdrop was used.

The series of photographs is aerodynamically instructive as it shows various aspects of bird flight, including wing-tip propeller action, use of the alula (the bird's 'thumb') and braking.

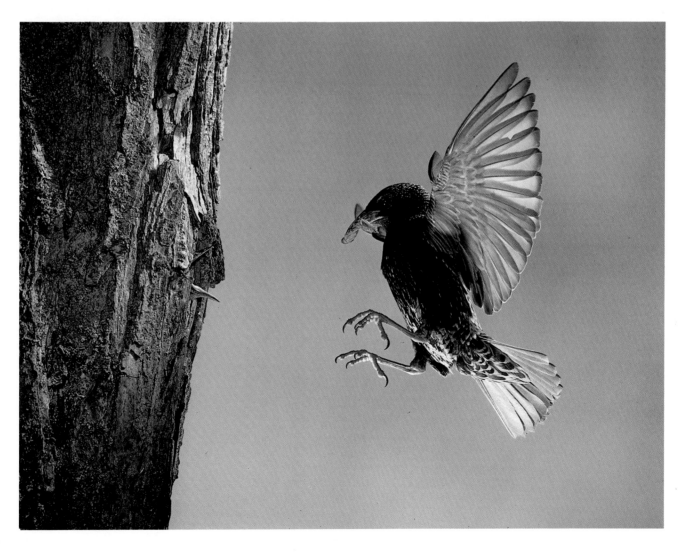

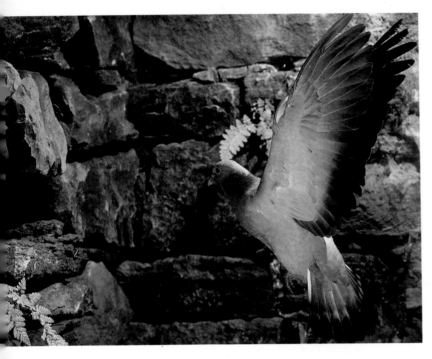

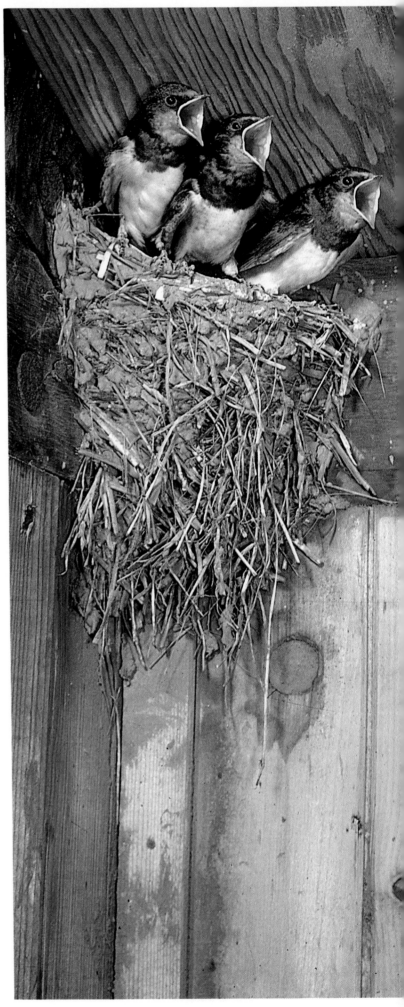

100 **Stock dove**

As the parents visited the nest so infrequently, the stock dove was an obvious contender for the motor winder. Pigeons and doves are shy and suspicious birds at the best of times, so they do not usually take kindly to photographers. With this in mind the hide and flash-heads were erected over a period of about ten days, but once all the apparatus was adjusted and functioning well, everything was left to operate automatically.

101 **Swallow at nest**

The parent swallows had selected a nest site in an old railway truck which was being used as a pig shed and was sited in the middle of a field. The same archaic high-voltage flash unit was used here as was employed to photograph the barn owl at the church tower – at one time the whole set-up, including the camera, became alive with escaped volts. Safety was a prime consideration in the design and construction of my later flash equipment.

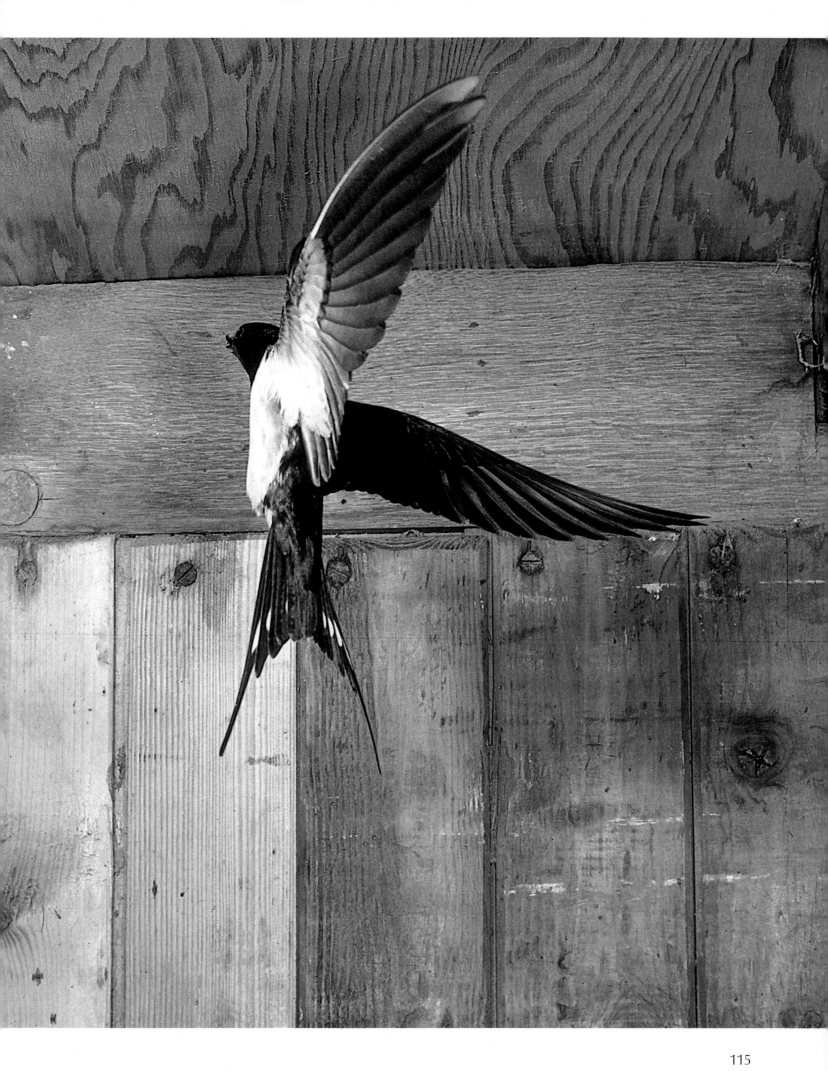

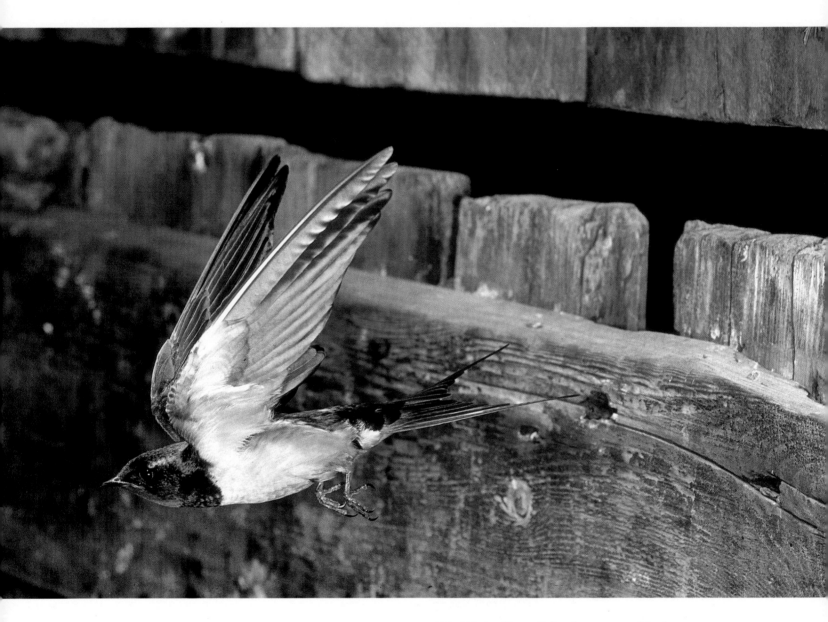

102, 103 Swallows flying between stable doors
It is always intriguing to watch swallows flying through narrow gaps such as these between stable doors – an obvious subject for high speed. I found that they could fly through spaces as narrow as one-and-a-half inches, but in doing so they had to tuck their wings and legs well into their bodies and dive through, projectile fashion.

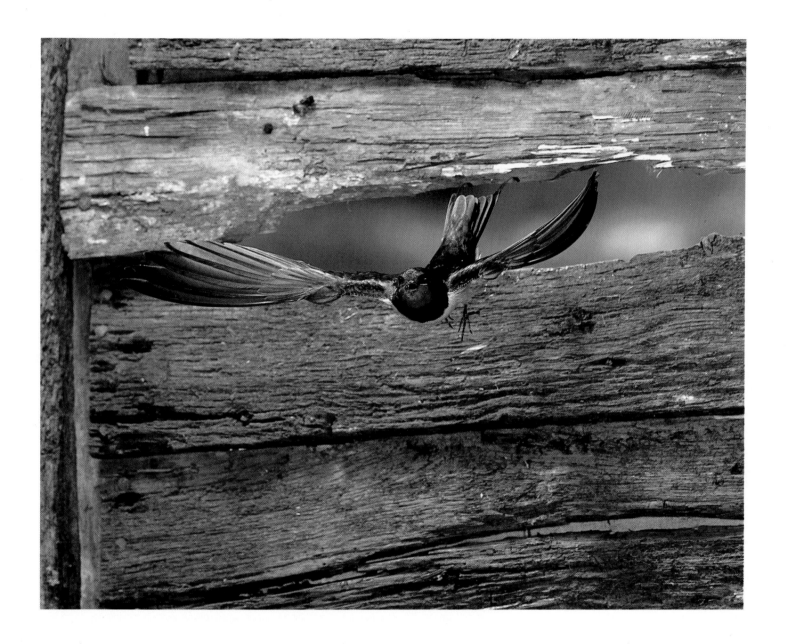

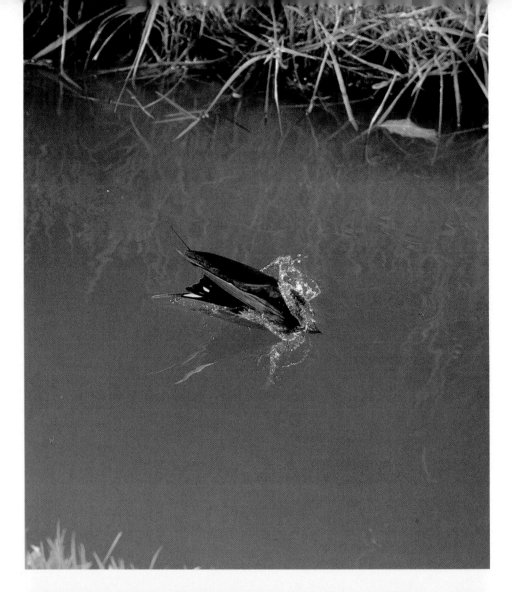

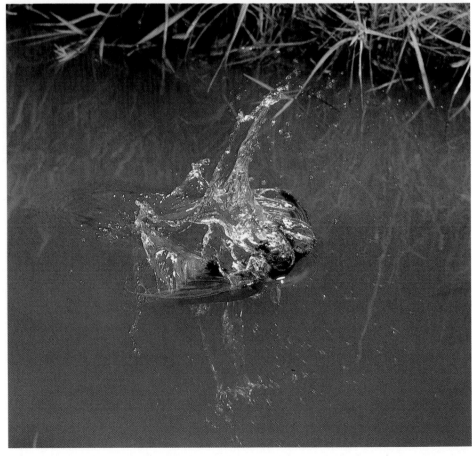

104–108 Swallow bathing, and (*overleaf*) **drinking**

Often I used to watch swallows dipping into the fishpond after completing a large circuit of our garden in Sussex. Sometimes they seemed merely to brush the surface with their beaks; less frequently they struck the water with an impressive splash. What was going on? Were they drinking, bathing or perhaps catching insects? High-speed photography would give me the answer, but I realized that the operation would be far from easy and might take weeks or even months to accomplish.

Without frightening them off, I somehow had to persuade the swallows to strike the water regularly at the precise point where my camera was focused. It was totally different from photographing birds at their nests: after all, the swallows did not have to visit this particular stretch of water.

First I masked most of the pond with netting, in order to confine the splashdown to a small area (see illustration on p. 94). I did this over a few weeks to avoid upsetting the birds. Then, over a few more days, I erected the photographic and electronic equipment. I had to remember to compensate for the shutter delay (about 1/20 second with mirror locked), so the camera was directed and focused some ten inches (25cm) from the plane of the light beam and photocell. Before I could start to photograph, the noisy motorized camera had to be silenced with a sound-proof cover, but there was no practical way of silencing the crack of the high-speed flash-heads. Fortunately the birds accepted this.

After a week or two of test exposures and adjustments, everything worked perfectly – now I could see what was really going on. Sometimes the bird approached the pond from a very low angle, skimming gracefully over the surface and scooping water into its beak for a drink (overleaf). Often it seemed to take too much , when it would squirt the excess out of its mouth. (Note the pond-skaters on the water's surface.) Occasionally the approach path was very much steeper, the bird diving into the water at an angle of about 45° with wings folded for a bathe. Up to a second later, with a dramatic splash, it would emerge like an aquatic jack-in-the-box.

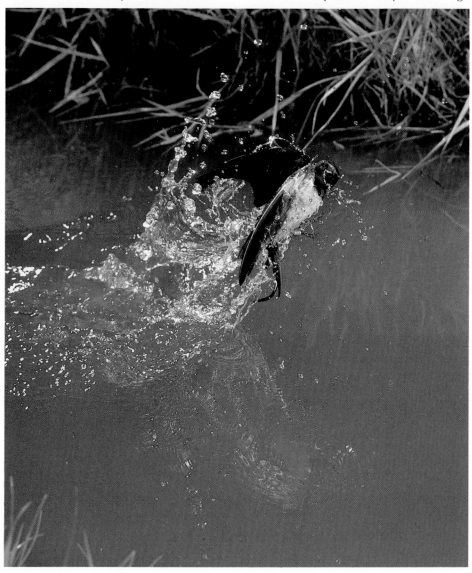

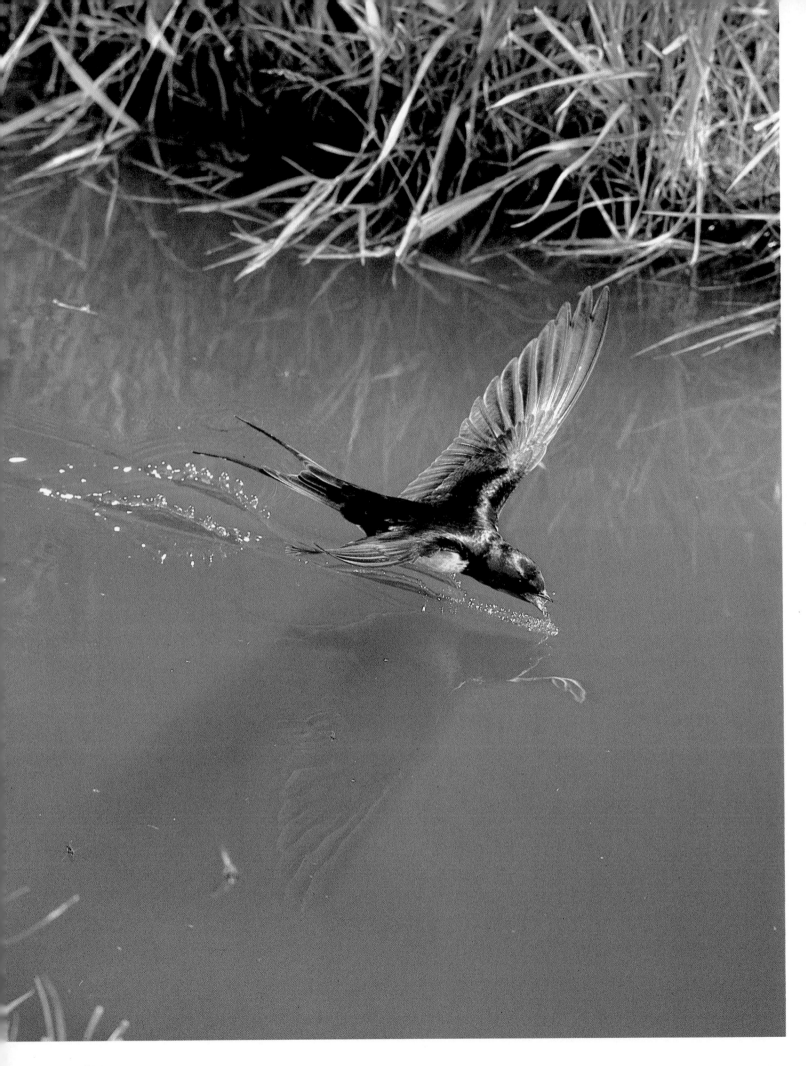

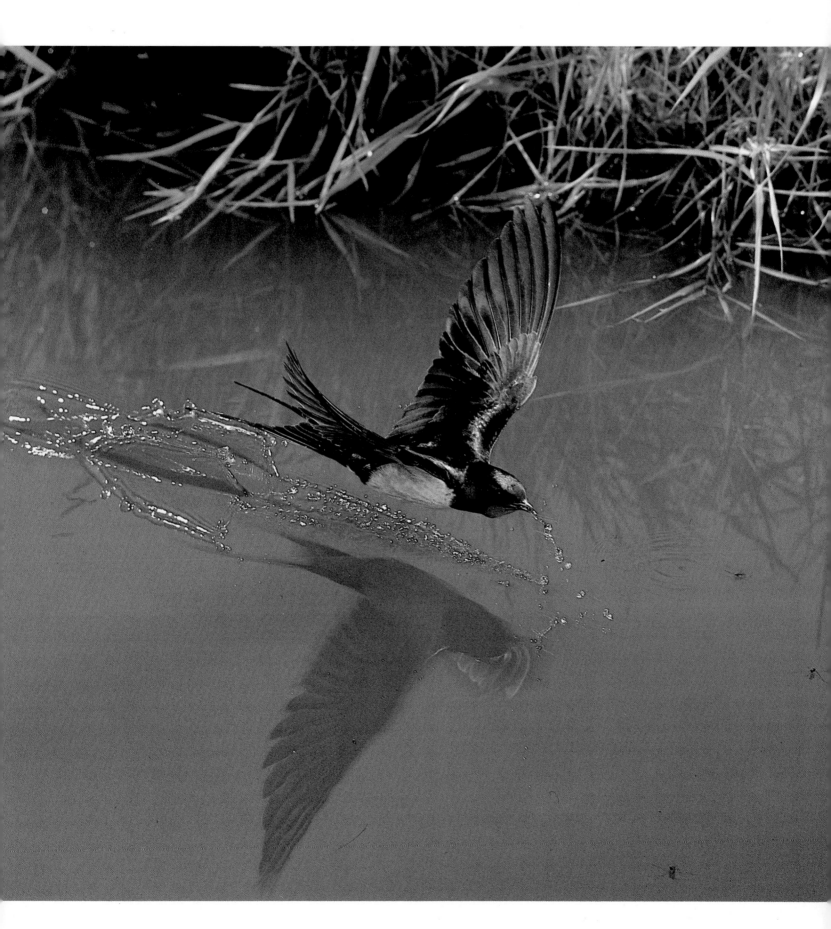

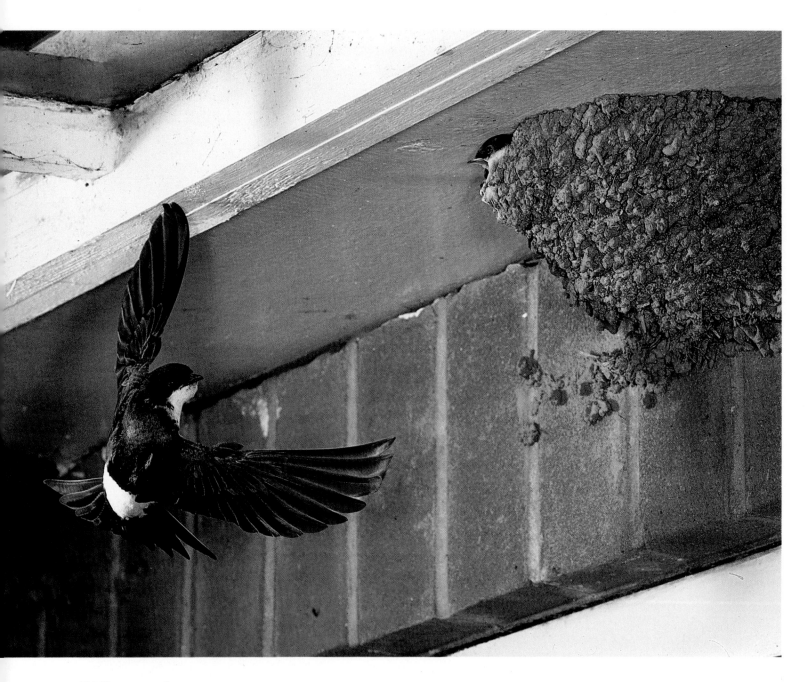

109 House martin
The nests of house martins are usually inaccessibly positioned high up under the eaves, but as this obliging pair chose a bungalow I had no trouble setting up the equipment in a suitable position.

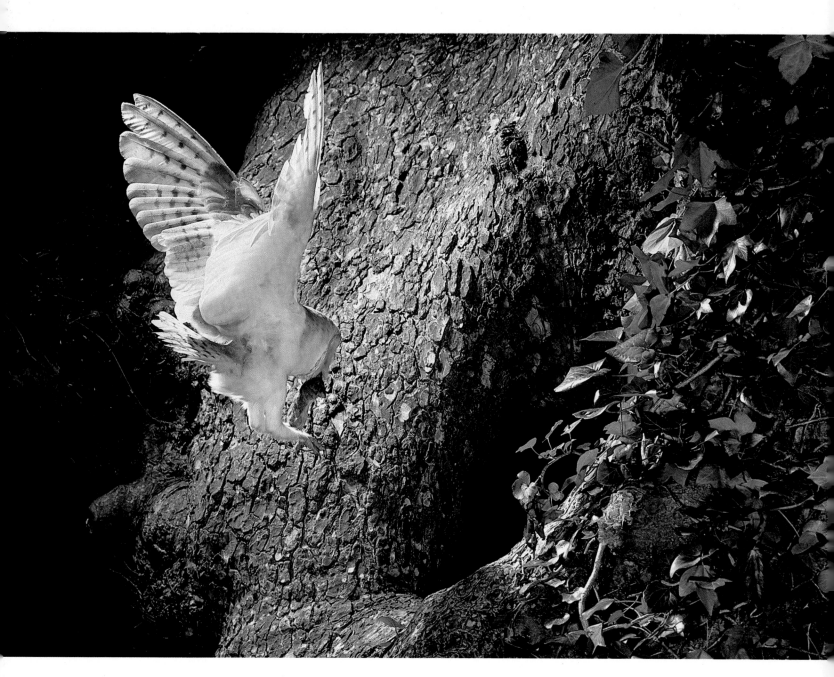

110 Barn owl
This was photographed near Salisbury five years after the 'tower' barn owl (Plate 84), with correspondingly more sophisticated electronic hardware. As I employed a motor winder I did not have to wait up in the hide all night, which was just as well as there were raging thunderstorms and torrential rain on three of the nights. Fortunately my equipment is almost immune to the effects of the weather.

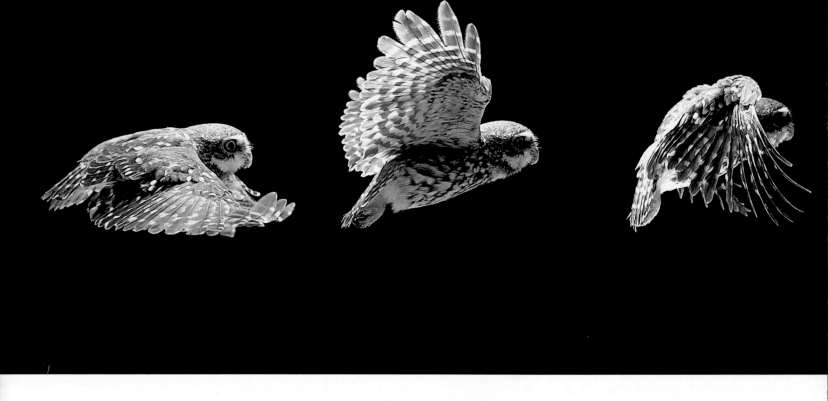

111 **Little owl**

This multiflash exposure demonstrates how birds slow up for landing, showing the increasing angle of attack with decreasing airspeed, use of tail as airbrake, lowering of 'undercarriage' and changes in the wing movements. Relatively large creatures such as birds are tricky to light satisfactorily with multi-flash, as my present technique allows me to use only a single flash-head per image.

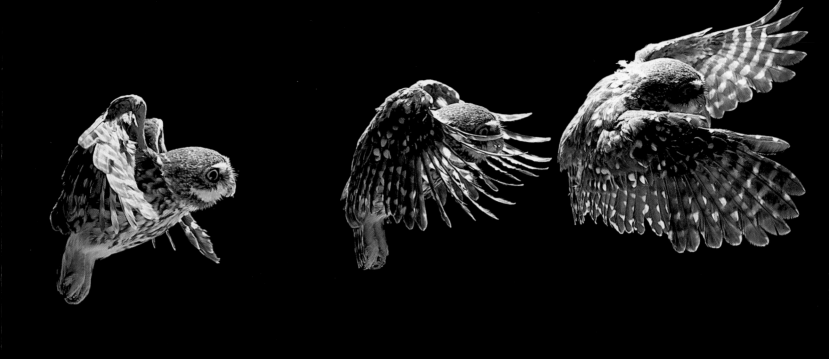

112 Violet-cheeked hummingbird

The Americas' richest gift to the avian
world is the spectacular family of
hummingbirds. Their dazzling iridescent
colours and diminutive size, combined
with their utter mastery of flight, place
them in a class of their own. The wings
of hummingbirds are designed to
provide maximum power, leverage and
movement. The upper arm is
comparatively short and the wing is largely
supported by the elongated wrist and
hand bones, while the shoulder girdle is
uniquely swivelled, enabling the bird to
adjust the angle of attack of the wing to
produce thrust on the upstroke as well
as the downstroke. Furthermore,
hummingbirds' wing muscles are,
relatively, much larger than those of
other birds. It is these features coupled
with its tiny size which account for the
hummingbird's breathtaking flight.

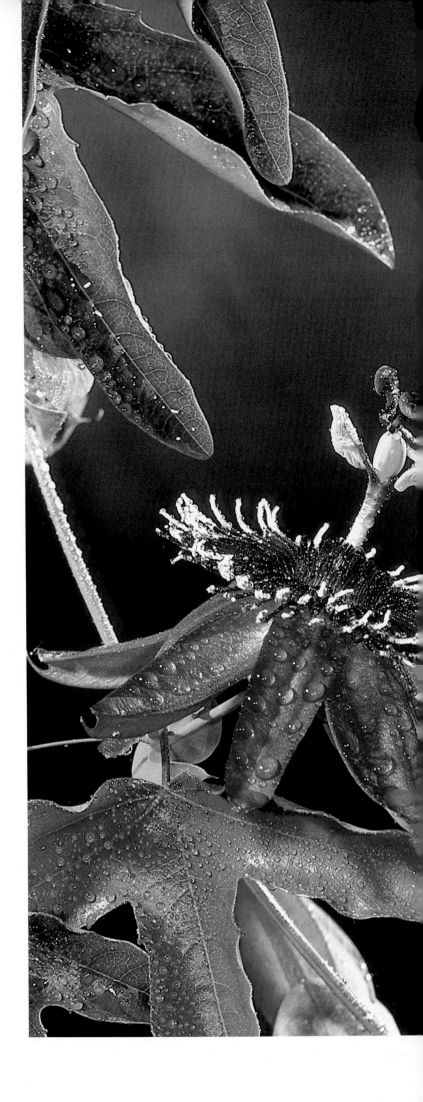

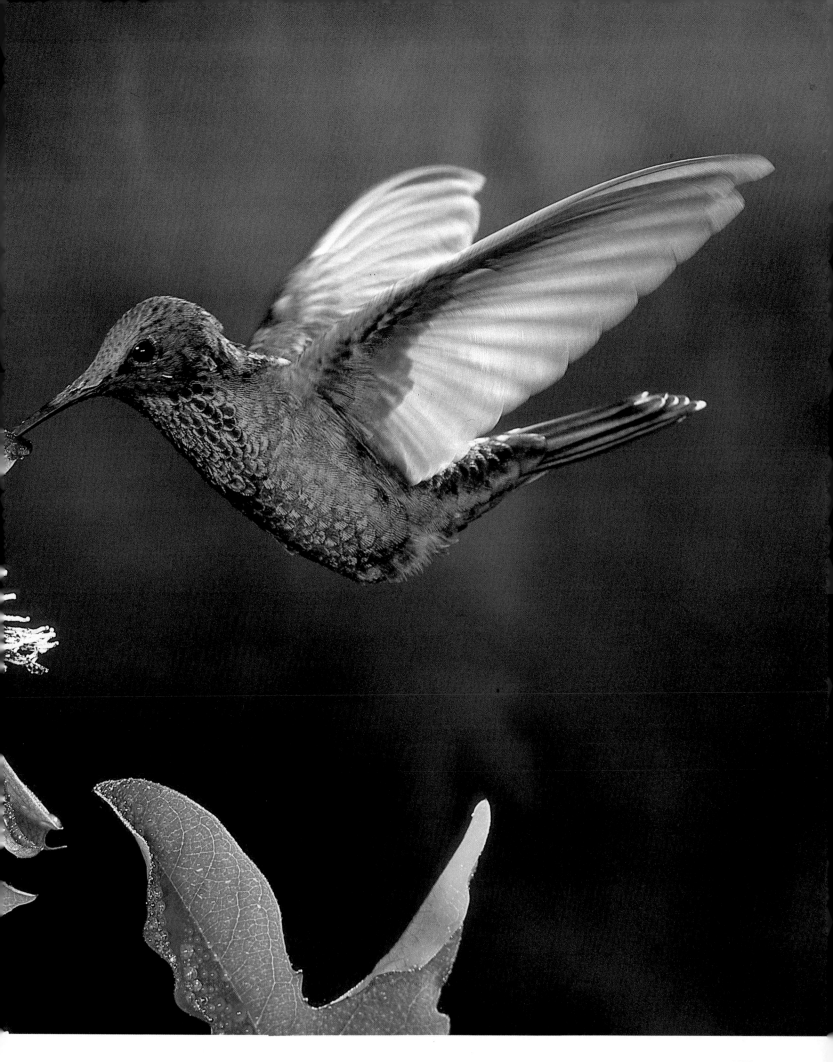

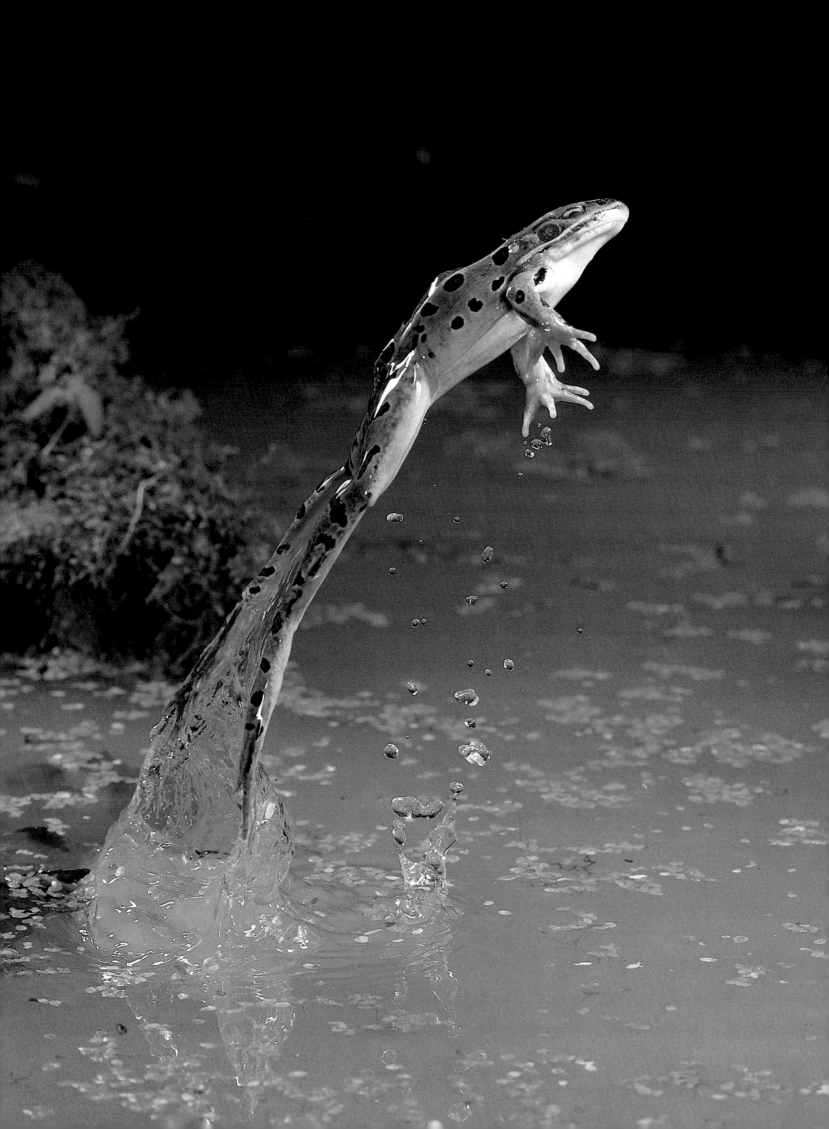

Amphibians and Reptiles

High-speed photography of reptiles and amphibians is obviously limited. Some species of lizards, snakes and frogs wander about in a leisurely manner on the lookout for prey, while others spend most of their waking hours hardly moving at all, waiting for some hapless creature to come within striking range. But, once stimulated, many reptiles can move like lightning. It is at such times that the high-speed camera comes into its own – leaping frogs, feeding chameleons and striking snakes are all extremely rewarding subjects to work on.

Like insects, reptiles and amphibians are best handled inside under controlled conditions – the mind boggles at the thought of attempting to photograph a striking rattlesnake in the wild. Cold-blooded animals rarely feed and tend their offspring, and are generally less prone to panic than birds, so a brief stint in captivity is unlikely to do them any harm. But enticing the creature to perform in front of the camera is another matter. Reptiles need warmth to be active; in fact, many become so lethargic when cold that they can scarcely move at all. Even deadly snakes can be handled with impunity if cold enough.

Chameleons are particularly sensitive to their environment, as I discovered while attempting one of my first tasks at Oxford Scientific Films, a British company specializing in wild-life photography, with which I am closely associated. We wanted the various stages of a chameleon catching its prey, and to work on this I was allocated a space in a somewhat dark and gloomy studio. After arranging a suitable perch for the chameleon and a flower for the fly, I positioned the flash-heads and carefully lined up the light-beam and photocell, so that the tip of the chameleon's tongue would intersect the beam a few millimetres in front of the fly. Once everything was ready the chameleon and fly were introduced to their respective stations, whereupon the fly contentedly fed on the flower's nectar and the chameleon ignored the fly altogether, apart from an occasional detached sideways glance with one of its independently mobile eyes. I tried all sorts of inducements such as extra heat, extra light and extra-juicy flies, but to no avail. After two unsuccessful days, I drove home with the chameleon for the weekend.

The next day was gloriously sunny, so, feeling optimistic, I decided to make another attempt. This time I constructed the set in my dining-room, next to the south-facing patio doors. Whether it was the sun or the luxuriant green Sussex countryside I am not sure, but the creature performed impeccably, devouring flies by the dozen.

One of my most hair-raising assignments was to photograph a rattlesnake striking. The exercise was performed not in the wilds of Texas, but in the studios of Oxford Scientific Films. I spent three weeks on this, during which time I employed a European viper, two puff-adders and a couple of rattlesnakes. A local wildlife park lent me the puff-adders, but contrary to what I was led to believe they made no attempt to strike, so they were returned. The viper also proved useless. After phoning around I then located a dealer in venomous snakes and selected a vicious-looking tiger rattler. I constructed a suitable snake-proof enclosure, filled it with barrowloads of sand and carefully arranged all the electronic and photographic hardware. The theory was to get the snake to strike in precisely the right spot and so intersect a two-millimetre light-beam with the tip of its nose, but after a few half-hearted attempts it never tried again.

113 Frog leaping out of water
The explosive power of the frog's hind legs is demonstrated as a leopard frog leaps from a stone just beneath the water's surface. Used chiefly for escaping predators, this is the outstanding feature which sets frogs apart from other amphibians. It only takes 1/10 second for a frog fully to extend its hind legs, and the leap can propel the creature twelve times its own length.

To get this photograph, the photo-electric cell was submerged under the water.

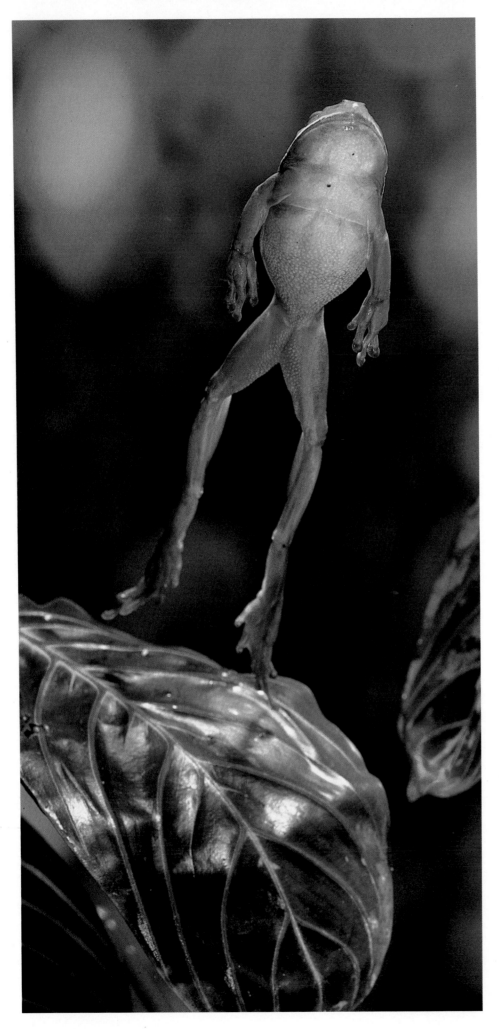

114 Tree frog
These frogs are specially adapted for life in the trees. Their feet have expanded sucker discs at the tips which enable them to grip on almost any surface — even a vertical sheet of glass. Most tree frogs are powerful jumpers and can launch themselves at an insect accurately enough to engulf it as they land.

Determined to get my picture, I swapped the tiger rattler for a mean-looking diamond-back rattler. To induce this serpent to strike, all manner of devious means were tried, but it would lunge out only if the object of its assault, preferably a human hand, was within its somewhat short striking range. If too close, the object appeared in the picture, if too far the snake merely puffed, rattled and hissed for all it was worth, but rarely struck. But on the odd occasion when the reptile did strike, it was so unexpected and with such awesome speed that it certainly got the adrenalin moving.

Part of the daily routine involved catching the creature with a 'snake-hook' and removing it from the photographic set to its sleeping quarters in another part of the building, a somewhat daunting procedure for those of us unaccustomed to handling snakes. When I attempted to do this, the creature escaped onto the cluttered studio floor on more than one occasion. Extricating an agile and exceedingly venomous serpent from a pile of coiled hosepipe dumped in a dark corner concentrates the mind wonderfully.

115 Rattlesnake striking

A deadly Western Diamondback rattlesnake strikes out at a human hand just out of reach. Small beads of glistening venom can just be seen flowing from the erected hollow fangs.

Capturing this action (at a speed of 1/12000 second) was a tricky operation, as on the few occasions when the creature struck it very rarely intercepted the 2mm light-beam.

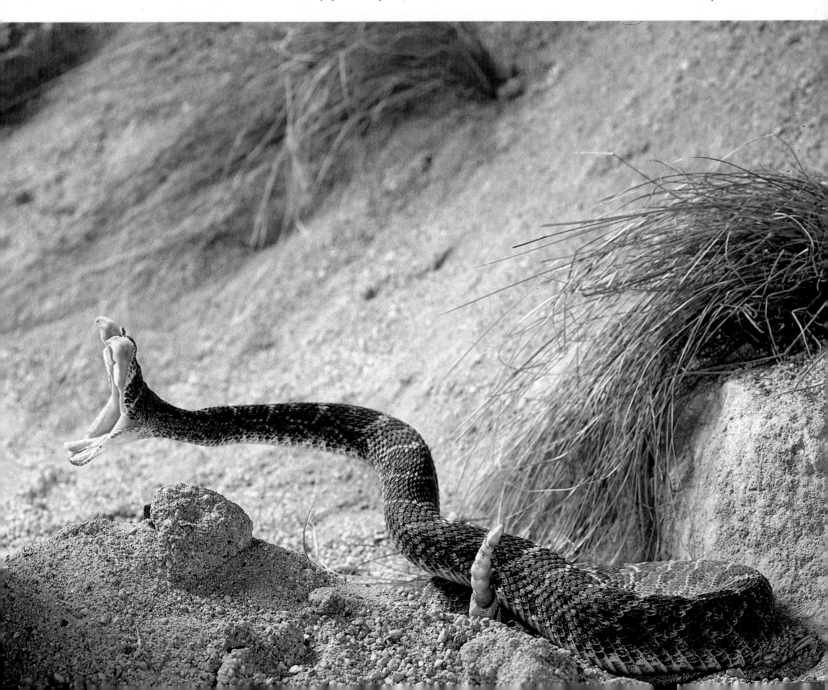

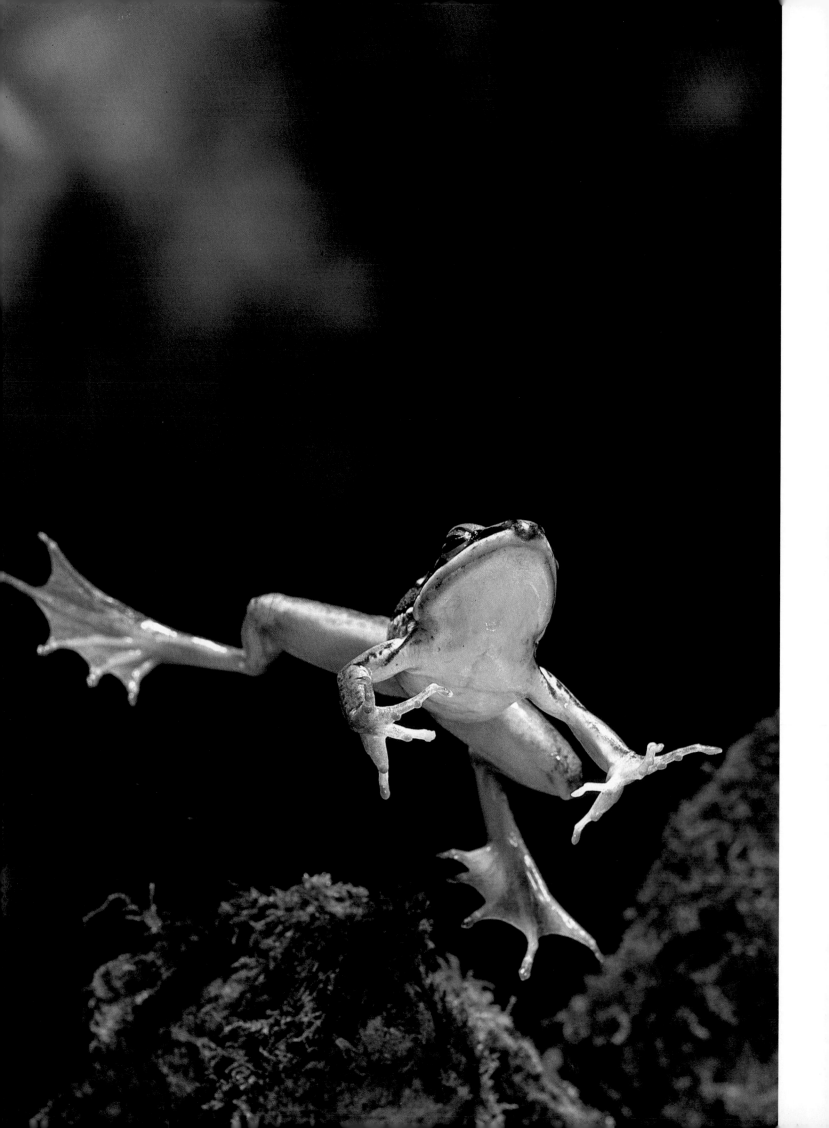

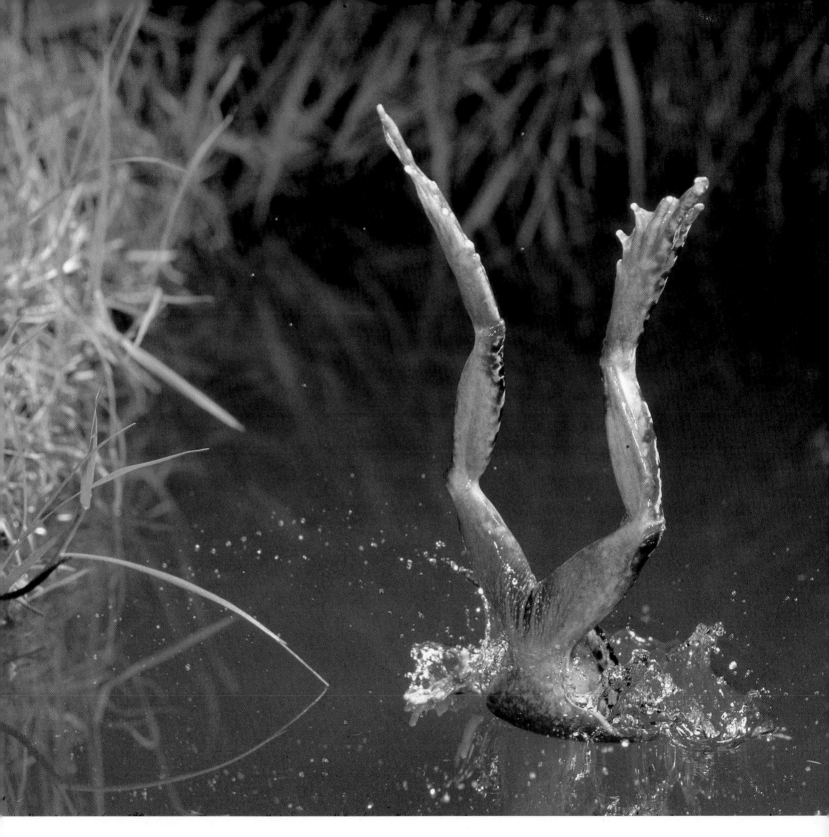

116, 117 Common frogs
Frogs do not spend all their time in water; often they sit on the bank of a pond or stream, but as soon as danger threatens they plunge headlong into the relative safety of the water, where they are better equipped to escape.

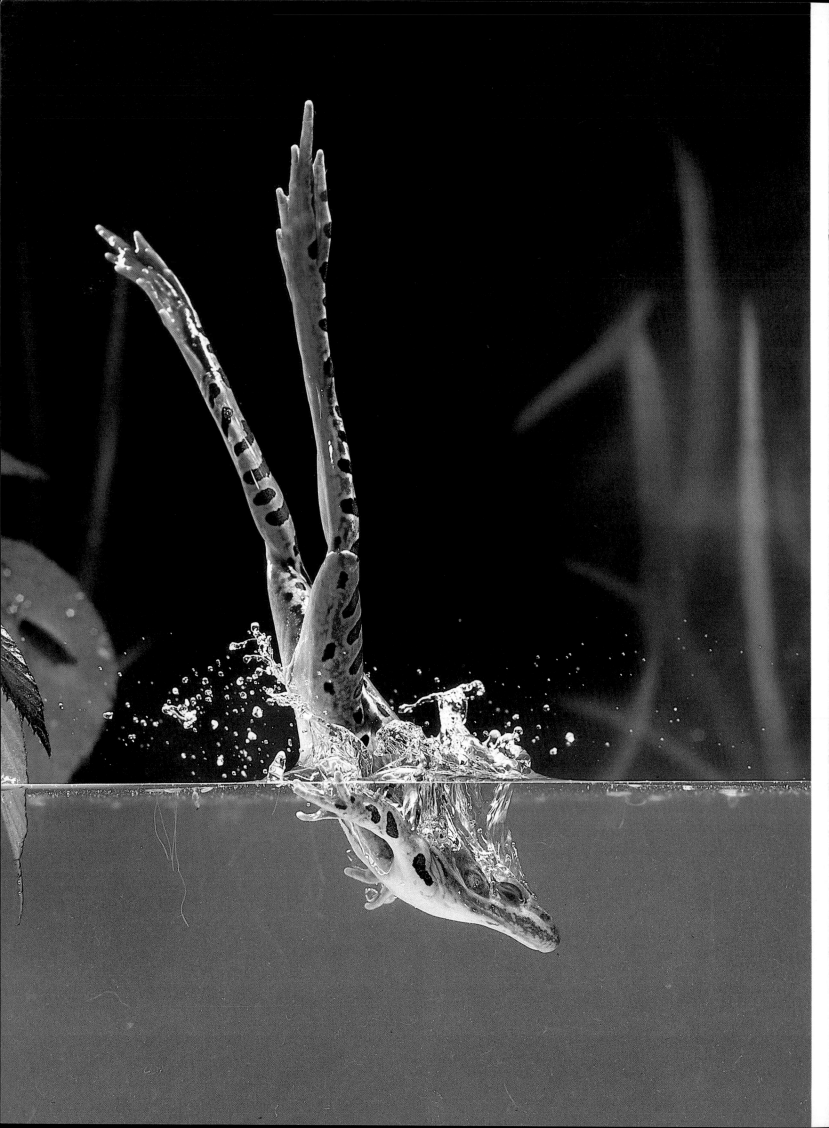

118, 119 Frog jumping into water
The leopard frog is the common frog of North America. This
one has decided to jump out of harm's way into the water.
These two pictures were specially taken for the covers of a
book on pond life published by Oxford Scientific Films.

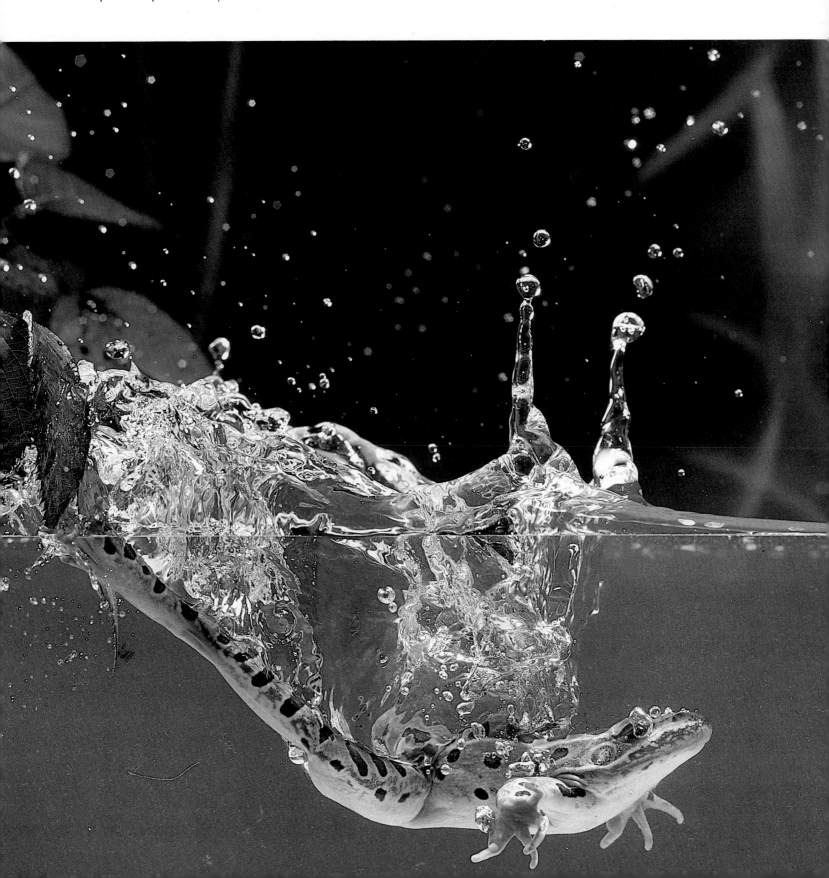

120 **Edible frog**
When frogs take off, the eyes are withdrawn into their sockets – presumably this is to protect them from damage rather than to improve streamlining. Here, the European edible frog is caught in mid-leap over a stump.

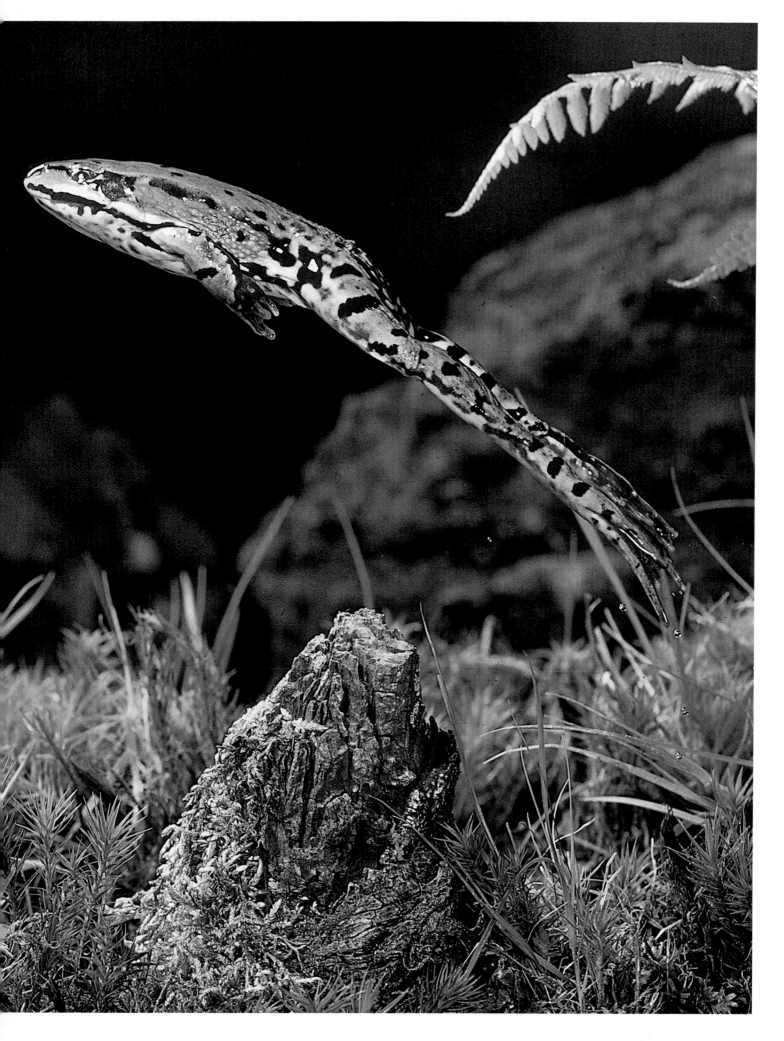

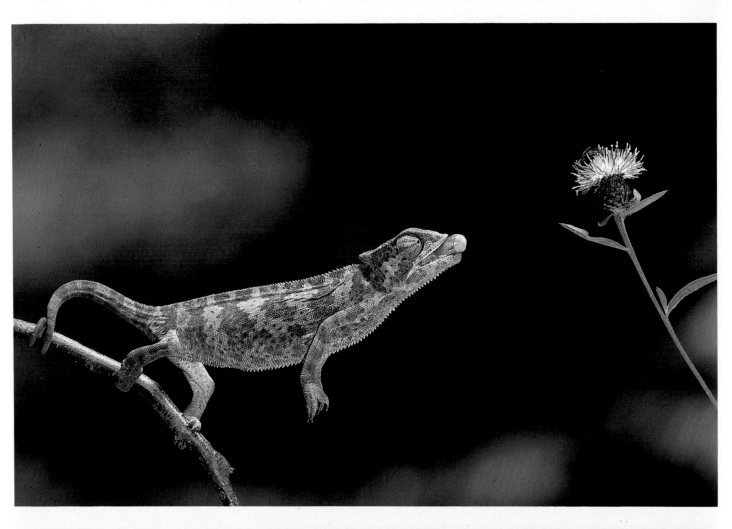

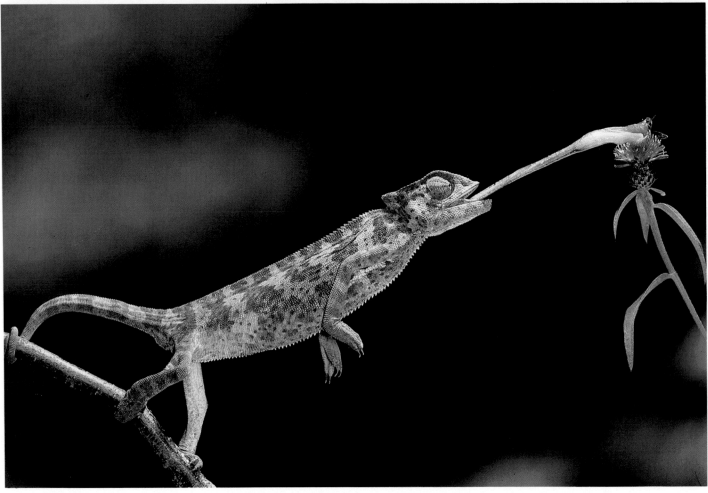

121–123 **Chameleon feeding**
The tongue of a chameleon, which can
extend to over eight inches (20cm), is
not a muscular structure but is powered
by a rapid inflow of blood. The tip is very
sticky and usually holds the prey fast.
 The best-known characteristic of the
chameleon was fascinating to watch:
within seconds of spotting prey its
colour and pattern intensified.

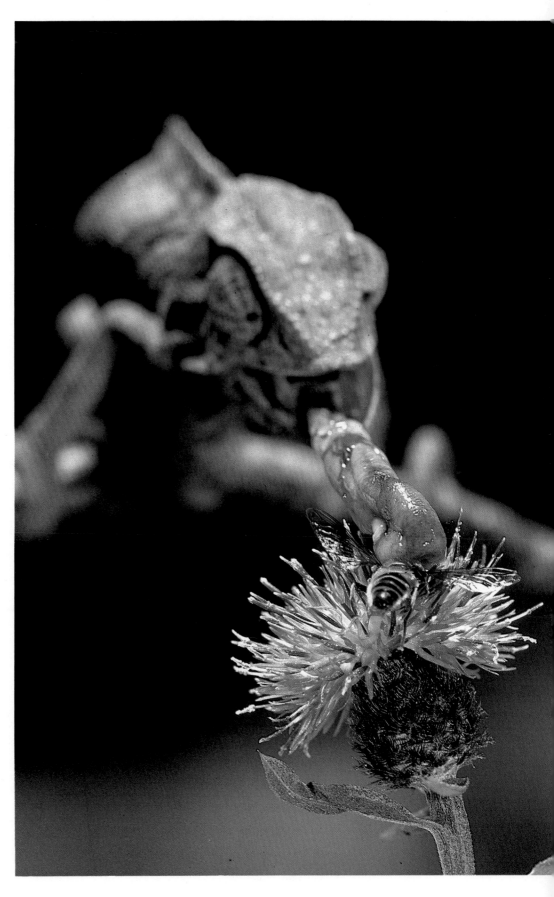

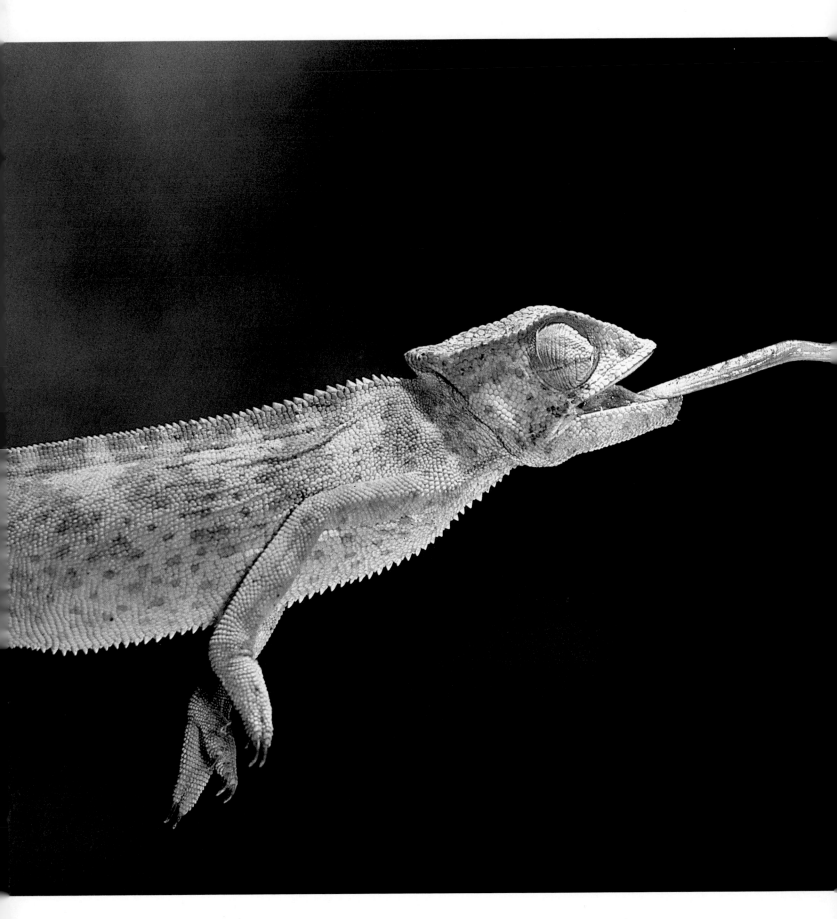

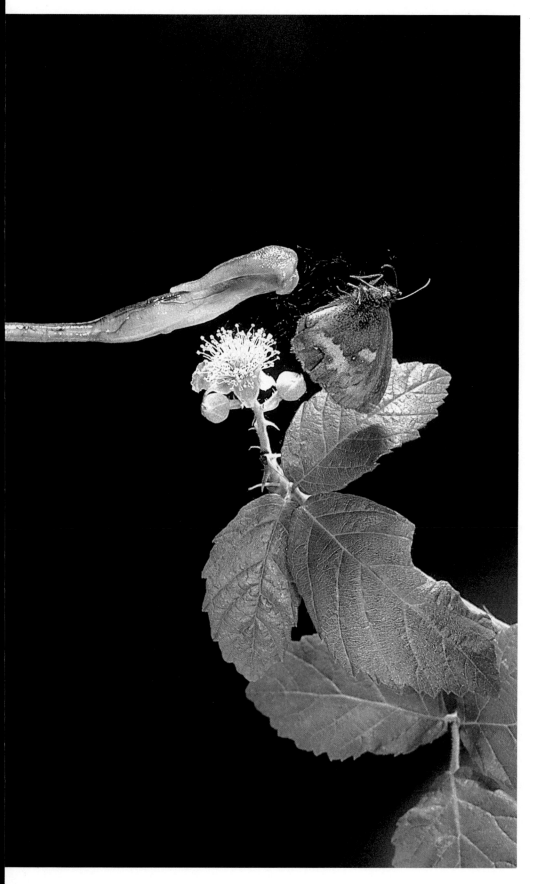

124 **Chameleon feeding**
Although the reptile's tongue usually secures its prey, the butterfly here lived to see another day, as its wing-scales, which easily become detached, stuck to the tongue and the insect escaped.

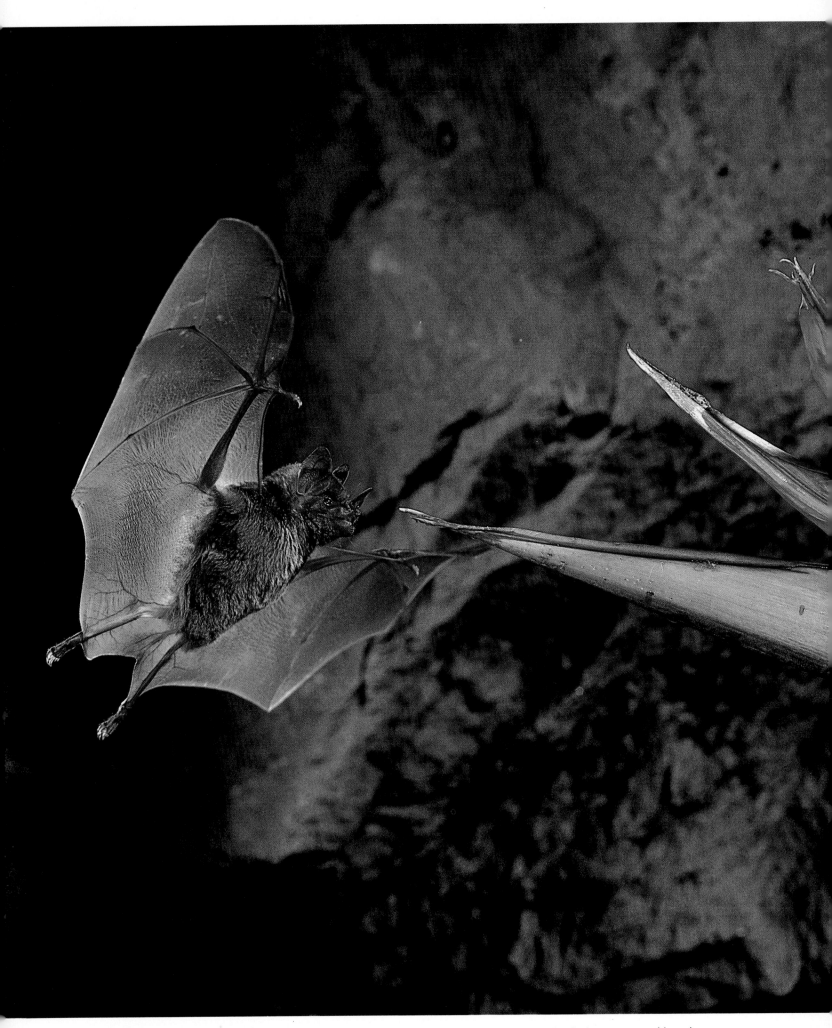

125 **Short-tailed leaf-nosed fruit bat** This bat, common in the New World, is about to drink the water or diluted nectar which has collected in a bird-of-paradise flower.

Bats

After devoting so much time and effort to insects and birds, it was natural that I should eventually turn my attention to the remaining group of flying animals, the bats. I have always been fascinated by these unjustly maligned creatures because of their amazingly sophisticated navigating skills in total darkness and their spectacular on-the-wing hunting techniques.

Many species of bats have evolved an unbelievably complex sonic radar enabling them to perceive more information about their surroundings through their ears than we can see with our eyes. Apart from 'hearing' the size, shape, distance and texture of an object, they can also establish its relative speed and direction of movement. Some bats can even detect and capture insects which are resting on leaves and branches, using the reflected sound waves of ultrasonic squeaks to differentiate between insect and background, while others are able to locate fish by acoustically 'seeing' the ripples produced by fish on the surface of water. Only now are scientists just beginning to unravel the intricacies of the bats' echo location system.

An opportunity to work with bats arose when the German magazine *Geo* asked me to undertake the photography for an article on the bat's hunting techniques. It was to be an ambitious project, as it involved photographing bats not only in flight, but capturing prey. Even at this early stage I began to wonder how on earth I was going to obtain pictures of bats actually catching insects on the wing – it can be hard enough to get one creature in flight, let alone two flying in opposite directions. In view of my total lack of experience with bats I decided to leave this knotty problem to the end.

The first species I had to tackle was a large predatory bat from India, the false vampire, *Megaderma*. In the wild these bats leave their daytime roosts in underground caves and skim over the ground hunting for frogs and mice. But as time and money were limited there was no question of photographing them in their natural habitat – besides, I did not relish the idea of squeezing into bug-infested cramped caves knee-deep in bat droppings. The answer was to work with captive bats, and the only place with captive *Megaderma* was Frankfurt University, where Professor Gerhardt Neuweiler and his team were conducting research on echo location.

The bats were housed in a disused underground bowling-alley. As I wanted shots of them hunting and catching their natural prey, the white mice on which they were fed were quite unsuitable – they had to be wild ones. Eventually, after much searching, we found a supply of brown mice.

These curious animals would begin by hunting passively like barn owls, flying a few feet above the ground with head and ears directed downwards, listening for rustles and other mouse-like sounds. If the mouse moved so much as a whisker, the bat would home in on the sound from up to twenty feet away and hover briefly above its prey to get a positive 'radar' fix, before seizing the poor creature by the scruff of the neck and carrying it away to its roost to devour.

Photographing all this was by no means easy. In the first place the mice were, understandably, reluctant to stay in one spot for long: even if a mouse was placed high up on a rock or branch, as often as not it would leap off at the sound of approaching membraneous wings. This was no help to either the mouse or to me, as the bat would pursue its victim over the ground and apprehend it a few feet away, well out of range of the camera. Another snag was that there was no way of knowing from which direction the bat was

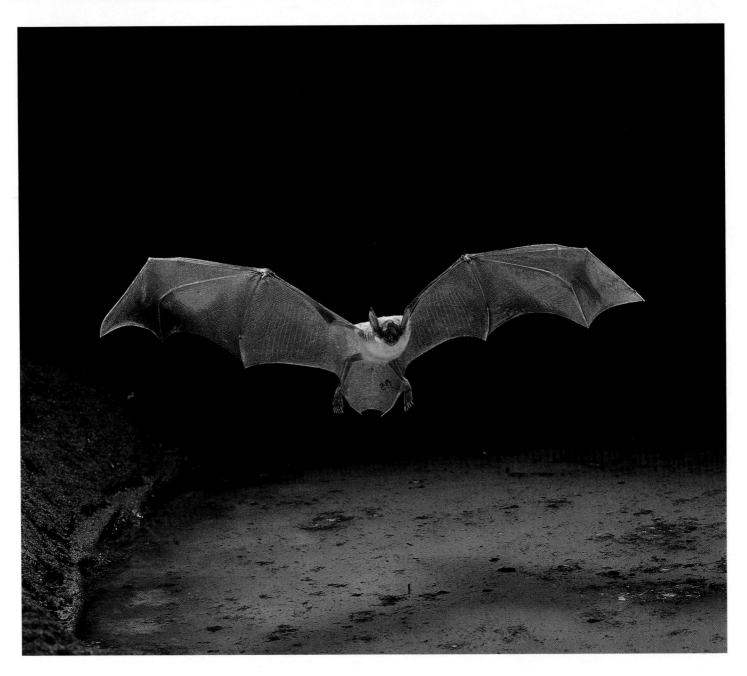

coming. I ended up by firing the camera manually whenever the bat was somewhere near the mouse, rather than relying on light-beams and photocells. As is so often the case with high-speed photography, I had to spend a lot of time and use much film before getting worthwhile results.

In all, the *Megaderma* project took three weeks to complete, and I spent a further few days working on another species, the mouse-eared bat. During this time I learnt a great deal about bats, and became captivated by their endearing qualities.

On returning home, I began to organize a second bat trip – this time to New York's Bronx Zoo, where there was a pair of fifteen-year-old fishing bats. These large and attractive-looking bats from South America feed exclusively on fish, which they hook out of the water. Twelve hours before I was due to fly out, having airfreighted the crates of equipment in advance, I received a phone call from Jim Doherty, the curator of mammals, to say that one of the bats, the only one that ever fished, had died and that it was pointless to come. As it was by then too late to abandon the project I turned up all the same.

Jim explained to me that although one of the bats used to catch fish, for the last few years they had been fed on a diet of chopped mackerel which was merely thrown into a box at the side of the cage. To make matters worse, the remaining bat rarely flew. Things looked bleak indeed, but I felt that in view of

126, 127 Fishing bat
With mouth wide open, emitting ultrasonic cries, the fishing bat skims low over the water's surface, dragging its gaff-like talons through the water in its efforts to catch fish. In the picture above the bat is descending and slowing down for a fishing run.

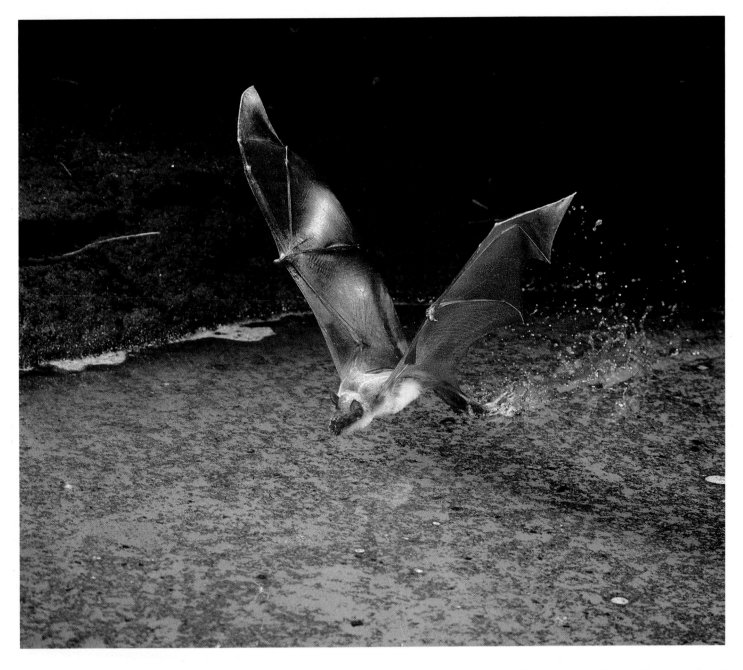

all the expense some sort of attempt ought to be made, so the next day I constructed a pool about eight feet (2.5m) long and stocked it with small fish. That evening, having cut down the mackerel supply, I sat in the subdued light and waited. Apart from the occasional thunderous roars of lions echoing from the big-cat house immediately above, everything stayed quiet, with no sign of activity from the bat.

The following evening brought a glimmer of hope. I had been waiting for perhaps two hours when I heard a shuffling sound from within the roosting box, and soon afterwards a groping shape appeared, crept a short distance down the wire and launched itself into the air. On brown wings the silvery bat flew gracefully over the water, completing only one circuit of its cage before flopping back into its box. But it was enough to revive my flagging optimism.

The next day I arranged all the equipment round the pool. Bearing in mind that the bat catches fish by dragging its long sharp-clawed feet through the water, I set the light-beam an inch or so above the surface. At nightfall, with the motorized Hasselblad in place and the batteries fully charged, I left the zoo for my Manhattan hotel hopeful of success. On my arrival the following morning I was delighted to find that the whole twelve-exposure film had run through the camera. Subsequent processing revealed twelve beautiful transparencies of the pool, but no sign of any bat. I soon tracked down the

fault and made another attempt that night. This time only one frame was exposed, but at least a bat's wing-tip could be discerned in one corner. The operation was repeated for another ten days or so, during which all sorts of alterations were made, including attempts to divert the bat's flight-path, and adjustments to the beam, focus and lighting. Although I finally succeeded in getting shots of the bat hunting for fish, I never managed to catch it actually gaffing one with its claws. When at the end of the session the fish were counted, none was missing. The poor animal was indeed incapable of catching fish.

The most impressive characteristic of bats, their ability to locate and catch small insects while flying in total darkness, had yet to be photographed. Clearly, to record such an aerial encounter would be a scoop for *Geo* and a triumph for me. But how was it to be tackled? There was little point in releasing a bunch of bats and insects in an enclosure in the hope that they would eventually make contact with one another in front of the camera. If there was to be any hope at all of obtaining the picture, then somehow the bat would have to catch its prey at a pre-arranged spot.

Perhaps the most promising approach would be to train a particular bat to feed exclusively on insects dropped or thrown to it at a fixed spot. With this in mind I discussed the project with Professor Neuweiler at Frankfurt, who had had considerable experience in training bats for his behavioural experiments. He kindly agreed to cooperate in every way possible and suggested that the greater horseshoe bat would be the most suitable species to work with. This European mammal is not only capable of performing astounding aerial manoeuvres, but also has a highly accurate and sophisticated echo-location system based on the Doppler principle.

During the following six weeks Neuweiler trained his bat to take mealworms thrown by hand, during which time we kept in close contact by phone to discuss progress and problems. At first the mealworms were snapped up in a very loosely defined area, but as the weeks slipped by, the techniques of both bat and 'thrower' became more coordinated. Finally a stage was reached when I felt that the time was ripe for me to appear.

Within an hour of my arrival in Frankfurt, I was in the familiar underground alley watching the bat ensnaring insects in mid-air within about three feet of my face. The precision and refinement of that friendly little creature's hunting technique were unforgettable. The instant the hand started to flick forward, the bat dropped from its roost some eight feet (2.5m) away and flew down so that by the time the mealworm had left the hand, the bat had already covered about half the distance to its prey. A split second later the bat enveloped the insect in its wings and flew back to its perch, transferring the morsel to its mouth on the way. Frequently the mealworm appeared to be caught directly by mouth with no assistance from the wings, but it all happened so rapidly that it was impossible to see what was actually taking place. After that impressive demonstration I could not possibly leave Frankfurt without the pictures.

As we did not want to risk upsetting the bat's hunting routine, the positioning of the apparatus could not be hurried. The animal needed time to get accustomed to all the unfamiliar echoes from the new obstacles in its path. In due course, after directing the beam and camera at the most promising spot, I made the first test exposures on Polaroid film. The results

128 The camera and apparatus set up to photograph a bat.

129 Bats leaving Carlsbad Caverns
Although this picture is not strictly high-speed, it is included because part of my assignment from *Geo* magazine included a trip to New Mexico to photograph the million or so free-tailed bats leaving the Carlsbad Caverns. As the bats did not leave the caves until after sunset, the only way I could get any picture at all was to combine a long-time exposure with flash. This unusual combination produced the weird result below – the nebulous grey vortex is the thousands of bats spiralling out of the cave, while the silhouettes on the interior walls and the highlighted bats at the entrance are due to the flash exposure.

were encouraging. The next hurdle was to replace the mealworms with flying insects. We decided on moths, as they were relished by the bat and easily found. The animal appreciated its new, bristly diet, although, hardly surprisingly, as soon as the moths were released most streaked off in the wrong direction. Nevertheless the bat very soon caught up with them, though some distance away from the planned spot. Watching the aerial combat from such close quarters was totally engrossing, particularly when for a split second the moment of truth was illuminated by the flash. Occasionally the bat would have to perform some completely unrecognizable aerobatic manoeuvre in order to catch its victim. Recording this on film was no easy matter; my success rate with moths was extremely low. In the end I had to make all sorts of minor alterations to both the positioning of my equipment and the bat's routine; fortunately the patient creature accepted all my fussing with resigned equanimity. Finally, after consuming countless rolls of film and scores of moths, I succeeded in my goal. Nobody was more surprised than I.

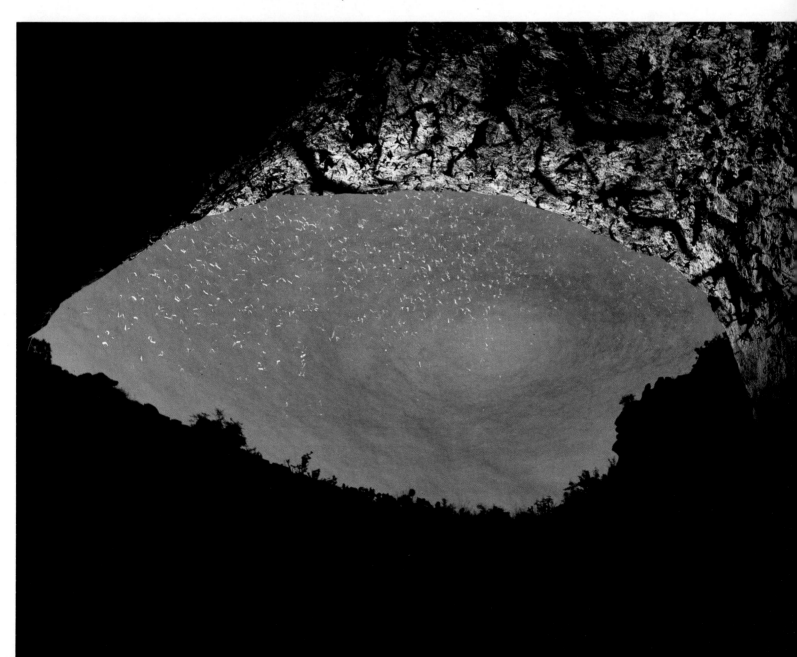

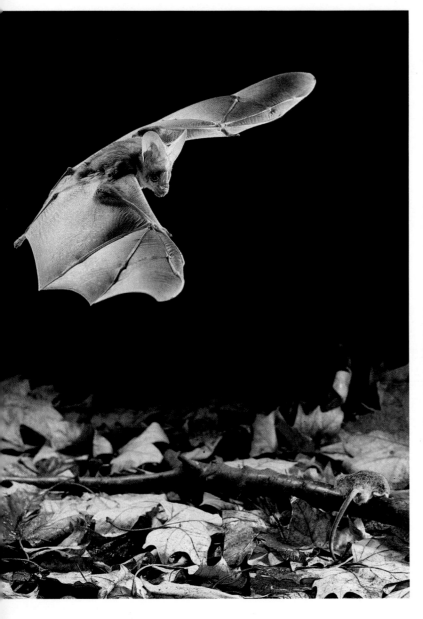

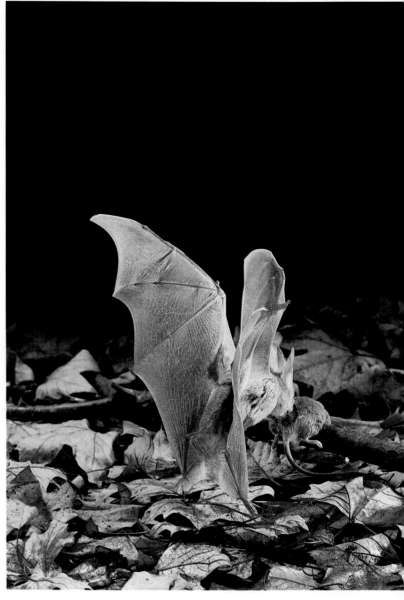

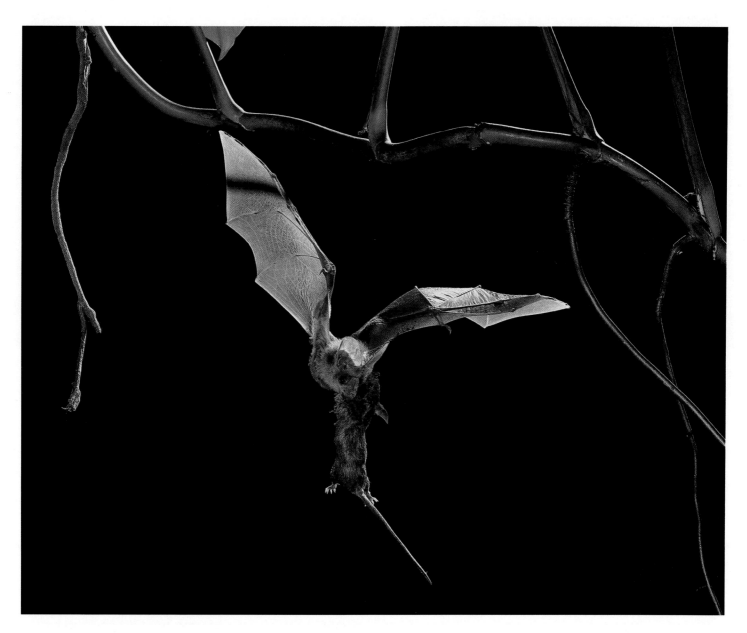

130–132 False vampire catching mice
The mouse is doomed as soon as it makes the slightest rustle, even if the sound lasts only a fraction of a second. The false vampire's incredibly sensitive hearing can pinpoint potential prey with uncanny accuracy, homing in on the sound source from up to thirty feet away. After hovering over the mouse to make a positive 'radar' fix, the bat drops down for the kill, and then carries its victim to a convenient perch where it can feast at leisure.

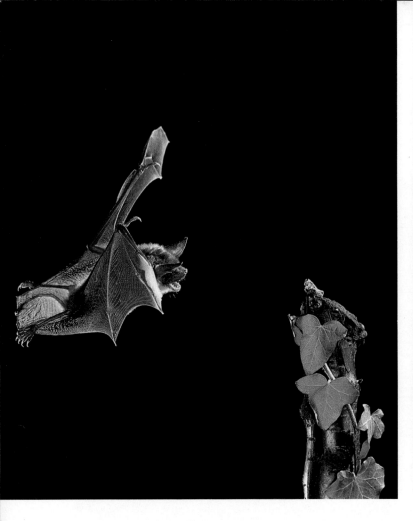

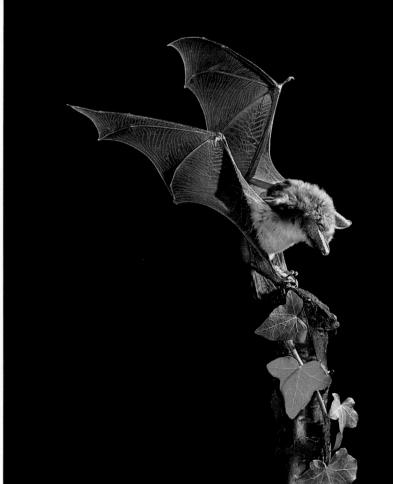

133–137 **Mouse-eared bat catching cricket**

Some bats can actually detect and capture insects which are resting on leaves or branches, using reflected sound-waves to differentiate between insect and background.

This series of photographs shows a mouse-eared bat homing in on a cricket sitting on a stump. Ultrasonic squeaks are emitted from the bat's open mouth as it approaches; it then sweeps up its victim in the tail pouch, and without delay curls its flexible body to collect the morsel in its mouth.

On rare occasions the bat miscalculates, as can be seen from the picture bottom right, which is not in the same sequence as the others; here the cricket got away.

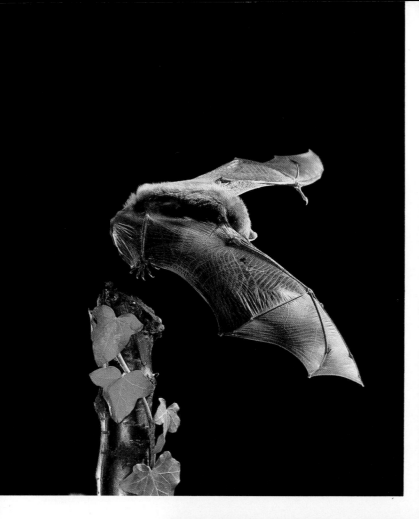
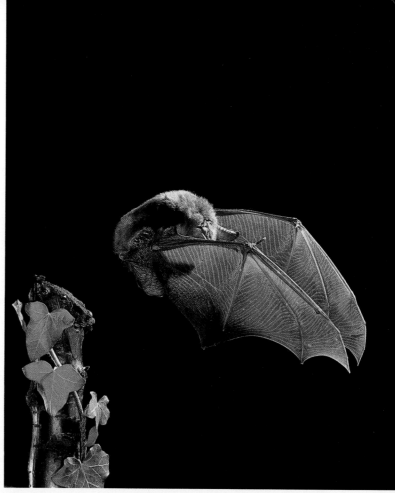
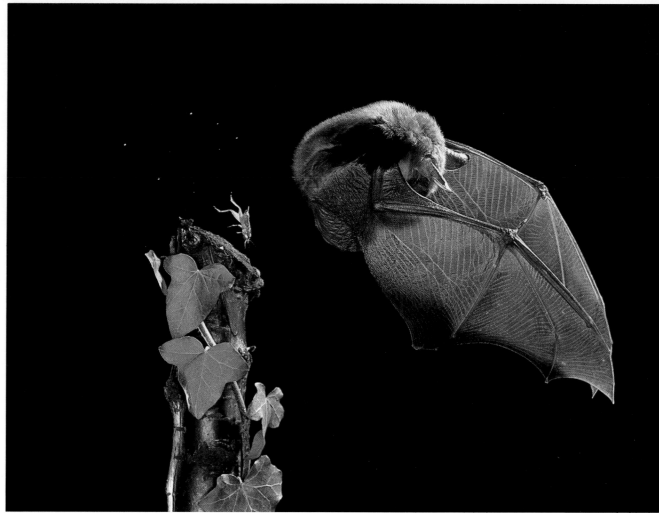

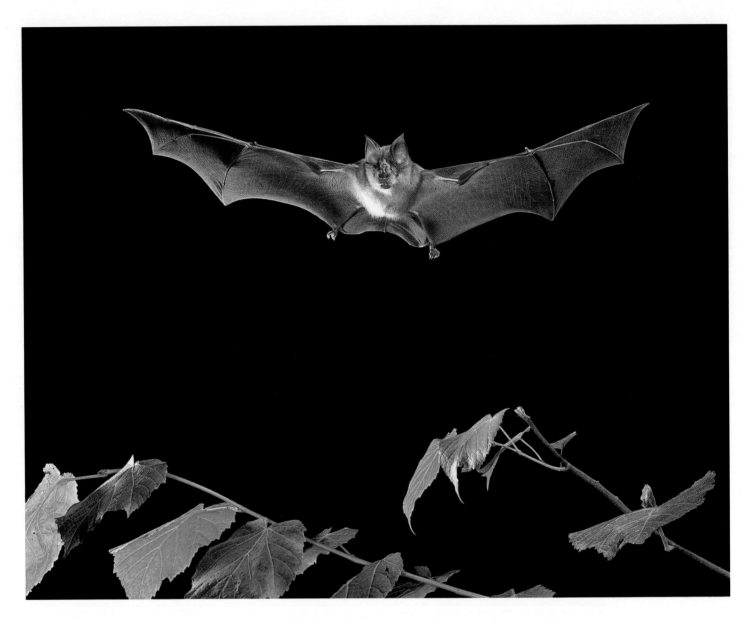

138, 139 Bat catching moths
Two shots of a bat hunting in the dark. The grace and speed
of these aerial wizards is truly breathtaking.

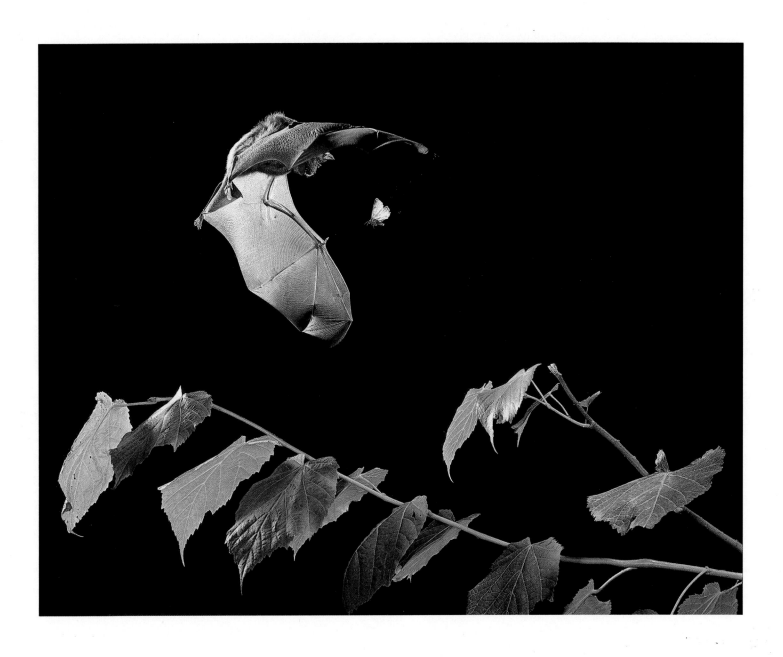

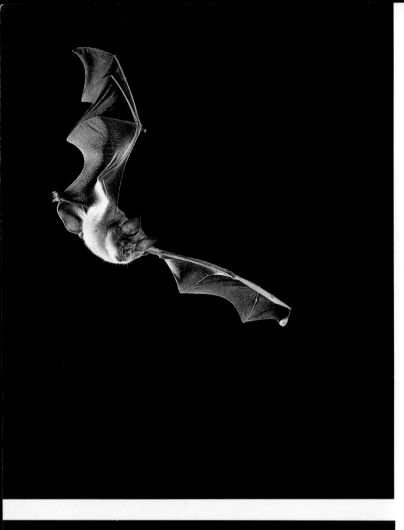

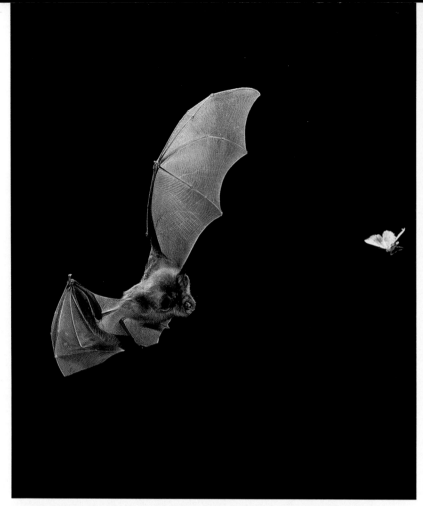

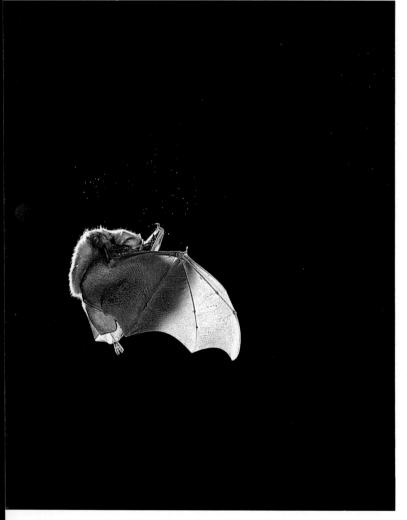

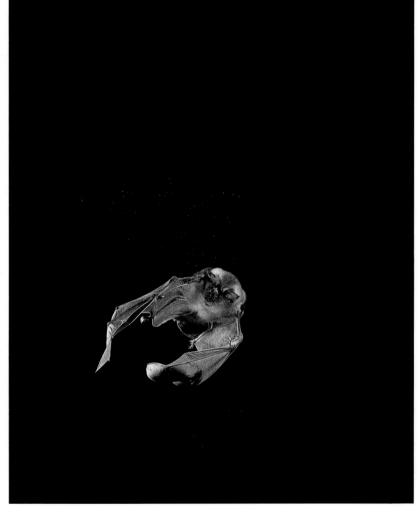

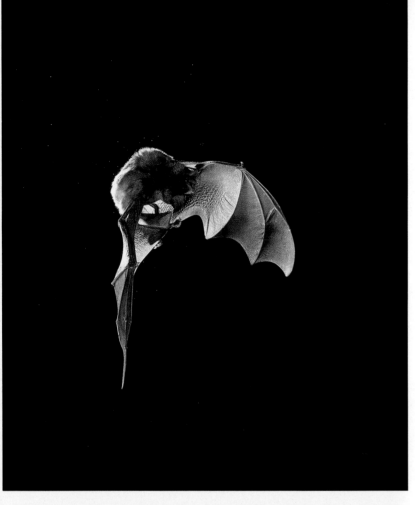

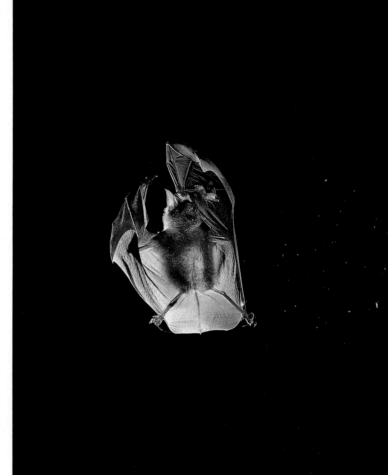

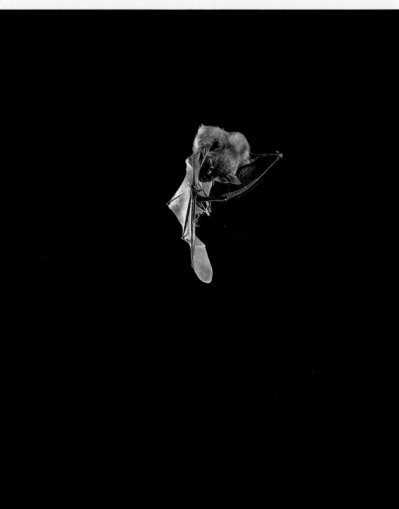

140–146 **Horseshoe bat catching moths**

The horseshoe bat's astonishing skill at catching small insects in complete darkness is based, first, on its ability to twist and turn on the wing in a way that can only be matched by hummingbirds, and secondly, on the unique and deadly accurate echo-location system with which the animal is endowed.

Sound vibrations appear closer together when the source of the sound is moving towards the listener than when it moves away. A familiar example of this 'Doppler effect' occurs when the whistle from a train seems to rise and then fall in pitch as the train approaches and passes. The horseshoe bat makes use of this by emitting a long pulse of constant frequency, and detecting the minute shift in apparent frequency of the echo resulting from the relative speed and direction of the moth. By adjusting the frequency of its cry and then altering its flight path, the bat homes in on its prey.

This series shows various stages in the riveting aerial battle.

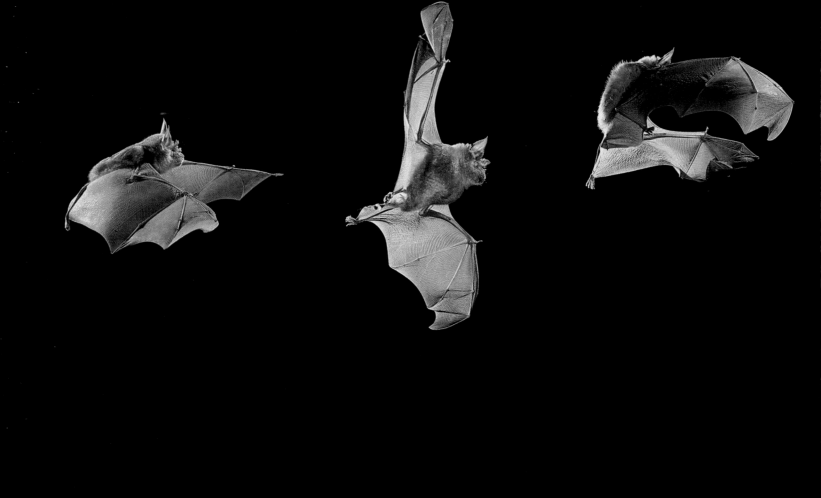

147 Moth avoiding bat
Aerial combat in total darkness: bat is
pitted against moth in a duel of
awesome sophistication. Some moths
have evolved the ability to detect the
cries of bats and avoid capture, as these
multiflash images show. The moth has
reacted to the cries by performing an
evasive loop; as a last resort it can fold
its wings and drop like a stone. (The
moth sequence was illuminated by
cinestrobe.)

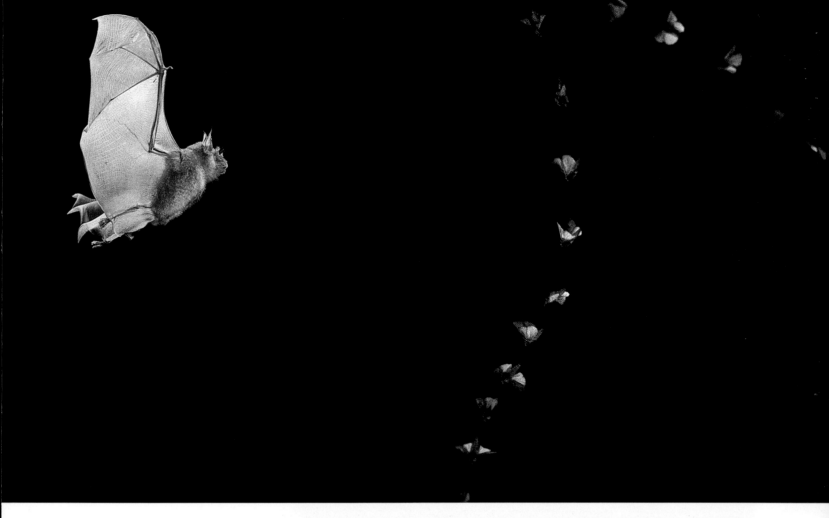

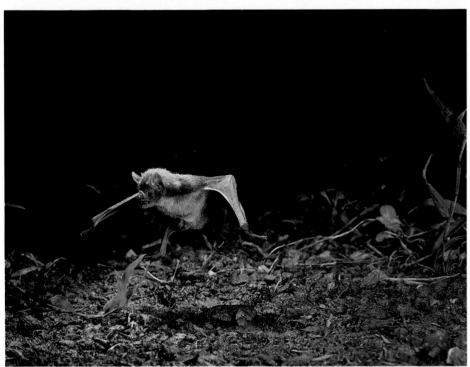

148 Vampire bat jumping
A true blood-sucking vampire jumping
out of the way of a sleeping pig (out of
picture) which has involuntarily kicked
out after being bitten by its assailant.

Vampires do not fly directly on to
their victim, but prefer to crawl or jump
about on the ground nearby in search
of a suitably soft area of skin to
puncture with their razor-sharp teeth.

As my high-speed flash equipment
had let me down for the first time in ten
years, this picture was taken by means
of 'computerized' flash units set at
about 1/4000 second.

List of Species illustrated

Insects

Ant-lion *Myrmeleontidae* 26
Black witch moth *Ascalapha odorata* 50, 51
Brimstone *Gonepteryx rhamni* 2
Bumblebee *Bombus agrorum* 71
 Bombus lucorum 3
Click beetle 78
Cockchafer *Melolontha melolontha* 1
Common coenagrion damselfly *Coenagrion puella* 23
Common sympetrum *Sympetrum striolatum* 22
Common wasp *Vespula vulgaris* 72, 73
Cranefly *Tipula* sp. 65
Damselfly *Hetaerena cruenta* 24
Desert locust *Schistocera gregaria* 28
Devil's darning needle *Aeshnidae* 21
Emperor moth *Saturnia pavonia* 8
Giant lacewing *Osmylus fulvicephalus* 25
Grasshopper *Tropidacris dux* 29
Greenbottle fly *Lucilia* sp. 63
Greenfly *Aphis* 31
Green lacewing *Chrysopa carnea* 17, 18
Green lestes damselfly *Lestes sponsa* 14
Green silverlines *Bena prasinana* 52
Gulf fritillary *Agraulis vanillae* 37
Harlequin beetle *Acrocinus longimanus* 61
Hawk moth *Amplyterus gamascus* 49
 Erinnyis ello 46
 Erinnyis sp. 48
 Xylophanes pluto 47
Heliconid butterflies *Heliconiidae* 20, 33–36
Honeybee *Apis mellifera* 69, 70
Housefly *Musca domestica* 62
Hoverfly *Eristalis arbustorum* 15
 Eristalis tenax 66
 Syrphus lunigar 68
 Syrphus ribesii 67
Ichneumon wasp *Ophion luteus* 76
Ithomid butterfly *Mechanitis polymnia* 32
Jumping spider 77
Ladybird (Ladybug) *Coccinellidae* 60
Leaf beetle *Diabrotica limitata 15-punctata* 12
Longhorn beetle *Strangalia maculata* 59
Meadow brown *Epinephele jurtina* 45
Micro moth *Nemotois degeerella* 58
Monarch *Danaus plexippus* 7
Mud-dauber wasp *Sceliphron caementarium* 75
Paper wasp *Polistes annularis* 74
Pericopid moth *Chetone angulosa* 55
 Eucyane sp. 56
Plume moth *Platyptilia pollidactyla* 57
Queen *Danaus gilippus berenice* 38
Red admiral *Vanessa atalanta* 41
Rhododendron leafhopper *Graphocephala coccinea* 4
Scorpion fly *Panorpa* 27
Short-horned grasshopper *Melanoplus* sp. 30
Shoulder-striped wainscot *Leucania comma* 53
Skeleton butterfly *Pteronymia* sp. 33
Small tortoise-shell *Aglais urticae* 42
Spurge hawk *Celerio euphorbiae* 9
Swallowtail *Papilio machaon* 43, 44
Tiger moth *Ormetica maura* 54
Waiter *Marpesia coresia* 40
Yellow dungfly *Scatophaga stercoraria* 64
Zebra *Heliconius charitonius* 19
'89' butterfly *Diaethria marchalii* 39

Birds

Barn owl *Tyto alba* 84, 110
Blue tit *Parus caeruleus* 87–89
Coal tit *Parus ater britannicus* 90, 91
Greater spotted woodpecker *Dendrocopos major* 5, 95
Great tit 99
House martin *Delichon urbica* 109
House sparrow *Passer domesticus* 85
Kestrel *Falco tinnunculus* 13
Kingfisher *Alcedo atthis* 93, 94
Little owl *Athene noctua* 111
Nuthatch *Sitta europaea* 11
Robin *Erithacus rubecula* 10
Spotted flycatcher *Muscicapa striata striata* 92
Starling *Sternus vulgaris* 97–99
Stock dove *Columba oenas* 100
Swallow *Hirundo rustica* 101–108
Tawny owl *Strix aluco sylvatica* 6
Tree creeper *Certhia familaris* 96
Tree sparrow *Passer montanus* 86
Violet-cheeked hummingbird 112
Wren *Troglodytes troglodytes* 81

Reptiles and amphibians

Chameleon *Chamaeleo chamaeleon* 121–124
Common frog *Rana temporaria* 113, 116, 117
Edible frog *Rana esculenta* 120
Leopard frog *Rana pipiens* 118, 119
Rattlesnake *Crotalus atrox* 115
Tree frog *Hylidae* 114

Bats

False vampire *Megaderma lyra* 130–132
Fishing bat *Noctilio leporinus* 126–127
Free-tailed bat 129
Horseshoe bat *Rhinolophus ferrum-equinum* 140–146
Mouse-eared bat *Myotis myotis* 133–137
Short-tailed leaf-nosed fruit bat *Carollia* sp. 125
Vampire *Desmodus rotundus* 148

Numbers refer to plates

Index

Numbers in *italic* refer to the plates